Timothy Hilton
was born in 1941. He was educated at
Aston Technical College, Birmingham, Balliol College, Oxford,
and the Courtauld Institute of Art, where he subsequently taught.
He is also the author of *Picasso*, published in
the *World of Art*.

WORLD OF ART

This famous series
provides the widest available
range of illustrated books on art in all its aspects.
If you would like to receive a complete list
of titles in print please write to:
THAMES AND HUDSON
30 Bloomsbury Street, London WC1B 3QP
In the United States please write to:
THAMES AND HUDSON INC.
500 Fifth Avenue, New York, New York 10110

D0167109

Printed in Singapore

THE
PRE-RAPHAELITES

TIMOTHY HILTON

157 illustrations

21 in color

THAMES AND HUDSON

Any copy of this book issued by the publisher as a paperback is sold subject to the condition that it shall not by way of trade or otherwise be lent, resold, hired out, or otherwise circulated without the publisher's prior consent in any form of binding or cover other than that in which it is published and without a similar condition including these words being imposed on a subsequent purchaser.

© *1970 Thames and Hudson Ltd, London*

Published in the United States of America in 1985 by Thames and Hudson Inc., 500 Fifth Avenue, New York, New York 10110

Reprinted 1993

Library of Congress Catalog Card Number 88–51873

All Rights Reserved. No part of this publication may be reproduced or transmitted in any form or by any means, electronic or mechanical, including photocopy, recording or any other information storage and retrieval system, without prior permission in writing from the publisher.

ISBN 0-500-20102-1

Printed and bound in Singapore

Contents

Preface 7

CHAPTER ONE
Beginnings 9

CHAPTER TWO
The Brotherhood 31

CHAPTER THREE
Realism and Romance 65

CHAPTER FOUR
The Movement 105

CHAPTER FIVE
Work 133

CHAPTER SIX
A Palace of Art 161

CHAPTER SEVEN
Beata Beatrix 175

CHAPTER EIGHT
Standstill 189

Bibliographical note 212

List of illustrations 212

Index 216

To Marghanita Laski

Preface

This is the first history of Pre-Raphaelitism to concentrate on the painting itself since 1899, when Percy Bate's pleasant *The English Pre-Raphaelite Painters and their Successors* was published, and it offers some adjustments to the straight art history, as it were, of the movement, and also reinterprets the activities of several of the artists. In the absence of much detailed discussion of the period, some of my conclusions are necessarily tentative, even though presented here as the last word on the subject.

Anyone who writes about nineteenth-century English painting must be conscious that he owes a great deal to Miss Mary Bennett, of the Walker Art Gallery, Liverpool, not only for assembling exhibitions of the work of Brown, Millais and Hunt, but also for accompanying them with such magnificent catalogues. I would add that I have found Allen Staley's catalogue entries to the 1968 Detroit exhibition of English Romantic Art most stimulating. This book, like many others, owes much to conversations with friends, including many students at the Courtauld Institute, as well as Helen Drabble, Peter Ferriday, Michael Kitson, Judith Landry and Nuala O'Faolain. Juliet Aykroyd helped in many ways. My greatest debt is to the dedicatee.

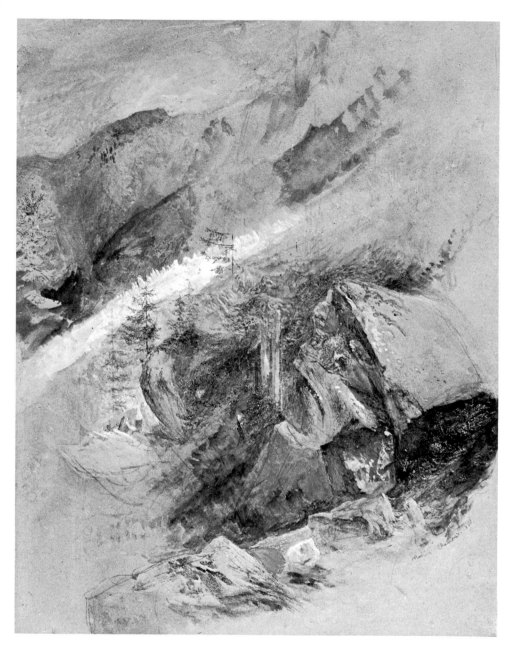

1 JOHN RUSKIN *Mer de Glace, Chamonix* 1860

Beginnings

'Because of a certain Pre-Raphaelite nastiness.' The year was 1894, and George Moore, incensed at Messrs W. H. Smith's decision not to stock his Zolaesque novel *Esther Waters*, had gone to their offices to enquire the reason why. This was the answer. It seems an odd kind of reason, especially if we think of the earnest and holy aspirations of some of the members of the Pre-Raphaelite Brotherhood; not so odd, perhaps, if one considers the unwholesome and sexy gloom in the art of, say, Simeon Solomon. But Smith's censor was probably thinking about naturalism, about the accumulation of detail in Moore's novel. He could have been confusing this with the meticulous care in recording wickedness of the painting of William Holman Hunt. It is hard to say what he had in mind, but what is clear is that he didn't really know what he was talking about.

Though this kind of confusion is unforgivable in people who ban books, in the rest of us it is a pardonable failing; as a glance through the pages of this book will immediately show, many of the paintings we designate 'Pre-Raphaelite' do not at all look like each other. How, one feels, can they belong to the same artistic movement? There could hardly be a greater contrast than that between Edward Burne-Jones's *The Beguiling of Merlin* and Ford Madox Brown's *Work*, or between *119, 112* Dante Gabriel Rossetti's *Beata Beatrix* and John Brett's *The Stone-* *114, 102* breaker. Stylistically, they do not have a common denominator. And to look for a common purpose in the Pre-Raphaelite painters, their admirers and followers, is to look in vain. They were thoroughly individual, and generally kept their own individuality. One would never mistake the work of one member of the Brotherhood for that of another. Pre-Raphaelitism cannot be defined; it was too various. To understand what it was about, we need to follow its differing paths, and it is often as important to describe differences as to record simi-larities. And as no artistic movement, and least of all this one, ever

moves at a uniform pace, or follows a straight route from one position to another, we should note Pre-Raphaelitism's shifts, its sudden leaps forward, its digressions, and finally, with the decadence of the movement, its queer ability to stand still.

We need most of all to chart the ways in which it responded to the conditions of Victorian society, and we need to take account of the effect of personal associations, and to understand its relationship to literature, to social theory, to education, to architecture. Art history is only a part of history, after all, and Pre-Raphaelitism is thick with references to the society in which it was produced. Again, it is not a self-contained movement; it not only has ragged edges, but does not start or finish at a definite place. It was part of a continuing process of changes in art which had begun before the Pre-Raphaelites were born, and still had effect long after their deaths. When the original members of the Pre-Raphaelite Brotherhood, James Collinson, William Holman Hunt, John Everett Millais, Dante Gabriel Rossetti, William Michael Rossetti, Frederick Stephens and Thomas Woolner, first formed their society in the summer of 1848, Pre-Raphaelitism was not born fully-fledged. The history of this movement does not begin with them, but rather with the career of its most illustrious adherent, John Ruskin. This we should examine first of all.

In so far as simple neglect can be called impertinent, this it surely is in the case of the twentieth century's continued ignorance of Ruskin's writing. He was not only England's greatest art critic, but the greatest of its great Victorians, the most sagacious of its sages, the most powerful and original thinker of the nineteenth century. Ruskin's career spans the century, and much of his life is inextricably mingled with the fortunes of Pre-Raphaelitism. He was born in 1819, in the same year as Queen Victoria, the year of Peterloo and Keats's 'Ode to a Nightingale'. His father was a prosperous sherry merchant, his mother a dour Evangelical. They lived just outside London, in a comfortable bourgeois mansion in Herne Hill, near to the Surrey countryside and within walking distance of one of the few public picture galleries of the day, that at Dulwich College. The young Ruskin was both

cosseted and bullied. He never went to school, but was given an intensive and, by the standards of the day, eccentric education by his parents and a number of tutors.

It was the austere religion of his Scottish parents that first instilled in him his inflexible moral sense. On their frequent travels through England and Europe – he always accompanied them – his eyes and mind were opened to the manifold beauties of the natural world; with him, natural history was to become natural art history. The formation of Ruskin's mind was a complicated one, but in the examples of three of his early heroes – who were always to remain his heroes – we can isolate some leading aspects. From Sir Walter Scott he took a Romantic medievalism, from William Wordsworth a belief in the significance of natural beauty. But most of all he learnt from an artist, J. M. W. Turner, many of whose watercolours his father bought, and whose illustrations to Rogers's *Italy* were to influence him so profoundly. From Turner he derived a passion for the 'icon', for representation, for the ability of man to reproduce and interpret the world through pictorial art.

Ruskin's tastes, as they developed, became Romantic, scientific and anti-classical. When touring through Europe, for business or pleasure, the Ruskin family took a noticeably different view – and a different route – from that of the classical Grand Tour, most of whose traditions, of course, had been effectively killed by the Napoleonic wars. While they went to Italy, their anti-Papist feelings worked hard against the inflated grandeur of the great monuments of Rome. As Ruskin wrote back to his tutor, Thomas Dale, who was later to found the first university English literature course, 'St Peter's I expected to be *disappointed* in. I was *disgusted*. The Italians think Gothic architecture barbarous. I think Greek heathenish.'

This attitude to architecture had its parallel in painting. The Ruskins scorned precisely those classical and Baroque masters so prized by earlier generations of English travellers, who had come home from Italy to fill country houses with works by the Caracci, Guido Reni, Claude, Canaletto – the great masters of the seventeenth century and their academic followers. The Ruskins could find little to please them in such paintings; they turned from art to look at the Alps, and looked

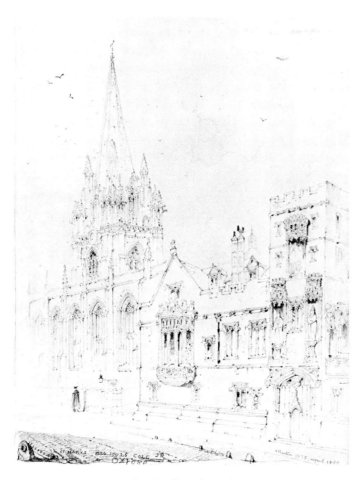

2 JOHN RUSKIN *St Mary's and All Souls, Oxford* 1835

at them with Wordsworth's eyes. They preferred the cantons of Switzerland to the states and cities of Italy, and loved the valley of the Rhine, where Turner and Samuel Prout had travelled before them, and the cathedral cities of northern France.

With the inspiration of Wordsworth and Turner, Ruskin looked at the Alps, drew them, and wrote poems about them. They were an artistic inspiration. But this was not all; for the young Ruskin was not only a poet, but a scientist too. These interests were most fully expressed in his study of geology, a science then still in its pre-Darwinian phase,

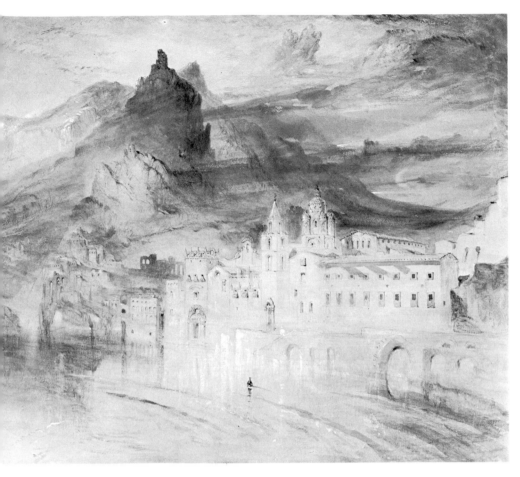

3 JOHN RUSKIN *Amalfi* 1840–41

not leading to Doubt, but explaining and proving all the goodness and infinite wonder of God's created world. Rocks, stones, and water, winds and clouds, leaves and grasses and flowers – all these, the various materials of the natural world, came under an intensely empirical scrutiny. He used a cyanometer to measure the intensity of the blue of the sky, he collected minerals and measured rainfall. He recorded, analysed, and classified, and did so, ultimately, to glorify. Nature was God's good nature, and all that God made was good. There was no such thing as bad weather, only different varieties of good weather.

13

But Ruskin's scientific impulses were expressed *poetically*; his prose often falls naturally into Shakespearean decasyllabics. For Ruskin is a remarkable example of a man whose sensibility was coextensive with his learning. Nothing he knew did not move him. In his earlier years this was expressed in a perfect union of the poetic and the scientific impulses – just as his whole career as an art critic can be seen as an attempt to balance the mimetic with the expressive.

Ruskin's early writing about nature, as in the first two volumes of *Modern Painters* (1843 and 1846), is highly personal as well as precisely descriptive; and this is also true of his attitude towards art. His criticism is most successful when the two are brought most closely together. Turner's painting, for him, was beautiful because it was true; *Modern Painters*, at any rate in its earlier volumes, is largely given over to the expansion of this idea. European painting of the post-Renaissance tradition, because stylized, formulaic and untruthful to the facts of nature, could not be anything but loathsome. Claude, Poussin, the classical masters of the landscape tradition, the religious painters of the High Renaissance (especially 'the clear and tasteless poison of the art of Raphael'), the genre painters of the Dutch school, were all therefore to be execrated. In *Modern Painters* they are criticized with some vehemence, not as a man might kick away the curs that snap at his heels, but exhaustively, at great length, with every rhetorical device and every instrument of castigation. Hardly any of the schools of European painting between the Renaissance and the Romantic era escapes this devastating onslaught.

But Ruskin, apart from being a writer and a critic, was an artist himself; he drew every day of his life. And his own practical experience of art was to have a decisive effect on his connection with Pre-Raphaelitism, no less than this general alignment of interests that excluded post-Raphaelite art. He was taught, from the age of twelve, by Alexander Runciman, by Copley Fielding, and by the Evangelical James Duffield Harding. Ruskin's precocity in the use of words was paralleled by his early ability with pencil and brush. But he had the precocity which is not merely a facility for imitation, but assimilates. 2 We thus find that in an early drawing like his *All Souls College*, there is a total mastery of the picturesque architectural style of his much-

14

admired Samuel Prout, in its eye for an aspect, in the broken line of soft pencil used to suggest the feeling of crumbling stonework, in the mingling of secular picturesque detail with the medieval forms of the college and St Mary's Church. A watercolour like *Amalfi*, lavishly 3 worked up from a neat yet sparse drawing on the spot, mysterious, swooping and towering, is a conscious and completely accomplished exercise in the manner of Turner, for whose work it could indeed be mistaken.

Ruskin, then, was at an early age fully able to reproduce the styles of both the minor and major artists of the day. The circumstances in which he renounced this ability to paint in any particular fashion, or like anyone else, are most significant. The imitations, or re-creations, suddenly stop. The moment at which this happened – it was clearly an ecstatic and revelatory experience – he later recalled as having been in 1842, on the road between Norwood and Peckham, south of London.

'In the spring of this year', he wrote in his autobiography *Praeterita*, 'I made, by sheer accident, my first drawing of leafage in natural growth – a few ivy leaves around a stump in a hedgerow. . . . I never imitated anyone after that sketch was made; but entered at once upon the course of study that enabled me afterwards to understand Pre-Raphaelitism.' In another account of this experience he rejects all his early artistic training, saying that he had 'virtually lost all my time since I was twelve years old, because no one had ever told me to draw what was really there.'

The experience was to be repeated a few months later in the Forest of Fontainebleau, when, drawing an aspen in an idle and disengaged fashion, he found that the identity, the quiddity, of the tree, had somehow taken over from his own personality as observer or as draughtsman: 'the beautiful lines insisted on being traced. . . . With wonder increasing every second, I saw that they "composed" them-selves, by finer laws than any known of men. At last, the tree was there, and everything that I had thought before about trees, nowhere.'

What effect did these experiences have on Ruskin's art, and on his attitude to art? The discovery of the ordinary, humble nature of a simple piece of ivy around a briar stump has its significance. It is an important milestone on the road between the Romantic feeling that all that lives

4 JOHN RUSKIN *Fribourg* 1856

is holy and the modern belief that anything that exists is, actually or potentially, artistic. Ruskin was always to insist on the validity of a homespun type of art, especially in the work of two painters he much admired, Samuel Prout and William Hunt, one from Brixton, and the other who only felt at home on the Hampstead Road. As he wrote in his *Notes* on the two artists:

'Drawings of this simple character were made for . . . the second order of the middle classes more accurately described by the term "bourgeoisie". The great people always bought Canaletto, not Prout, and Van Huysum, not Hunt. There was indeed no quality in the

46

16

bright little water colours, which indeed could look other than pert in ghostly corridors, and petty in halls of state; but they gave an un-questionable tone of liberal-mindedness to a suburban villa, and were the cheerfullest-possible decorations for a moderate-sized breakfast parlour, opening on a nicely-mowed lawn.' That is to say, in houses like that of the Ruskins in Herne Hill.

But in more purely stylistic and pictorial terms, we should note these experiences as summarizing a change to a fully Ruskinian style of drawing, a style almost of absence of style, rejecting nothing and composing nothing. For Ruskin no longer composes his work as the drawing masters and drawing manuals recommend. Nor does he compose with any natural felicity, except in so far as nature herself does. The drawings never look as if they are finished, for a new power of concentration on the thing seen is a concomitant of what seems like negligence. There is never any attempt to fill up the paper. Never more, in Ruskin, do we find that his subject is totally adjusted to the rectangle on which it is drawn. There are always blank patches. The subject never takes possession, as it were, of the area within the four margins of the paper, and there is no attempt at that amplitude of balance between form and form, with motif answering motif, which we normally recognize as the quality of design. Ruskin is not interested in making pictures; he hardly ever framed and hung his own work. He never alters what he sees in front of him and he hardly ever draws from memory. He is concerned only with the precise recording of natural appearances. And yet he is not dispassionate, for everything he draws seems now to proclaim that he has indeed examined the natural world with the eyes of love.

Two examples of this sort of drawing will suffice. In *Mer de Glace, Chamonix*, the small tree at the centre is what has caught his eye, and this is caught itself, in pen and body-colour; as one moves out from this central, ardent *aperçu*, the drawing is sketchier, lighter, and the outsides of the paper are simply abandoned. It is centripetal, like a vortex (as are many of Turner's paintings) and is signed at the bottom right as if it were one of those oval-shaped vignettes from a keepsake manual. The same is true of that wonderful, and very cultural, drawing of the houses in a mountain valley, *Fribourg*.

1

4

Like Ruskin, Ford Madox Brown was of a slightly earlier generation than the members of the Pre-Raphaelite Brotherhood; and, again, we can see in his work the early development of some principles that were to be fully expressed in the painting of the members of the Brotherhood itself. His early career was very individual, as was always to be the case, for Brown was a determined loner, even to the point where he seemed to express resentment at being influenced by those around him. Usually he found his own way. He was born in Calais in 1821, the son of a ship's purser, and lived on the Continent during most of his youth. For this reason he avoided the usual training experienced by young English artists. He studied first in Bruges and Ghent under Albert Gregorius, who himself had been a pupil of David, and then moved to the Antwerp academy in 1837 to study under Baron Wappers. In 1839 and 1840 he was in Antwerp and Paris, though some kind of feeling for his homeland was expressed in *The Execution of Mary Queen of Scots* and *Manfred on the Jungfrau*, the latter being a subject from Byron.

5
6

In 1844 Brown, now married and with a daughter – Lucy, who was later to marry William Michael Rossetti – came to live in England.

5 FORD MADOX BROWN *The Execution of Mary Queen of Scots* 1840

6 FORD MADOX BROWN *Manfred on the Jungfrau* 1841

7 FORD MADOX BROWN *Wycliffe reading his Translation of the Bible to John of Gaunt c.* 1847–48

But further trips to the Continent, and especially to Italy, were to have their effect. In Rome he made contact with the Nazarenes, a group of expatriate Germans led by Peter Cornelius and Friedrich Overbeck, whose intention it was to purify their own national art by the manipulation of religious and cultural archaism. The Pre-Raphaelites, initially, were to have similar aims and methods, and Brown's first two English paintings, commenced between 1845 and 1848, provide some sort of link between the two movements.

These were *Chaucer at the Court of King Edward III* and *Wycliffe reading his Translation of the Bible to John of Gaunt.* These paintings both follow Nazarene precedent in their typically Romantic concern with

19

8 'ethnology': the intention behind *Chaucer* was originally 'to produce a masterpiece illustrative of the glories of English sentiment and English poetry', but archaistic impulse concentrated this aim, and the central incident, suggested by James Mackintosh's Scott-inspired *History of England*, became 'a vision of Chaucer reading to knights and ladies fair, to king and court, amid air and sunshine'. The first designs were made in the form of a triptych, for which there was again a Nazarene precedent. Its wings were to enshrine Spenser, Shakespeare, Milton, Pope, Byron, Moore, Wordsworth, Keats, Shelley, Chatterton, and so on; but these were soon abandoned. In its finished state the picture had other Pre-Raphaelite characteristics besides its literary and medieval bias. Together with the array of carefully chosen archaeological detail and the flatness of construction, Brown, as he later explained in the catalogue to his 1865 one-man exhibition, 'endeavoured to carry out the notion of treating the light and shade absolutely as it exists at any one moment instead of approximately or in general style'. Brown often experimented with naturalistic systems of lighting in his early painting. It anticipated what, in a few years' time, was to be a cardinal article of the Pre-Raphaelite faith.

7 *Chaucer* was the result of much cogitation, but *Wycliffe* seems to have come to Brown quite suddenly. He thought of the subject, made a first sketch that evening, and the next morning was to be found in the Reading Room of the British Museum, looking up John Lewis's *Life of Wiclif* and Robert Southey's *Book of the Church*. Such works provided a convenient ideological solidity for the anti-Catholic content of the picture. Wycliffe, as the first man to translate the Bible into English, must have had his attractions as a kind of proto-Protestant, as well as being a semi-legendary figure from the medieval world. Brown also consulted the Gothic Revival architect Augustus Welby Pugin to establish the correct designs for his furniture, and copied Gothic alphabets. *Wycliffe*, with its light, flat tones and dispersed composition, looks very like a Nazarene painting, and this led the *Athenaeum's* generally favourable reviewer to believe that it was designed with a view to an ultimate execution in fresco.

 The Germanic influence, so marked in these paintings by Brown, was a general one in the English painting of the day, and is no less

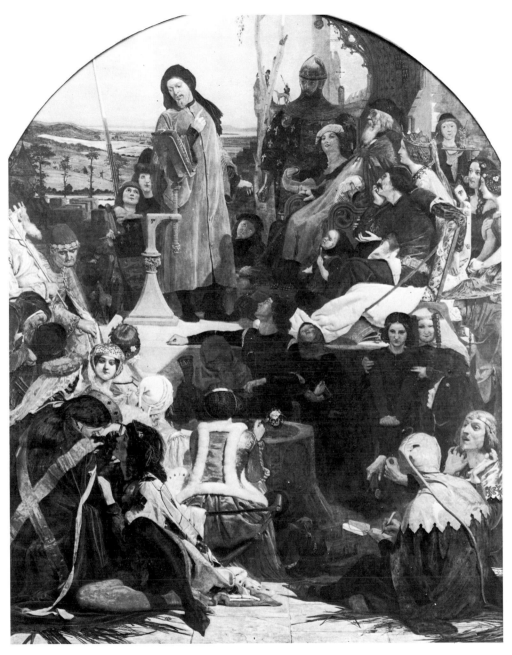

8 FORD MADOX BROWN *Chaucer at the Court of King Edward III* 1845–51

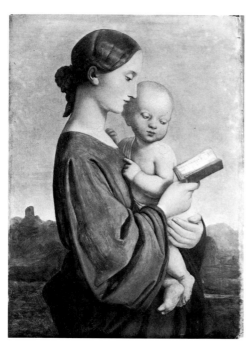

9 WILLIAM DYCE *Virgin and Child c.* 1838

10 JOHN ROGERS HERBERT *Our Saviour Subject to his Parents at Nazareth* 1847–56

clearly seen in the art of William Dyce. Born in Aberdeen in 1806, Dyce was a deeply religious High Churchman. Visits to Italy in 1826 and 1827 stimulated his interest in the Quattrocento, and there he met Cornelius and Overbeck. Dyce was interested in fresco techniques, and was involved in the decoration of the Palace of Westminster, a
9 project that occupied many leading artists at this time. His *Virgin and Child* of 1838 is clearly an archaizing picture, with oil worked to look like tempera, but is too near to Perugino (whom he much admired), and even to Raphael himself, to be classed with the later Pre-Raphaelite paintings. But it does anticipate what was to become Pre-Raphaelitism, as do the paintings of J. R. Herbert, a Roman Catholic convert, a friend of Pugin's, an admirer of German painting and an artist who devoted himself to Biblical scenes painted with great
10 archaeological accuracy. *Our Saviour Subject to his Parents at Nazareth* is the best known of them, and interestingly prefigures the theme of
19 Millais's *Christ in the House of his Parents*.

In the 1830s and 1840s, there was an increased interest in the painting of pre-Renaissance times, the companion, though one that lagged a

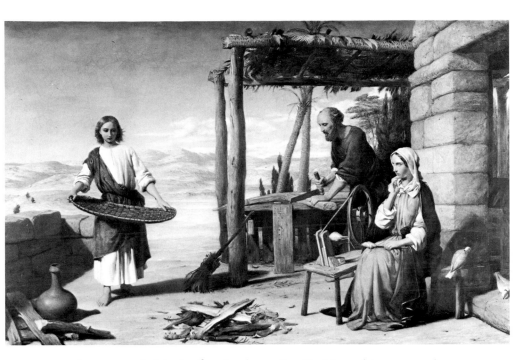

generation or two behind, of enthusiasms for Gothic architecture and medieval literature. Although the National Gallery in its first years had no early Italian pictures, collectors and connoisseurs such as William Roscoe and William Young Ottley were already either buying medieval pictures or writing about them. Prince Albert, Victoria's German consort, made a collection of pictures which included works by Van Eyck, Roger van der Weyden, Duccio, Fra Angelico and Gentile da Fabriano. But the relative obscurity and inaccessibility of such pictures increased the importance of reproductions. In 1848 Albert, together with Ruskin, Lord Lindsay, and some others, formed the Arundel Society, whose object it was to record and reproduce early paintings, so that 'the greater familiarity with the severer and purer styles of earlier Art would divert the public taste from works that were meretricious and puerile, and elevate the tone of our National School of Painting and Sculpture'.

A popular focus of this interest in early art was in the Campo Santo in Pisa. The frescoes there, by (it was thought) Orcagna, Simone Memmi, Giotto, Buffalmaco and Benozzo Gozzoli, impressed Ruskin.

11 They were, via their *conservatore* Lasinio's engravings, a direct influence on the Pre-Raphaelites themselves, and they often appear in the literature of the day – as in John Henry Newman's *Loss and Gain* – as a significant cultural landmark.

Leigh Hunt saw these frescoes when in Italy with Shelley and Byron, and in his *Autobiography* gives a typical, and very English, account of their character and historical standing. Whereas it had previously been held that Italian painting started with Masaccio and Perugino (Vasari, who says that it started with Giotto, was little read, and was not translated until 1850), Leigh Hunt claims that 'the Masaccios and Peruginos, for all that I ever saw, meritorious as they are, are no more to be compared with [the earlier masters] than the sonneteers of Henry the Eighth's time are to be compared with Chaucer'.

Hunt takes up the analogy with our own early national literature elsewhere; to give someone an idea of the atmosphere of the Campo Santo frescoes, he writes, 'the best idea, perhaps, is by referring him to the engravings of Albert Dürer, and the serious parts of Chaucer. There is the same want of proper costume – the same bookish, Romantic, and retired character – the same evidence, in short, of antiquity and commencement, weak (where it is weak) for want of a settled art and language, but strong for that very reason in first impulses, and in putting down all that is felt.' Such sentiments as these, and such comparisons, were common, though rarely so neatly expressed.

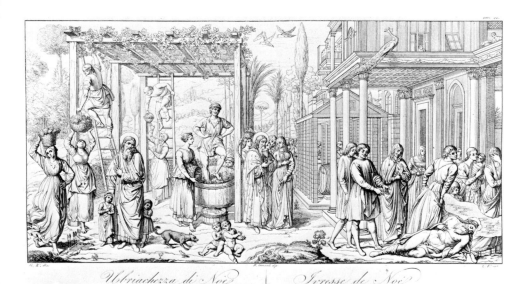

Ubriachezza di Noè *Ivresse de Noé*

11 GIOVANNI
PAOLO LASINIO *The*
Drunkenness of Noah
(after Benozzo
Gozzoli) c. 1832

12 WILLIAM DYCE
Titian's First Essay in
Colour 1856–57
(see p. 128)

The influence of the German Nazarenes, the adumbration of such principles as accuracy, archaism, a new look at the medieval past, an intensity of religious, human and literary feeling; all these are present in the course of English art before the formation of the Pre-Raphaelite Brotherhood, and it must be recognized that the Brotherhood was part of this movement, not its source. Where did this all take place, in what context did such feelings finally appear as oil on canvas, in what conditions were the paintings seen, to be either accepted or rejected as worthwhile art? The answer is in a very concentrated locale, in the institution which held a dominant position – some might say a stranglehold – in English art: the Royal Academy.

This body has now been moribund for so many years that it is easy to forget its immense importance in the first half of the nineteenth

25

century. The Academy was founded in 1768, its first president being Sir Joshua Reynolds, whose *Discourses*, together with the pronouncements of successive presidents and professors, constituted the only body of art theory in England before the publication of Ruskin's *Modern Painters*. Such pronouncements enshrined and propagated the whole idea of the postRenaissance tradition of academic art. But this was not simply a matter of theory; for the Royal Academy Schools were practically the only place where an aspiring painter could learn the elements of his art. Until 1853, the course of training was reckoned to last for ten years, several of which the student would spend on laborious exercises in the Antique School, drawing from casts of classical statues, before ever getting to the stage where he encountered real paints and real people to paint from.

The Royal Academy occupied the eastern half of the building in Trafalgar Square which is now the National Gallery, in what were really very crowded conditions. At the time of the summer exhibitions there was very little room left for the students. What is more, there was little room for the pictures, and with a shortage of wallspace the proportion of rejections to acceptances for hanging in the summer exhibitions increased. This was hard on the artists, for it was at these exhibitions, and hardly anywhere else, that they could hope to sell their paintings.

It was in and around the Royal Academy Schools that the PreRaphaelite Brotherhood was formed. A kind of preparatory establishment for the R.A. itself was in Sass's school, where young artists learnt the preliminary skills that would enable them to qualify for the Academy. There, in 1841, Gabriel Charles Dante Rossetti (his full name), ardent, poetic and feckless, began his life as an artist. He was the son of Gabriele Rossetti, an Italian poet and scholar, who had been forced by political pressures to leave his native country and had settled in England in 1824. Gabriele became Professor of Italian in King's College, London, and was the father of four highly artistic children. Maria was born in 1827, Dante Gabriel in 1828, William Michael in 1829, and Christina in 1830. Dante Gabriel left school at the age of thirteen and went to Sass's, where he remained for the next four years.

In 1839, two years before Rossetti arrived in this small art school,

a brilliant child from the Channel Islands had begun his attendance. This was John Everett Millais, born in 1829. He was so obviously a talented artist that his parents moved to London to improve his chances in the profession. They showed his work to Sir Martin Archer Shee, President of the Royal Academy, who was impressed. The young painter scampered through the course at Sass's and, at the unprecedentedly early age of eleven, in 1840, became a probationary student at the Royal Academy.

Unlike Millais, among whose many gifts was obviously that mysterious talent that some people have for exam-passing, Rossetti lingered at Sass's, perhaps apprehensive that he had not the ability to go on to the next stage in the career of a young artist. But in the summer of 1845 he too was made a probationary student at the R.A. His attendance was certainly erratic, and so too was the bent of his preferences in art and literature. In these years he first discovered William Blake, coming across his manuscripts in the British Museum, and actually buying, with ten shillings borrowed from his brother, one that contained verse, drawings, aphoristic prose and Blake's memorably angry 'Annotations to Sir Joshua Reynolds' Discourses', which Blake described as 'the Simulations of a Hypocrite'. Rossetti treasured this lucky purchase. At much the same time he was forming an admiration for Robert Browning, whose verse it was his ambition to illustrate.

As important as these enthusiasms were two personal contacts. Impetuously, Rossetti wrote in 1847 to two men who were to confirm his commitment to the artistic life. The poet and painter William Bell Scott answered his letter kindly, and so too did the aging Leigh Hunt, with a generous commendation of the young man's poems. Rossetti wanted to be both a poet and a painter, but he was bored with the Academy. He had been doing the same things for too long, had not been doing them particularly well, and was not even yet at the stage in his studies when he was allowed to handle oils and brushes. He dropped out of the Schools. He wanted the personal inspiration of a tutor, not the impersonal routines of an institution. The man he chose for his inspiration was Ford Madox Brown, part of whose attraction must surely have been his independence from the Academy. Rossetti

wrote him an extravagant letter, praising him so fulsomely that the distrustful and touchy painter – who had never before been addressed in such terms – assumed that he was the butt of some infantile jest. He took his thick walking-stick and stormed round to Rossetti's to sort him out. An embarrassing situation; but all was explained. Rossetti became Brown's pupil, and was much affected by the two canvases on which the older man was currently working, *Chaucer at the Court of King Edward III* and *Wycliffe reading his Translation of the Bible to John of Gaunt*.

8

7

This was in the early summer of 1848. A few weeks later, the Royal Academy exhibition was opened. Rossetti walked through the galleries in Trafalgar Square, and saw nothing to please him except one painting, William Holman Hunt's *The Eve of St Agnes*. He liked the picture, and he liked the subject, for it was from Keats, archetypally the poet for Romantic young men, and yet at that date still largely unknown, though a personal favourite of Rossetti's. He approached Hunt and warmly congratulated him.

76

Hunt, who was born in 1827, a year before Rossetti, was the son of a warehouse manager in the City of London. His early ambitions to become an artist had been strongly opposed by his father. Hunt, therefore, did not go to Sass's, but did a variety of odd jobs, studied independently, and managed to support himself by painting portraits. When he entered the Royal Academy Schools, he did so without preconceptions. And, most importantly, he had studied Ruskin's *Modern Painters*.

Rossetti and Hunt would already have known each other by sight, but it was only now that they became firm friends and, as they were to find, comrades too. Rossetti called on Hunt at his home in Holborn, and as they talked together – Rossetti no doubt deriving some of his ideas from Ford Madox Brown – they developed a degree of unanimity in their approach to the arts. As Hunt put it later (as always, assuming the credit for himself as the leading force), 'my last designs and experiments I rejoiced to display before a man of his poetic instincts; and it was pleasant to hear him repeat my propositions and theories in his own richer phrase'.

We can surmise that it was in fact Rossetti who had more ideas;

but there was no doubt that Hunt was the person who knew how to paint, and Rossetti – again – appealed to his new friend for instruction. This instruction Hunt was pleased to give, but it inevitably led to a certain coolness between Brown and Hunt when Rossetti first introduced them, for Rossetti's personal and artistic allegiances had, after all, visibly shifted from one to the other.

The two younger men were to become even closer when Hunt sold *The Eve of St Agnes*. With the £70 that he received for the painting Hunt rented a studio in Cleveland Street, in that corner of artists' London to the south of Fitzroy Square and the east of Great Portland Street. F. G. Stephens recalled, in his *Dante Gabriel Rossetti*: 'Nothing could be more depressing than the large gaunt chamber where Rossetti executed two memorable paintings, and from which posterity must perforce date the inception of Pre-Raphaelitism. . . . in a street which even then was going down in the world – it was sliding, so to say, to its present [1894] zero of rag and bottle shops, penny barbers, pawnbrokers, and retailers of the smallest possible capital.'

And then Rossetti met Millais, who was already a friend of Hunt's. Millais agreed with Hunt that Reynolds's teaching had led to harmful tendencies in English art, and that Raphael, the most respected of academic artists, had produced in his *Transfiguration* a painting that should be condemned for its 'grandiose disregard of the simplicity of truth, the pompous posturing of the Apostles, and the unspiritual attitudinizing of the Saviour'. Encouraged by this, Hunt had tried – not totally successfully – to direct Millais towards Ruskin and Keats. Millais had been in Oxford during the summer, and when he came back to London, Hunt and Rossetti walked from their studio in Cleveland Street, across Charlotte Street, where Rossetti's parents lived, along Tottenham Street, where Hogarth had worked, past the Hope, and across Tottenham Court Road, where the Brotherhood were later to look for models, to Millais's home in Gower Street. Hunt made the introductions; they sat down; they talked; and a few days later they founded the Pre-Raphaelite Brotherhood.

13 DANTE GABRIEL ROSSETTI *The Girlhood of Mary Virgin* 1848–49

The Brotherhood

It all took place between Cleveland Street and Gower Street. Hunt and Rossetti worked all day in their studio, and Millais painted in the con-verted greenhouse at the back of his own home. They met in the even-ings. In late August they were poring over Lasinio's engravings of the Campo Santo frescoes in Pisa, and were especially taken with the work of Benozzo Gozzoli. This was not a totally new discovery. As we have seen, Leigh Hunt had loved these Pisan paintings, and so too had Ruskin, who three years before had written to his father: 'You cannot conceive the vividness and fullness of conception of these great old men. In spite of every violation of the common confounded rules of art, of anachronisms and fancies . . . Abraham and Adam, and Cain, Rachel and Rebekah are all there, real, visible, created, substantial, such as they were, as they must have been; one cannot look at them without being certain that they had lived.'

Ruskin was maintaining that these paintings, however different they were from official, accomplished post-Renaissance painting, had the qualities of great art, and especially of great religious art. Hunt, Rossetti and Millais probably had similar ideas in mind. But they were more taken than Ruskin – especially since they had only seen the pic-tures through the medium of engraving – with the formal qualities of the paintings as they appeared in Lasinio's volume, and particularly _11_ with their abrupt, shallow depth, their angularity and their decision of line, as if they really had originally been the product of a burin or engra-ving-needle rather than a brush. Millais especially seems to have been fascinated by this.

F. G. Stephens records that these reproductions caused some amuse-ment, but yet that they became 'points of crystallization or nuclei of enthusiasm for their till then somewhat nebulous ideals in art'. They can therefore be seen as some sort of focal point in the rebellion of the Pre-Raphaelites, though perhaps only, to use a homely simile, in the

way that one starts a quarrel over a point that does not necessarily contain or summarize all the points at issue.

Hunt, Rossetti and Millais were bound together by their friendship, by their dissatisfaction with the art establishment, and by their own indefinite aspirations. It was Rossetti, conceivably with some Italianate feeling for a *cosa nostra* rather than the English liking for a club, who had the idea of consolidating and crystallizing these discrete elements into a Brotherhood. And it was he who suggested 'extending our numbers'. But this was done in a haphazard and somewhat irrational manner. Ford Madox Brown was the obvious choice; but Hunt was opposed to him, and Brown was seven years older than they were, and had no liking for such activities. The new members were to be largely Rossetti's personal friends.

The first, the sculptor Thomas Woolner, was twenty-three years old, moderately successful, with a slender talent, and an amateur poet. Rossetti liked him. But Woolner's only real pretensions to what was later known as 'P.R.B.ism' were to be found in his embittered attitude to the Academy, which he held responsible for the current low standing of sculpture. Holman Hunt, in his memoirs, states that 'the many indications of Woolner's energy and his burning ambition to do work of excelling truthfulness and strong poetic spirit expressed in his energetic talk were enough to persuade me'. But this was hindsight, and in any case the sort of statement that might mean anything.

Rossetti's other nominees were his brother William Michael and James Collinson. William Michael Rossetti was not even an artist, though he did attend some classes at the Maddox Street drawing school; he was a civil servant. Hunt may have demurred, but William Michael was elected all the same. James Collinson was the son of a Nottingham bookseller, and had been a fairly successful R.A. student for some years. In 1847 both Rossetti and Hunt had been impressed by his unimpressive *The Charity Boy's Début*. A more important qualification for his membership was that it seemed very likely that he was going to marry Rossetti's sister Christina. Hunt's only candidate was his own friend Frederick George Stephens, a youth whose studies had not progressed beyond the R.A. Antique School. He had never painted a picture. These seven members completed the Brotherhood.

There are differing accounts of the origin of the name they gave their society, and the historian can more or less take his pick between them. The 'Brotherhood' part was almost certainly Rossetti's. But whence 'Pre-Raphaelite'? On one account (A. C. Benson's) it grew out of Rossetti's reading of Lord Houghton's recently published *Life and Letters of Keats*. Rossetti wrote to William Michael to say that Keats 'seems to have been a glorious fellow, and says in one place that, having just looked over a folio of the first and second schools of Italian painting, he has come to the conclusion that the early men surpassed even Raphael himself'. Ford Madox Brown maintained that he was responsible for the name: 'When they began talking about the early Italian masters, I naturally told them of the Italian Pre-Raphaelites (the name at that time was fairly familiar in the art world), and either it pleased them or not, I don't know, but they took it.' But Holman Hunt, who ought to know, says that the name came about as a result of an incident in the Royal Academy in 1847. He and Millais, working in the Schools, had been criticizing Raphael's *Transfiguration*; a fellow student said 'Then you are Pre-Raphaelites.' 'Referring to this as we worked side by side Millais and I laughingly agreed that the designation must be accepted.' The banal inconsequence of this is perhaps a guarantee of authenticity.

The Pre-Raphaelite Brotherhood held its initial meeting in Millais's studio early in September 1848. There is little evidence of what principles of the organization were discussed there, but we can assume that the original trio, Hunt, Rossetti and Millais, did most of the talking, and that the other four, the recruits, did most of the agree-ing. We can also be sure that the Brothers laid claim to some kind of bond between themselves and the Italian painters of the Quattrocento, in purpose if not in technique; and that they determined to approach nature with a freshness and directness of technique that was absent from academic painting of a conventional sort. They would have discussed their dislike of the classical and baroque traditions. Hunt would surely have talked about the principles behind *Modern Painters*. Rossetti would have talked of the poetic content of painting, and per-haps of the Nazarene-derived ideas he had learnt from Brown. They might – *might* – have talked of some moral and religious purpose. In any case, they were to follow Ruskin in the historiographical shift that

33

14 JOHN EVERETT MILLAIS *Cymon and Iphigenia* 1848–51

depressed the status of post-Renaissance art and elevated that of the early masters and – potentially – contemporary painting.

History upset in one way needs to be rebalanced in another. The Pre-Raphaelites did not have the fullness of historical knowledge and imagination that Ruskin possessed, and tried to assert their position as the contemporary heirs to what was good in the past by a random list of heroes. Their 'immortals', as they called them – a natural term for revered historical figures with a continued relevance to the present – formed a pyramidal structure of five strata. Jesus Christ was alone at the apex, put there by Hunt. Immediately below him were Shakespeare and the author of the Book of Job. In the third layer were twelve names, those of Homer, Dante, Chaucer, Leonardo, Goethe, Keats, Shelley, King Alfred, Landor, Thackeray, Washington and Browning. Below these were many others, similarly variegated.

The jumpy and irregular nature of this selection is some indication of the Pre-Raphaelites' intellectual uncertainty. And yet they did have some kind of common purpose, and they expressed a unity among themselves, socially, if not artistically, by agreeing to the principle of secrecy. And, as secret things are often felt to be more fully so with the help of some very arcane clue to their disclosure, they agreed to inscribe the mysterious initials 'P. R. B.' on all their paintings. This led to some jokes. The initials were said to stand for 'Please Ring Bell', or, in the case of Rossetti, 'Penis Rather Better'. There was a lot of enthusiasm in the Pre-Raphaelite Brotherhood, but they were hardly ever solemn.

Such activities, such a programme, have more than a touch of naïveté. It is part of their charm. They were, after all, very young men. But this was balanced by a refreshing capacity for mockery, often directed as much against themselves as against outsiders. And one should not underestimate their intelligence, or ignore the fact that there was a real exchange of ideas within the group, and a fast-moving evolution of ideas, together with a readiness to experiment, and, perhaps most of all, a determination to improve. One can sense the eagerness and confidence in Millais as he grew impatient to finish – to have done with – his conventional *Cymon and Iphigenia*. Beyond it he could 14 see a totally new career. The talk, the whole atmosphere of the Brotherhood, had raised him to an unprecedented pitch of keenness. 'You shall see in my next picture if I won't paint something much better', he wrote to Hunt.

The result, his first fully Pre-Raphaelite oil, was very ambitious. The subject, *Isabella*, originated in a communal scheme; each member 16 of the Brotherhood was to contribute a design, illustrating Keats's poem 'Isabella; or the Pot of Basil', which was to be 'executed entirely on our new principles'. Millais's painting exhibits both 'truth to nature' and a conscious archaism of style. It is both naturalistic and highly stylized, calculatedly fresh. One remarks its shrewd and varied portraiture, the splendid Gothic dope who serves at table, the neat observation of archaeological detail (though there are some anachronisms), and the way in which the artist has caught the empty-headed malevolence of the two brothers. Yet the motif of the leg stretched out to kick the dog is, in its way, wilful; realistic, yet contrived. The casual

16 JOHN EVERETT MILLAIS *Isabella* 1849

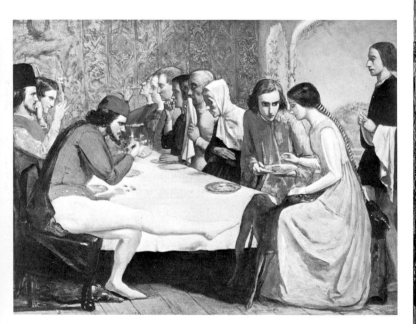

15 JOHN EVERETT MILLAIS *Study for 'Isabella'* 1849

grace with which Isabella fondles the dog contrasts with her heavily symbolic acceptance of half a blood orange from Lorenzo. And the minutely worked detail jars with a strange unreality of design. Millais ignored plenty of precedents for his picture, for thirteen people round a table equals a Last Supper, and no Academy-trained artist would have been likely to produce such a design as this one. Here (with some echoes of Benozzo Gozzoli's *Marriage of Beatrice and Isaac*), the composition tilts sharply to the left from a central incident which is coincidental to the theme of the painting; the eye is made to follow a bumpy progres-

36

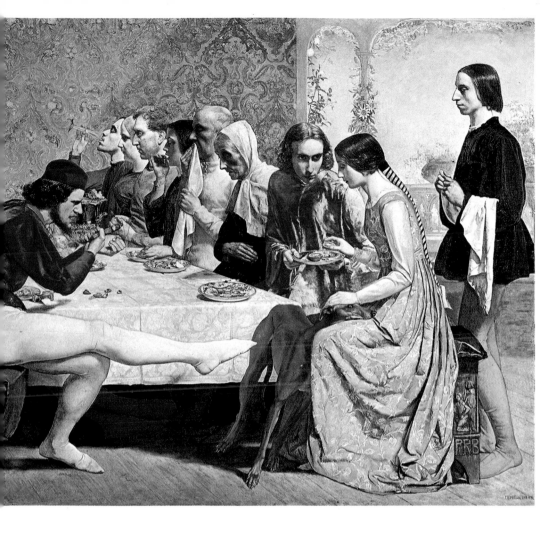

sion of heads to the left, coming back more slowly over a series of portraits on the other side of the table to rest finally on the tender gestures of the doomed lovers.

Comparison with an earlier oil sketch of the subject shows an uneasiness about the relationship between the flatness of the tapestry-covered wall at the back and the adjacent wall opening on to a landscape. In the final version this is not resolved. The space is ambiguous, and it is as easy to read the composition as flat all the way across the back as to imagine that the landscape wall is at right angles to the

15

tapestry, and thus parallel with the right-hand side of the table. In his attempt to reorganize pictorial space, Millais found that he was unable to accommodate the daring of his compositional method to the demands of naturalistic perspective.

Holman Hunt's first attempt in the new mode was less adventurous than Millais's, though he too was anxious to reject the more conven-76 tional style of his *Eve of St Agnes*. A Ruskinian emphasis on truth to nature characterizes his search for 'an out-of-door picture, with a fore-ground and background, abjuring altogether brown foliage, smoky clouds, and dark corners, painting the whole out of doors, direct on the canvas itself, with every detail I can see, and with the sunlight brightness of the day itself'.

17 The picture was *Rienzi vowing to obtain justice for the death of his young brother, slain in a skirmish between the Colonna and the Orsini factions*, illustrating an episode from the novel *Rienzi* by Bulwer Lytton. The components of Hunt's mature style, of his personality as a painter, are already present in this early work. There is, first, the strained posturing of the figures. This indicates how difficult Hunt always found the organization of natural movements, natural gestures, in his paintings – one reason why it is easy to prefer such a simple and unadventurous

17 WILLIAM HOLMAN HUNT *Rienzi vowing to obtain justice for the death of his young brother, slain in a skirmish between the Colonna and the Orsini factions* 1849

18 WILLIAM HOLMAN HUNT *Love at First Sight* 1848

painting as his *Love at First Sight* to his more deliberate statements. *18*
And with this strained emphasis on human action begins that dogged
concentration on the depiction of material fact which was always to be
a leading feature of his art. Again, his explanation of this is very Ruski-
nian. 'Instead of the meaningless spread of whitey-brown which usually
served for the near ground, I represented gravelly variations and pebbles,
all diverse in tints and shapes as found in nature.'

 Rienzi is scarcely a successful work, and does not stand up well to
comparison with Millais's *Isabella*, with which it was exhibited (both *16*
with the initials P.R.B. after the signature) at the Royal Academy
exhibition of 1849. Millais's canvas, for all its uncertainties, was clearly
that of a natural painter; Hunt's was exploratory, and bears all the
signs that nothing came easily to him.

Not surprisingly, considering his lack of training, there was something of this in Rossetti's first Pre-Raphaelite painting too. He had been working on *The Girlhood of Mary Virgin* during the late summer of 1848, under the constant supervision of Hunt, who seems to have been anxious to minimize the influence of Ford Madox Brown on his Pre-Raphaelite brother. Rossetti's painting, unlike the other two first Pre-Raphaelite works, is of a religious subject – and was originally conceived as a triptych. One might have expected Rossetti to take a subject from literature, as had his two friends. Yet a sacred theme is clearly suitable for a painting in the Quattrocento style, and it suits a tendency in Rossetti's art. For one hardly feels that he was inspired by religious sentiment, or that *The Girlhood* is in any sense a morally purposive work; what fascinated him was less that a painting might impress its ideas on an audience than that it might possess depths of significance.

The painting is in some sense naturalistic, in that some of the paraphernalia that usually surrounded religious subjects has been cleared away, but it is not realistic, for the ineptitude of its execution precludes that. What is remarkable about it is the fascination with emblematic detail. It is heavily loaded with symbolic meaning, carefully explained by Rossetti in a brace of sonnets that were to be attached to the frame. Thus, the books represent virtues, the lily innocence, 'the seven-thorned briar and the palm seven-leaved' are the Virgin's 'great sorrow and her great reward', and so on.

Stylistically, *The Girlhood of Mary Virgin* is composed with a kind of simple-minded originality, in which it is difficult to distinguish the parts played by calculation and by sheer lack of ability. Rossetti's tuition from Hunt and Brown had not included perspective. It bored and irritated him; he would not persevere with it. Consequently, all the figures crowd up to the picture plane, with St Joachim looming disconcertingly close to us, the floorboards on the left shoot away to a different vanishing point from those on the right, and an unintegrated landscape peeps from behind a strong device of verticals and horizontals, the trellis-work forming a cross behind St Ann.

Millais was undoubtedly struck by the symbolic content of Rossetti's first picture, and felt that there were possibilities for it in his own art.

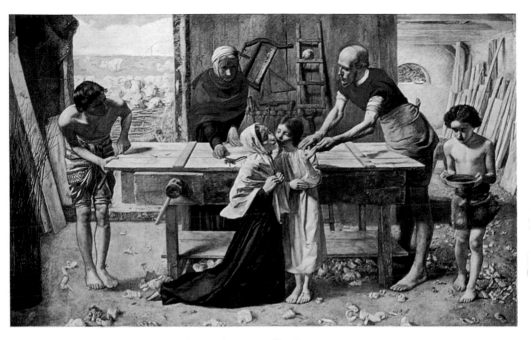

19 JOHN EVERETT MILLAIS *Christ in the House of his Parents* 1849

This explains the particular kind of meaningfulness in *Christ in the* 19
House of his Parents. But he was also influenced, if not very thoroughly,
by the oddness of its space. If it is surprising that a person as academi-
cally competent as Millais should have been affected by a beginner,
there is yet a way in which drawings by the two artists come very close
together at this time, with a stylistic homogeneity that bears witness to a
real fraternity of spirit. If we look at Rossetti's crowded *Dante drawing* 20
an Angel on the First Anniversary of the Death of Beatrice (which is inscri-
bed 'to his P.R. Brother John E. Millais') it is obvious that the peculia-
rities of organization, the intensity, the refined clumsiness, the poign-
antly awkward movements, are very similar to Millais's style in the
preliminary drawing for *Christ in the House of his Parents*. Other 22
Millais drawings of the period have many of the same characteristics –
like the beautifully sweet and sharp vision of *Two Lovers by a Rose* 21
Bush, which illustrates a poem by Woolner and is inscribed to Rossetti.

41

20 DANTE GABRIEL ROSSETTI *Dante drawing an Angel on the First Anniversary of the Death of Beatrice* 1849

21 JOHN EVERETT MILLAIS *Two Lovers by a Rose Bush* 1848

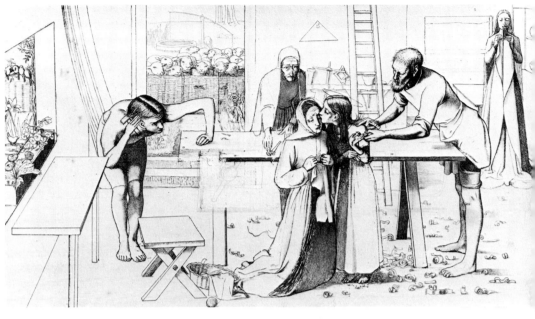

22 JOHN EVERETT MILLAIS *Study for 'Christ in the House of his Parents'* c. 1849

23 JOHN EVERETT MILLAIS *The Disentombment of Queen Matilda* 1849

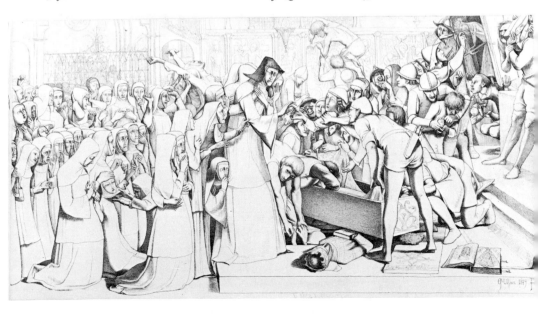

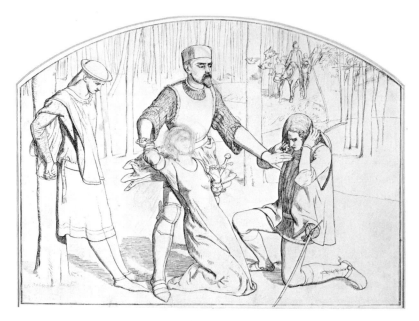

24 WILLIAM HOLMAN HUNT *Study for 'Valentine Rescuing Sylvia from Proteus'* 1850
25 WILLIAM HOLMAN HUNT *Valentine Rescuing Sylvia from Proteus* 1851

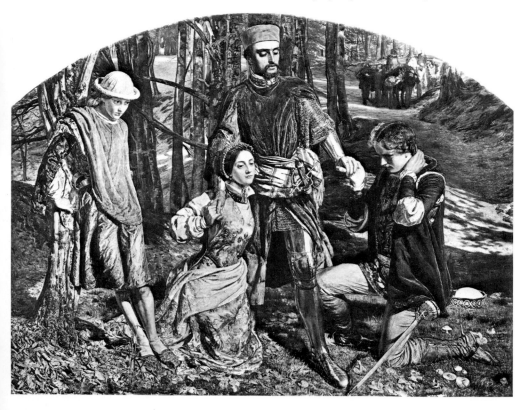

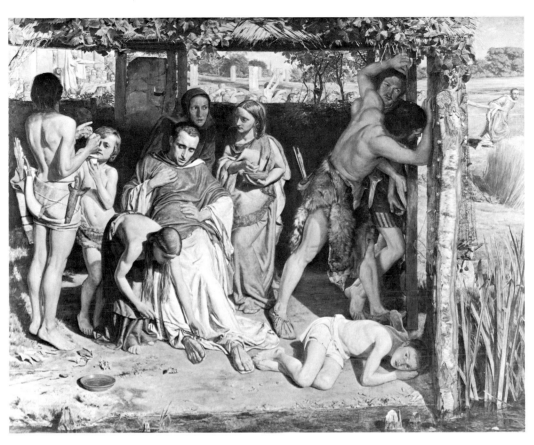

26 WILLIAM HOLMAN HUNT *A Converted British Family Sheltering a Christian Missionary from the Persecution of the Druids* 1850

27 WILLIAM HOLMAN HUNT *Study for 'A Converted British Family . . .'* 1849

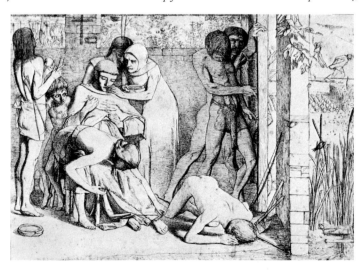

That Hunt too was not unaffected by this manner of drawing can be
seen in his first designs for *Valentine Rescuing Sylvia* and *A Converted
British Family*. In fact, it is in this group of drawings – with a Germanic
as well as an early Italian flavour to them – that the three main members
of the Brotherhood approach nearest to a unified style. This was the
basis of the first, which we might call the Gothic, phase of the Pre-
Raphaelite movement – and produced a minor masterpiece in Millais's
High Church-inspired illustration *The Disentombment of Queen Matilda*
(the wife of William the Conqueror, whose grave was spoliated by
Calvinists).

 This similarity of treatment argues a common purpose. One can see
that Millais, for instance, was experimenting in order to find what he
could do to rid himself of academic convention, and thus develop a
style based on his own very acute apprehension of nature, and on a
mannered naïveté derived largely from early Italian models. There
can be little doubt that the whole post-Renaissance tradition of Euro-
pean art had few charms for him. It was 'sloshy', the Pre-Raphaelite
term for, according to William Michael Rossetti, 'anything lax or
scamped in the process of painting . . . and hence . . . any thing or
person of a commonplace or conventional kind'. But just as Reynolds
('Sir Sloshua') was looked on by the Brotherhood more as an old buffer
than as a malevolent enemy, so too did Millais regard post-Renaissance
art with an amused kind of indifference. A pleasant sheet from one of
his early sketch-books is filled with caricatures of this type of painting.
In the centre is a simpering Perugino-Raphaelesque Madonna; at one
side of her a Guercinoesque saint, that worst type of excitable foreigner,
rolls his eyes in a parody of Baroque ecstasy; in the corner are some low
Dutchmen at their asinine junketings. These represent, of course,
precisely the types of painting that Ruskin had attacked in the first
volumes of *Modern Painters*, but in Millais's satire the intent is more
kindly, and has none of the critic's righteous viciousness.

 In fact, just as one can feel that there was something rather easy-going
in Millais's criticism, one can detect, even at this early date, a somewhat
equivocal attitude to the Brotherhood's attempts to supersede old-
fashioned methods of composition. The first drawing for *Christ in the
House of his Parents*, as we have noted, has much in common with

28 JOHN EVERETT MILLAIS
*Caricature of Post-Raphaelite
Composition*

Rossetti, especially in the daringly steepened perspective at the left-hand wall, and the angularity of pose of the figures. The use of symbolism in Rossetti's *The Girlhood of Mary Virgin* has been transmitted. The symbolic content of such motifs as the well, the sheep, the instruments of the Crucifixion and Deposition, the nails, the wound, St John with the pitcher, cannot be ignored, even if the most immediately striking aspect of the painting is its quite astonishing realism. However, a comparison of the pencil design and the finished painting shows that a great deal was rejected. The whole left-hand side of the drawing disappears; so too does the mysterious figure folding a winding-sheet, who is replaced by John the Baptist. The stiff, thin, abrupt drawing is developed into a more rounded and fully realistic painting; and while we can still admire the psychological exactness of the pose of the central figures, Millais seems to have reverted somewhat to an old English tradition: the comfortable arrangement of the conversation piece. If such adjustments were made to satisfy the demands of Academy taste, they were, as we shall see, to be of little avail.

It is sometimes thought that the members of the Pre-Raphaelite Brotherhood met nothing but criticism from the time that their work was first placed before the public. This was not the case. The attacks

13

19

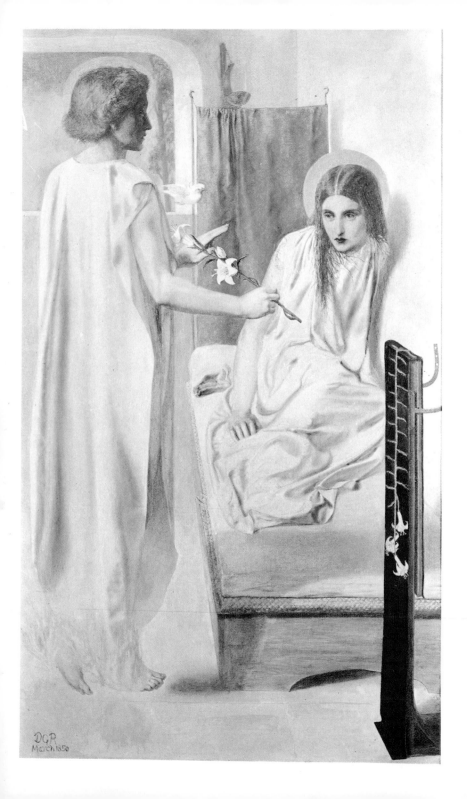

on their painting date largely from the time when the press first dis-
covered the existence of the semi-secret society itself. Hunt and Millais
individually had not fared at all badly at the Royal Academy exhibition
of 1849. Bulwer Lytton wrote to Hunt to tell him how much he
appreciated the illustration of his novel, and the highly influential *Art
Journal* concluded its remarks on *Rienzi* by stating that 'the work . . . *17*
is assuredly that of a man of genius; if he be young . . . he is of a surety
destined to occupy a foremost place in Art'. *Isabella* gave some concern *16*
to the reviewer of the *Athenaeum*, who felt that 'to engraft the genius of
foreign nations upon our own is a most dangerous experiment', but
this criticism was amply recompensed by the *Art Journal*, which enthused
over 'a pure aspiration in the feeling of the early Florentine school . . .
an example of rare exercise and learning' that 'cannot fail to establish
the fame of the young painter'. Moreover, both paintings were sold,
though Hunt had an agonizing wait after the exhibition had closed.
Rossetti's *The Girlhood of Mary Virgin*, too, had been very favourably *13*
received at the Free Exhibition which took place annually just before
that at the Royal Academy, with commendatory and even glowing
reports in all the major journals, and a quick sale (helped by a vague
family connection) to the Dowager Marchioness of Bath. This led
Millais to write to him that 'the success of the P.R.B. is now
quite certain'.

The confidence they felt at this stage led to an enlargement of their
activities, and in particular to an involvement in literature that went
beyond mere enthusiasm for certain writers. As was natural, Rossetti,
who had always been more of a poet than a painter, led the way. He
proposed that the Brotherhood should publish a magazine. This was
to be *The Germ*. Though a paltry thing in itself, *The Germ* occupies a *30*
historical niche of some importance in that it was the first house journal
of a self-consciously avant-garde artistic group, and set the usual pattern
of the many such productions that have succeeded it – a large amount
of initial enthusiasm, a dearth of good copy, endless trouble with
printers, no sales and a short life.

Rossetti's idea for the magazine was most speedily taken up by those
members of the Brotherhood, Woolner, Stephens and William Michael
Rossetti, who were not primarily painters. It was to be the medium

29 DANTE GABRIEL ROSSETTI *Ecce Ancilla Domini* 1849–50

which would give them their chance, in which they could exhibit as Hunt and Millais had exhibited at the Academy, and which would impose none of the restrictions inherent in any Establishment such as the Academy. One outsider was immediately included in the scheme, Coventry Patmore, a friend of Woolner's and at that time a promising but largely unknown poet; and he was joined by various others, most notably Christina Rossetti, Ford Madox Brown, William Bell Scott, Walter Howell Deverell and William Cave Thomas, who drew up an immense list of about sixty-five possible titles from which that of *The Germ* was finally selected.

The first number was published in January 1850, bearing on its cover an etching by Holman Hunt and an obscure and feeble sonnet by William Michael Rossetti which was intended to 'express the spirit in which the publication was intended', reminding us that this is as near as the Pre-Raphaelites ever came to a concerted effort, or a manifesto of their aims. The second issue of the magazine appeared in the following month and was most notable for its publication of Dante Gabriel Rossetti's poem 'The Blessed Damozel'. The sales were so small that it was impossible to continue beyond the fourth number, which was retitled *Art and Poetry*, and subtitled *Being Thoughts towards Nature*. But if the circulation was minute, the work involved in producing the magazine had enlarged the previously very small circle of actively productive Pre-Raphaelites – though Pre-Raphaelite activity was now at least as much poetic as artistic. For *The Germ* was where Dante Gabriel Rossetti's career as a poet really started – it was the first time that his work had actually appeared in print.

Here began a special development in the history of the old idea (first formulated by Horace) of *ut pictura poesis*, the theory that poetry and painting are sister arts, fulfilling much the same function, and conse-quently that a text can illustrate a picture as much as a picture a text. The ramifications of this tradition have been widely felt in English culture, but with a bias, as is natural in a verbally sophisticated but visually under-educated nation, towards the illustration of a literary text – the painter's art thus becoming a mere adjunct to something which is self-explanatory in the first place. Rossetti's contribution to the tradition, as we shall find in examining his later work, was to have

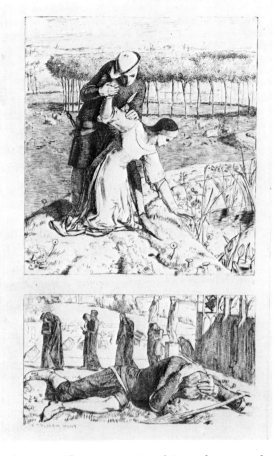

30 WILLIAM HOLMAN HUNT
Frontispiece to 'The Germ' 1850

a decisive effect in reversing this tendency, and was to be an influential component of the doctrines of aestheticism.

But the immediate effect of the activity surrounding *The Germ* was to bring the P.R.B. out into the open. As there were so many others apart from the original members concerned in its production, it was natural that the Brotherhood's pretensions to secrecy – never very tight – should have been eroded. By the spring of 1850, a large section of young artistic and literary London must surely have known of its existence as a group articulated by shared beliefs. It was not to be long before the news crept into the pages of both the popular and the artistic press, especially after the Free Exhibition in April, where Rossetti exhibited his *Ecce Ancilla Domini* and Walter Howell Deverell his 29

31 *Twelfth Night.* The sour and distrustful reception of these paintings seems to have been at least partly due to a feeling on the part of the reviewers that they were the products of a particular school, and a school characterized by wilfulness and impertinence. Before the Royal Academy exhibition – which was to contain five Pre-Raphaelite pictures – opened, the *Illustrated London News* gossiped:

'Has the casual reader of art criticisms ever been puzzled by the occurrence of three mysterious letters as denoting a new-fashioned school or style in painting lately come into vogue? The hieroglyphics in question are "P.R.B." and they are the initials of the words "Pre-Raffaelite Brotherhood". To this league belong the ingenious gentlemen who profess themselves practitioners of "Early Christian Art", and who – setting aside the medieval schools of Italy, the Raffaeles, Guidos and Titians, and all such small-beer daubers – devote their energies to the reproduction of saints squeezed out perfectly flat.'

The tittle-tattle of journalism, perhaps, and more or less unexceptionable. Such comments gave no indication of what was to come, the virulence of the attack when the exhibition opened a week later.

19 Millais's *Christ in the House of his Parents* took most of the beating. *The Times* said: 'the picture is plainly revolting'; the *Literary Gazette* dismissed it as 'a nameless atrocity . . . in which there is neither taste, drawing, expression, or genius'. Hunt was criticized for 'abruptness, singularity, uncouthness', and the *Art Journal* thought that 'the manner and drawing of the figures show all the objectionable peculiarities of the infancy of Art'. But by far the most objectionable notice came from Dickens, in his journal *Household Words*. He described Millais's painting as follows:

'You behold the interior of a carpenter's shop. In the foreground of that carpenter's shop is a hideous, wry-necked, blubbering, red-haired boy in a nightgown, who appears to have received a poke playing in an adjacent gutter, and to be holding it up for the contemplation of a kneeling woman, so horrible in her ugliness that (supposing it were possible for any human creature to exist for a moment with that dislocated throat) she would stand out from the rest of the company as a monster in the vilest cabaret in France or in the lowest gin-shop in England.'

31 WALTER HOWELL DEVERELL *Twelfth Night* 1850

By the summer of 1850, two years after the formation of the Brother-
hood, when their secret was out, when they were publishing a magazine,
when their pictures were there for all to see, when they were the most
talked-of artists in England, what changes were to be seen in English
art?

We should consider this question first on a rather larger historical
scale, and note that the Pre-Raphaelites expressed and solidified, rather
than created, a new spirit, one that had been gaining ground for the
previous ten years or so. By 1850, art was generally held to be more

important than in 1840. Ruskin had led the way, asserting that the practice of art had more to it than the mere production of pictures, that it was always a significant activity, that it contained the possibility of both good and evil, that it could be the instrument of immense moral power. No previous writer on art had ever said this so forcibly, or at such length, or had made so many people believe it. And Ruskin was not alone in his conviction that there is more in art than meets the eye. In their differing ways, such people as Prince Albert, William Dyce, and many others, were paying more thoughtful attention to art. Now, a humble watercolourist, known primarily for his pictures of birds' 46 nests, William Hunt – a man totally without pretensions to High Art – could say, without a trace of irony, 'I feel really frightened every time I sit down to paint a flower.' Art critics were more alert, and better informed, and there were more of them. There was more argument and discussion about art. It was no longer the intellectual province only of its practitioners, but a matter for public controversy.

One cannot, of course, say that the Pre-Raphaelites were responsible for this change of attitude, only that they embodied it more fully than anyone else and helped the process along by their own capacity for promoting debate. They worried about their functions as artists, and they worried even more about the expression of these functions. Collinson said, 'I have always tried to paint *conscientiously*.' Hunt continually insisted on his own probity, and even Millais can be caught making the uncharacteristic remark that it was their duty as artists to turn 'the minds of men to good reflections ... heightening the profession as one of unworldly usefulness to mankind. *This is our great object in painting.*'

On the actual canvases, there is an obvious insistence on holiness, on deep feeling and on literal truth; and of course their general worries about rightness and wrongness are often concentrated in their feeling for fidelity to fact. In his diary, William Allingham reports a conversation between Tennyson and Millais, who had originally put 45 daffodils together with wild roses in his *Ophelia*, on the reasonable grounds that he wanted some yellow in the picture. He got them from Covent Garden. Tennyson, on botanical grounds, said that this was 'quite wrong', and Millais, abashed, painted them out.

But art can be more or less important only through the effect it has on men; and Pre-Raphaelitism, broadly, was for the people. Again, this was not the simple effect of two years of Pre-Raphaelite activity. But, in the people with whom the new art was popular, we must note the final consolidation of a shift in the patronage of art, from the country houses to the new cities, from an old aristocratic class to a new and bustling bourgeoisie. Wilkie Collins, a friend of Millais and the brother of the Pre-Raphaelite painter Charles Allston Collins, amusingly describes this change in his novel *A Rogue's Life*, serialized in Dickens's *Household Words* in 1856; and his account, notable as much for its Ruskinian taste as for its social observation, is important enough to be quoted at length.

'Traders and makers of all kinds of commodities . . . started with the new notion of buying a picture which they themselves could admire and appreciate, and for the genuineness of which the artist was still living to vouch. These rough and ready customers were not to be led by rules or frightened by precedent. They were not to be easily imposed upon, for the article they wanted was not to be easily counterfeited. Sturdily holding to their own opinions, they thought incessant repetitions of Saints, Martyrs, and Holy Families, monotonous and uninteresting – and said so. They thought little pictures of ugly Dutchwomen scouring pots, and drunken Dutchmen playing cards, dirty and dear at the price – and said so. They saw that trees were green in nature, and brown in the Old Masters, and they thought the latter colour not an improvement on the former – and said so. They wanted interesting subjects; variety, resemblance to nature; genuineness of the article, and fresh paint; they had no ancestors whose feelings as founders of galleries it was necessary to consult; no critical gentlemen and writers of valuable works to snub them when they were in spirits; nothing to lead them by the nose except their own shrewdness, their own interests, and their own tastes – so they turned their backs valiantly on the Old Masters, and marched off in a body to the living men.'

This engagingly vulgar piece of writing merits our attention, for it reveals a great deal about Victorian attitudes to painting. First of all, it is a classic document in the history of English philistinism; but, this apart, Collins reiterates some characteristically Pre-Raphaelite beliefs.

If contemporary painting was to be great, it would never be so through following convention. It ought to be various, realistic and concerned with human emotion. Collins is also very insistent on another point: paintings should be clean and fresh and genuine. New pictures should look as if they were new, and they should be colourful.

The bright, highly coloured Pre-Raphaelite paintings were the result of a special technique that itself was the culmination of a fairly long process of change: the use of the wet white ground.

At the opening of the nineteenth century, English painting generally was extremely dark in colour (as for instance are English neo-classical paintings, or the early oils of Turner), due largely to the admiration felt for seventeenth-century masters, and to the discovery of bitumen, which, although capable of warm dark contrasts, is always destructive of paintings (as it does not dry) and inevitably leads to blackening. It was just this sort of dark-cornered effect that Hunt condemned in his remarks on *Rienzi*, that Ruskin attacked in *Modern Painters*, and that was distrusted by a bourgeois clientèle afraid that darkness might cover – as it so often did – a forgery.

But for some years before the Pre-Raphaelite movement, paintings had been becoming lighter in colour, especially of course in the case of Turner after his 1819 visit to Italy. In the 1820s the popular genre painter William Mulready was developing a heightened effect by painting colours very thinly over a white ground, thus giving an impression of luminosity. Luminosity is a relevant word for this technique, for (as did not escape the Pre-Raphaelites' more Romantically minded commentators) the most brilliant effects of colour are in stained glass, those of light itself passing through a coloured medium, and the use of transparent colours over a white ground was the nearest way in which painting could approach such an effect.

The classic Pre-Raphaelite painting, then, was probably produced, with individual variation, in the following manner. The design would be carefully outlined on the canvas, and over this would be painted – only on the portion to be completed at that sitting – a film of white pigment, worked off with a dry brush, then tapped with the brush to ensure evenness. The design would be visible through this thin film, and the painting would be done over it, necessarily with meticulous

care, with the smallest of brushes and at a very slow rate. This technique satisfied a demand for brilliance of colour and minuteness of observa‑ tion, and for a time assumed the status of an article of faith within the Pre‑Raphaelite circle.

It was in 1849 and 1850, with the first Pre‑Raphaelite paintings, that the stylistic significance of this technical innovation was first noticed. The pundits of the art world were duly hostile. They objected to two Pre‑Raphaelite principles. The first of these was the evenness of working over the whole surface of the canvas, so that subordinate parts of the picture are as fully detailed, as clearly seen, as the central subject. The second was the evenness of light, and the refusal to proceed from dark edges towards a light centre. One comparison the critics used was with underlining certain words in prose. To underline one word gives it emphasis; but not if every single word has a line underneath. The Pre‑Raphaelites were not much impressed with this argument, and they had very little appreciation for the old‑fashioned idea that a painting should have a 'principal light', and that the colours should be organized so as to proceed towards this central light from darker tones round it. The simple answer to this argument (Ruskin gave it) was that their system of lighting was that of the sun. The sun illuminates everything, and they painted what they saw. These changes can be seen quite clearly by contrasting the paintings that Hunt and Millais did at the Academy before their Pre‑Raphaelite days, and those that they painted afterwards. There is a gulf between Hunt's *Eve of St Agnes* 76 and *Converted British Family*, and an even greater gulf between Millais's 26 *Cymon and Iphigenia* – a very worldly subject, incidentally – and 14 his *Isabella*.

And yet, looking at *Isabella*, one is led to wonder about the early 16 achievement of Pre‑Raphaelitism. The picture is certainly impressive and beautiful, but how did it come about that a realistic revolution was served or furthered by such an affected, such an *unlikely* picture? And were not the historicist and archaizing emphases of the movement, if not simply reactionary, as obscurantist as their own cliquishness, as the name they gave their movement, as their decision to affix the arcane initials 'P.R.B.' to each of their productions? The point about secrets is not so much that they cease to be interesting when unveiled, but

rather that their worth can only be gauged on exposure. Secretiveness is not only the enemy of debate, but also of a basic assumption of realism, that all the facts should be there for all to see. The early, Gothic, phase of Pre-Raphaelitism, to which *Isabella* belongs, was actually quite short-lived, and coincided with the period when the existence of the Brotherhood was kept from public knowledge; Pre-Raphaelite paintings of the type that depend on the mannered affectation of medieval forms are few in number. But it was a stage that had to be passed, and in a way one feels as if Pre-Raphaelitism needed this sudden dip into historicism in order to slough off connections with the recent past, and emerge to reinvigorate English painting.

And an invigorating influence they certainly were. Quite a few dusty old cupboards were swept out by the Pre-Raphaelites. We can look at three aspects of English art to see what differences they made; portraiture, religious painting and the illustration of literature.

No single aspect of our national art is more likely to depress the historian than is portraiture. And yet English people have always had much respect for this branch of art, so much so that a great deal of mediocre painting is revered in the long galleries of country-houses, and the halls of fame, because of either reverence for ancestry or an awe-struck regard for Important People (the outstanding examples of this feeling are in Hampton Court Palace, the halls of Oxford colleges, and the National Portrait Gallery). The first President of the Royal Academy, Reynolds, was a portrait painter. He made a lot of money out of it. The practice of portraiture has always been a staple for artists who earn their living out of art (and especially, it must be said, a staple for bad artists).

In the Romantic period, a certain liberation was effected. The relationship between sitter and artist was no longer exclusively the same as that between employer and employee; and for the first time it was not automatically assumed that the painting, when completed, would become the property of its subject, or that a person was the proper subject of art because he was an Important Person. The memorable Romantic portraits are self-portraits, like Turner's or Samuel Palmer's, or, often, are acts of emotional homage – as for instance to poets rather than politicians; one thinks of John Linnell's superb drawing of

Blake, of Benjamin Robert Haydon's picture of Wordsworth, beetle-browed and brooding, up a crag, and, on a more homely level, Joseph Severn's vision of Keats doing a bit of musing at the bottom of his garden.

The Pre-Raphaelites were very occasionally official portrait painters when they needed money. Hunt painted portraits in his struggling early days, and Millais did so later, after his Pre-Raphaelite period, in order to pay for shooting-lodges and so on. (It is noticeable that he then reverts to pastiches of Reynolds.) But generally the Pre-Raphaelites did not paint portraits for gain, but because they liked the people they painted. Pre-Raphaelitism completes the process, initiated in Romantic art, whereby the artist came to regard his sitter as an equal. The final and logical outcome of this tendency is in the portrait as an expression of love, in Millais's drawings of Effie Ruskin, in Rossetti's many delineations of Lizzy Siddal and Jane Morris. The Pre-Raphaelites delighted in portraying each other. In *Isabella* can be seen the Rossetti *16* brothers, F. G. Stephens, Walter Deverell, and members of Millais's own family; in Hunt's *Rienzi* is Millais, in Millais's *Ferdinand Lured* *17, 41* *by Ariel* is Stephens again. The last corporate action of the Brotherhood was to be the meeting when they gathered together to draw each other and send the results to their lost brother in Australia, Woolner.

In religious painting, the Pre-Raphaelites attacked convention mainly by their democratization of holiness. This was what had so displeased Dickens when he saw Millais's painting of the Holy Family; he objected to the plebeian look they had about them. Rossetti, too, in his first painting, *The Girlhood of Mary Virgin*, had attempted to make the *13* Holy Family more ordinary, more clearly human than divine. Ford Madox Brown, in *Christ Washing Peter's Feet*, begun in 1851, followed *34* this trend in determining to paint Christ as engaged in a particularly humble activity. A rather different tendency, however, is found in Charles Collins's *Convent Thoughts* of 1850. This reflects the heightened *35* interest in Christian symbolism that inspired the Anglo-Catholic Oxford Movement; it shows a nun in deep examination of a passion-flower. This kind of pietistic feeling, present also in Millais's *Disen-tombment of Queen Matilda*, was repeated in the Roman Catholic *23* Collinson's *St Elizabeth of Hungary*, which (like Collins's *Pedlar*) *32*

is in the early, Gothic style of Pre-Raphaelitism. This type of painting led many commentators to the conclusion that Pre-Raphaelitism generally was a Romanist movement. The painters themselves always denied this.

The Pre-Raphaelite interest in literature has already been noted, as in their enthusiasm for Keats, and in the enterprise of *The Germ*. English literature has always provided both an inspiration and an ever-ready pool of subjects for English painters. But enthusiasms change. In Pre-Raphaelite painting, Milton was dropped completely, as also were the popular writers of the eighteenth century, such as Goldsmith. *The Vicar of Wakefield*, which had formerly appeared in the Academy almost every year, now was to be seen no more. There was to be one abortive attempt (by Lizzy Siddal) to illustrate Wordsworth's 'We are Seven'; Shelley lent himself too readily to the mode of the Burkeian sublime to be of any pictorial interest to the Pre-Raphaelites, though he was included in their list of 'immortals'. For these writers were substituted Keats, Malory (though at a slightly later date), and – significantly – contemporaries, such as Tennyson and Coventry Patmore. Shakespeare could not be other than a continual inspiration, however, and is illustrated by Hunt, Millais, Deverell and even Rossetti.

32 JAMES COLLINSON
St Elizabeth of Hungary
c. 1848–50

33 CHARLES
ALLSTON COLLINS
The Pedlar 1850

Millais attempted to 'naturalize' Shakespeare, and first tried this in painting a scene from *The Tempest*, so much a play that seems to float away as one tries to grasp it. In the resulting work, *Ferdinand Lured by Ariel*, Millais does substantialize his subject, and at just that point where, visually, the play is most vague; for here is a fairy. In 1850, fairies were quite difficult to paint, not only because rarely seen, but also because there were not, as there were in the case of angels, many pictorial precedents to give one an idea of what they looked like. But Victorians were interested in fairies and wanted to have a look at them, and fairy painting has a discernible tradition in nineteenth-century art. In the most fully realistic phase of Victorian art, fairies are represented with vivid intensity (as by Millais and Richard Dadd), but this later degenerated into vapid whimsy (as in Noel Paton and Kate Greenaway).

Nothing could be less fey than Millais's Ariel, a hideous green goblin, more like a bat than a sylph. Ferdinand is very interestingly posed, with one leg forward, one leg back, half stooping, his hands cupping his ears, rather as if he were trying to do the mambo to the faintly heard burthen of Ariel's mysterious song. To say that Ferdinand looks as if he is dancing is not to be simply frivolous. Dancing is one of those sanctioned human activities in which people can put themselves into preposterous attitudes and yet not feel foolish, and what has

happened here is rather the opposite: Ferdinand's very ordinary human gesture is meant to be realistic, and fails to be so because it is so much contrived, so much the result of the painter's wayward ingenuity.

A somewhat similar attempt at realistic and yet other-worldly treatment of Shakespeare was in a picture exhibited in the same year, 31 Walter Deverell's *Twelfth Night*, in which Orsino occupies a determinedly naturalistic pose. But, as Viola asks in the play, 'What country, friends, is this?' What perspective there is in the painting leads in different directions to nowhere. Neither trees nor architecture have their normal roles, and Orsino's favourite art is represented by the members of a weird Arab band, standing in a circle as they play.

34 FORD MADOX BROWN *Christ Washing Peter's Feet* 1851–56

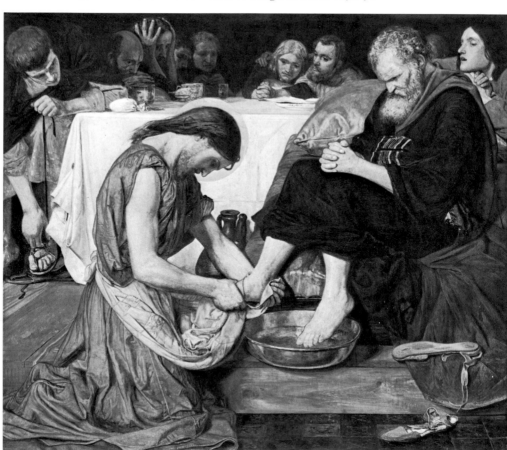

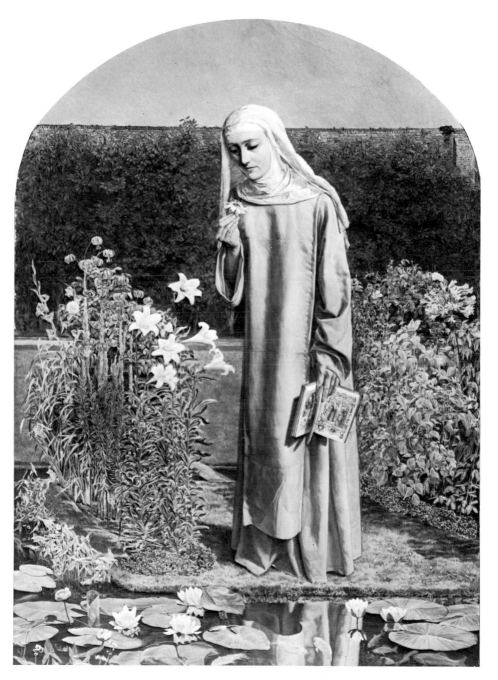

35 CHARLES ALLSTON COLLINS *Convent Thoughts* 1850

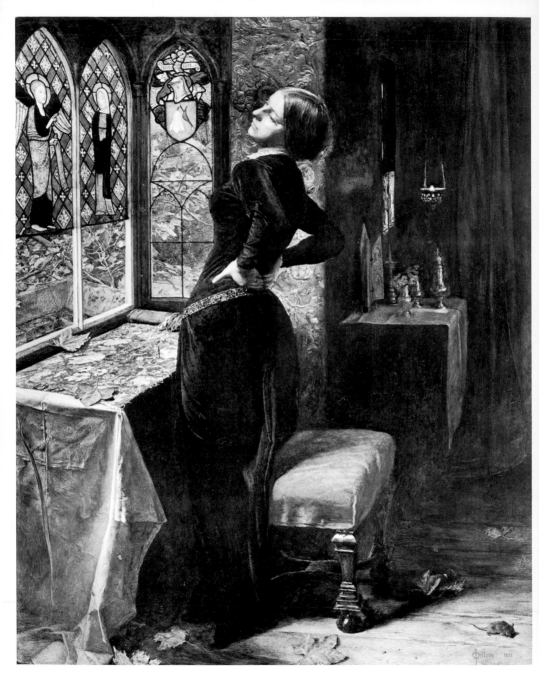

36 JOHN EVERETT MILLAIS *Mariana* 1851

Realism and Romance

Millais was only momentarily stunned by the vicious criticisms that
Christ in the House of his Parents had drawn when exhibited at the *19*
Royal Academy in 1850. One might have expected him to be daunted
by attacks so severe, critics so uniformly of the opinion not only that
technical abilities were lacking, but that the whole *attitude* of his art
was mistaken. Perhaps Millais's relationship with the art establishment
would have been more troubling to him had he not been able to rely
on the encouragement and solid basis of support provided by the other
members of the P.R.B. For in the three pictures that he was to exhibit
in the following year his general approach did not change; there is the
same typical combination of a religious subject, a bejewelled medieval-
izing illustration, and a sentimental moment from recent literature.
But there is now a significant advance in the use of a far deeper and
richer colour, and with it a rather less rigid, more assured, sometimes
almost caressing handling, a handling with something of voluptuousness
added to its precision.

Rossetti's fascination with the sumptuous colouring of medieval
manuscripts and the painting of Memling and Van Eyck has clearly
entered *Mariana*, which illustrates some lines from Tennyson's poem. *36*
The deep blue of Mariana's dress contrasts vividly with the intense
colours of the stained glass that Millais copied from the windows of
Merton College Chapel. Mariana's awkwardly languorous pose, and
the stubborn deliberateness of Millais's resolve to paint someone
stretching with boredom, show an obvious kinship with the way in
which the figures are arranged in *Isabella*; but he is using a far simpler *16*
motif than in the Keats illustration. In the same way he turned from
the programmatic and involved Christian subject of *Christ in the
House of his Parents* to the plainer outlines of *The Return of the Dove to* *37*
the Ark, which replaced a more complex idea for a painting about the
Deluge. It is an uninvolved and lovely painting; it is unforced, and

shows that Pre-Raphaelitism was now something that Millais found easy. The greatly increased fluency of this work is in striking contrast to the unease of the third of the 1851 paintings, an illustration to *38* Patmore, *The Woodman's Daughter*, which had been begun a couple of years earlier.

These new paintings by Millais were joined at the Royal Academy exhibition of 1851 by three other Pre-Raphaelite works; Brown's *8, 35* *Chaucer*, Collins's *Convent Thoughts*, and Hunt's *Valentine Rescuing* *25* *Sylvia*. They again received an extremely bad press, led by *The Times*, whose critic said, 'We cannot censure at present as amply or as strongly as we desire to do, that strange disorder of the mind or the eyes, which continues to rage with unabated absurdity among a class of juvenile artists who style themselves P.R.B.' With this pompous meanness went a now familiar condemnation of their 'absolute contempt for perspective and the known laws of light and shade, an aversion to beauty in every shape, and a singular devotion to the minute accidents of their subjects'. Other journalists voiced similar complaints, with the natural exception of William Michael Rossetti's piece in *The Spectator* which claimed 'the certain reversion of supremacy in art to the newcomers' (and gave him some anxiety that he might lose his post).

William Michael, however, was able to record a most encouraging development in his entry in the P.R.B. journal only a couple of days later. Hunt had been told by Patmore that Ruskin wished to buy *37* Millais's *Return of the Dove to the Ark* (which actually had already been sold to Millais's old patron Thomas Combe, the Printer to the University of Oxford). Patmore knew Ruskin through a family connection, and was able to use his good offices to persuade the critic to write something in favour of the maligned Brotherhood. The result was that Ruskin wrote his famous letter to *The Times*, an event which has often been taken as a most significant turning-point of the Pre-Raphaelite fortunes.

It should not be thought that this was a particularly laudatory letter; indeed, Ruskin was at some pains to make it clear that he was not in agreement with what he took to be the Brotherhood's aims. 'I have no acquaintance with any of these artists,' the letter began, 'and only a very imperfect sympathy with them.' He felt distrust for their 'Romanist

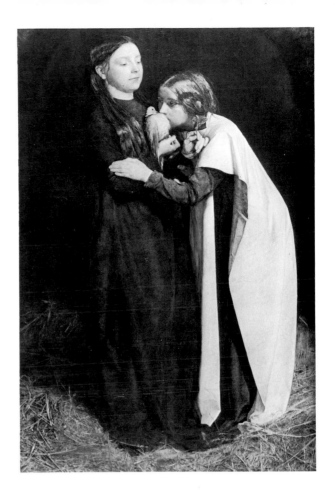

37 JOHN EVERETT MILLAIS
*The Return of the Dove to the
Ark* 1851

and Tractarian tendencies'. However, he very much approved of their
naturalism, especially in Collins's *Convent Thoughts* ('I happen to have 35
a special acquaintance with the water plant Alisma Platago . . . and
never saw it so thoroughly or so well drawn'), and pointed out that
they were attempting to return to archaic honesty, not to archaic art,
and that their perspective had been unjustly accused in *The Times*,
it being actually superior to that of most academicians. In a second letter
not long afterwards, he became more fulsome, asserting that the
Pre-Raphaelites 'may, as they gain experience, lay in our England the
foundation of a school of art nobler than the world has seen for three
hundred years'.

Such a generous and timely intervention obviously had to be thanked, and accordingly a letter was composed and sent to Ruskin, using Millais's address in Gower Street. Ruskin drove round from his home in Mayfair on the afternoon when the letter arrived, and brought with him his wife – the gay, pert, good-looking Effie, whom Millais was to marry four years later.

It was the beginning of a tragic friendship between the painter and the critic, based on art and broken by love. Friendship, perhaps, is not quite the word to describe their relationship; the cordiality that existed between Millais and the older man had no equality about it. It was the relationship between master and pupil, mentor and protégé. For a most important part of Ruskin's emotional make-up, and one that was always allied to the intensely educative slant of his art criticism – and, indeed, of all his writing – was a need for protégés: bluntly, for artists that he could dominate. He cared for them, but he cajoled and badgered them too, an attitude not always concealed by his friendliness, his charm, his generosity, and his total involvement in the production of art.

In Millais Ruskin almost immediately glimpsed the natural successor to Turner, the idol of his youth. And so, in the summer of 1851, after the letters to *The Times*, and having made personal contact with the Brotherhood, Ruskin added words of praise about their efforts to his new edition of the first volume of *Modern Painters*, and also issued the pamphlet *Pre-Raphaelitism*, a publication which actually contained very little about Pre-Raphaelite painting, but insisted on a connection between Millais and Turner, something Ruskin was to try to enforce, rather than demonstrate, as soon as Millais came fully under his influence.

As the young painter, excited, breathless, wrote to Combe, 'We are as yet singularly at variance in our opinions on Art. One of our differences is about Turner. He believes that I shall be converted on further acquaintance with his work, and I that he will gradually slacken in his admiration.' Ruskin wanted to take Millais away with him to Switzerland, *Modern Painters* and Turner country, but the painter declined the invitation, eager to stay in Surrey with Hunt and Collins and there work on paintings for the Royal Academy exhibition of 1852.

38 JOHN EVERETT MILLAIS *The Woodman's Daughter* 1851

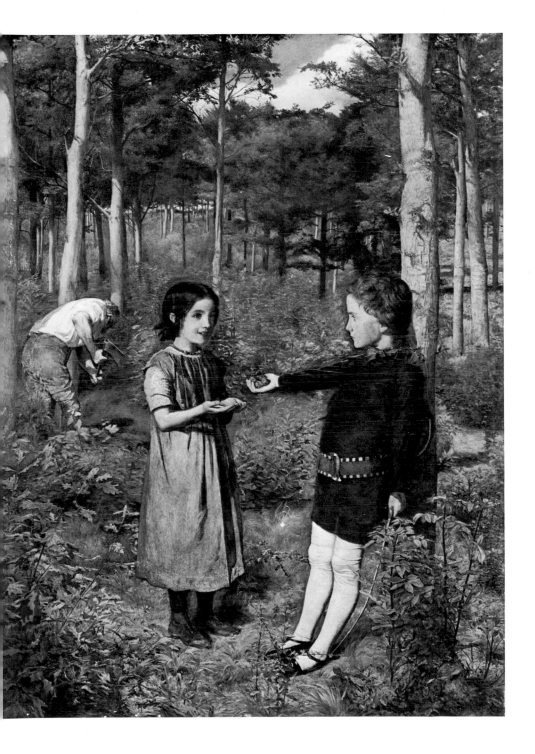

39 JOHN RUSKIN *Study of Gneiss Rock at Glenfinlas* 1853

40 JOHN EVERETT MILLAIS *John Ruskin* 1854

45, 47 *Ophelia,* the painting that Millais was most anxious to tackle, both continues and intensifies the attitude to Shakespearean illustration 41 already noted in *Ferdinand Lured by Ariel.* The subject was an unusual one at the time (though it was to be repeated many times later in the century), and the idea of a young mad girl drowning gave Millais the opportunity to develop his earlier experiments with attitude into something supremely graceless and (necessarily, of course) totally lacking in poise.

But even more striking than this complete novelty of posture is the quickness and acuity of his eye, and an unequalled ability, never before seen in English painting, to extract beauty from English hedges and ditches in summer, far from the walls of Elsinore. One cannot help thinking of a snatch of Millais's conversation that William Michael Rossetti recorded in the P.R.B. journal: 'Millais said that he had thoughts of painting a hedge (as a subject) to the closest point of imitation, with a bird's nest – a thing which has never been attempted. Another subject he has in his eye is a river-sparrow's nest, built, as he says they are, between three reeds; the bird he describes as with its head always on one side, "a body like a ball, and thin legs like needles".'

There, in such a delightful piece of observation, is the painter as naturalist. But however naturalistic the greenery in *Ophelia* was, the painting cannot have totally satisfied Ruskin. For the treatment of the water, sluggish and yet brightly coloured, is deficient by the standards of *Modern Painters* (and if this should seem a negligible point, it should be remembered that such observations were the very basis of Ruskin's critical method). For Ruskin, Millais must have been a young artist of genius who yet had never painted rocks and had never painted water, those two elemental subjects which had so moved the critic himself, and whose treatment by Turner had enabled Ruskin to construct so many nobly Romantic and passionately realistic and scientific theories about the nature of Art and the goodness of God's created world. There can be little doubt that, charmed though he was with Millais's impetuous and boyish enthusiasm, and liking him though he did, the real point of taking him away on the fateful holiday at Glenfinlas in 1853 was to make him paint in a Ruskinian fashion.

40 The result was the Ruskin portrait. The critic gleefully wrote to his

41 JOHN EVERETT MILLAIS *Ferdinand Lured by Ariel* 1849

father: 'Millais has fixed on his place, a lovely piece of worn rock, with foaming water and weeds and moss, and a whole overhanging bank of dark crag; and I am to be standing looking quietly down the stream; just the sort of thing I used to do for hours together. He is very happy at the idea of doing it, and I think you will be proud of the picture, and we shall have the two most wonderful torrents in the world, Turner's *St Gothard* and Millais's *Glenfinlas*.'

39 The extent of Ruskin's contribution to the portrait can be gauged by one of his drawings of the rock, which is in effect a preparatory study for the painting. He must have continually influenced what went down on the canvas, for here is a landscape scene that fulfils all Ruskin's demands for poetry and accuracy, based on his study of Turner. It is a remarkable and probably unparalleled example of a critic and theoretician making his experience of one artist reappear in the painting of another.

Ruskin's recent work on *The Stones of Venice*, his epic architectural history, also left its mark on Millais. During the holiday they designed a church together, Millais working under Ruskin's supervision. In their enthusiasm they felt that the designs would 'smash Margaret St. Church entirely' (meaning Butterfield's All Saints, Margaret Street, begun in 1849). Few of these designs have survived, but a dully coloured 44 charcoal and sepia wash drawing – on grocery paper – is an astounding adumbration of Art Nouveau. For this was not totally a master-pupil relationship; the Glenfinlas holiday was marked by experiment as well

42 JOHN EVERETT MILLAIS *Effie in Natural Ornament* 1853

43 JOHN EVERETT MILLAIS *Effie in a Ball-dress*

44 JOHN EVERETT MILLAIS *Design for a Gothic Window* 1853

as instruction, by a restless development of new ideas, a situation which, if largely attributable to Ruskin's taste, eloquence and knowledge, was enlivened too by Millais's eagerness to create, and perhaps also by his growing love for Effie Ruskin, whose portrait he painted sitting by the stream a little below the waterfall where her husband had posed. Effie appears again in a couple of pen drawings of the time, inspired by Ruskinian ideas on the subject of ornament derived from natural forms. Covered in wheat-ears, trailing convolvulus, grass, shells, lizard-heads and the like, she looks understandably ill at ease. In later drawings, Millais was to abandon such accuracy and purposefulness for a swifter and more stylish representation, with flowing ball-dresses dominating and designing the picture area.

42

43

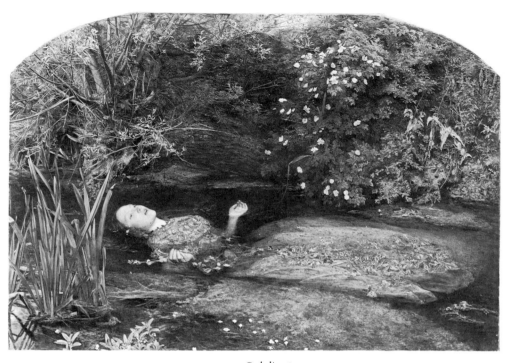

45, 47 JOHN EVERETT MILLAIS *Ophelia* 1851–52

46 WILLIAM HENRY HUNT *Primroses and Bird's Nest*

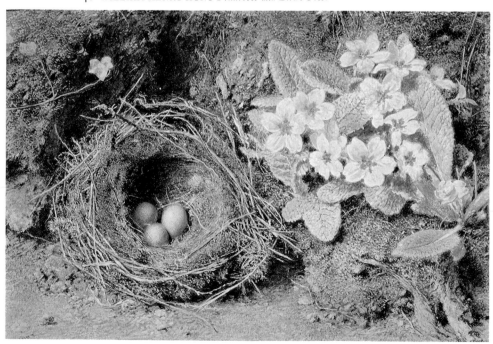

Millais's love was returned; Effie left Ruskin, and after a scandalous annulment, was to become Millais's wife in 1855. Elected an Associate of the Royal Academy when he returned from Scotland to London in November 1853 (with the exception of Sir Thomas Lawrence, the youngest painter ever to be so honoured), it seemed that without the stimulus of Ruskin's company, and now without the earnest camara‐ derie of the Brotherhood, Millais would be content to settle into the path that was to give him a baronetcy and the Presidency of the institution which had nurtured him. But the huge talent was not yet overcome, as it was later to be, by sloth, by expediency, by accommo‐ dation to official standards, or by any other fault of the many that have been attributed to him. It is arguable that the alienation of Millais from Ruskin did lead to this subsequent decline in the quality of Millais's work; there is no doubt that such a decline did take place. But first there was a change of style, and one that should not be confused with a declination from a standard.

51 In *The Blind Girl*, for instance, he painted a moving representation of affliction. With its superbly leaden sky and double rainbow, the technique is almost as brilliant as it ever was. The very power of Millais's own eyesight becomes the measure of his sympathy for the fact of blindness, a sympathy not yet marred by the sentiment which embarrasses in so much of his later work.

And Millais was yet to paint three large canvases that by reason of their technique and subject-matter stand together and form a definite final phase in his career as a Pre-Raphaelite painter. *Sir Isumbras at the Ford, The Vale of Rest* and *Autumn Leaves* are all late afternoon and twilight scenes, and all three are concerned with death.

49 *Autumn Leaves* has the same subject as, to take a later Victorian example, Gerard Manley Hopkins's poem 'Spring and Fall: to a young child'. The young and beautiful, seeing but not fully comprehending the certainty of transience, are filled with sadness. But in contrast with Hopkins's plain conjunction of youth with the brute fact of death, the emotion here is smudged and softened into wistfulness. There is something ingratiating about it; but to argue, as can be done, that the girls are as pretty as a picture and the picture merely as pretty as the girls, is to miss its haunting quality and genuine concern with grief.

48 JOHN EVERETT MILLAIS *The Vale of Rest* 1858–59

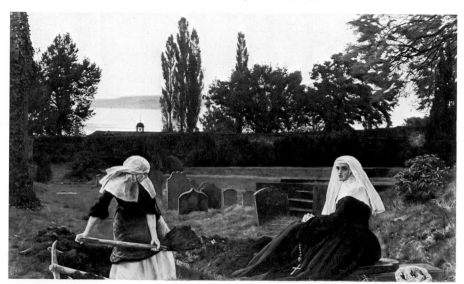

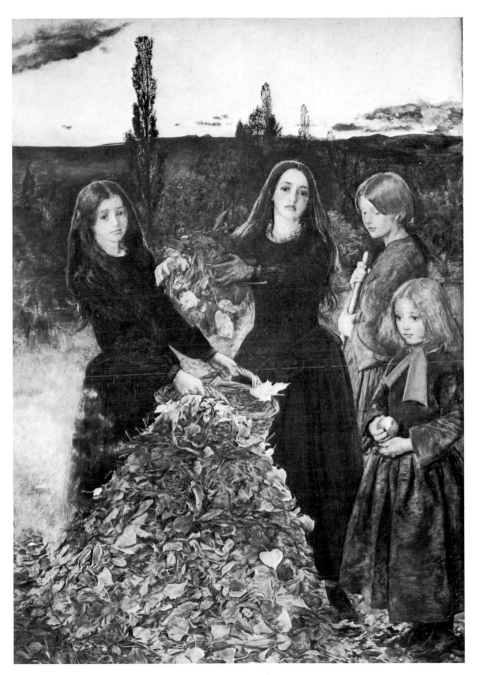

49 JOHN EVERETT MILLAIS *Autumn Leaves* 1856

50 JOHN EVERETT MILLAIS
Sir Isumbras at the Ford 1857

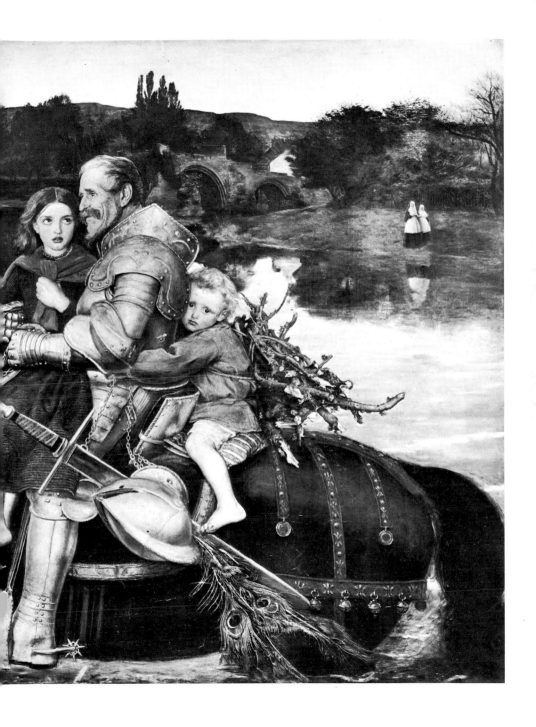

Tonally, *Autumn Leaves* is very like *Sir Isumbras at the Ford*, which was exhibited in the following year, in 1857. This is a painting that seems without a definable theme; the spoof medievalesque verses which were appended by the journalist Tom Taylor do not elucidate what was felt by contemporaries to be a symbolical work, a notion no doubt strengthened by the title under which it was exhibited, *A Dream of the Past*. 'I have not patience much to examine into the meaning of the painting', said Ruskin, and criticized it on what he took to be its technical defects, though he did speculate that it would be possible to take the painting 'as a fact or as a type', and that it might therefore be meant to convey 'noble human life, tried in all war, and aged in all counsel and wisdom, finding its crowning work at last to be the bearing of the children of poverty in its arms'. Or, he continued, 'there might be a yet deeper theme, a pictorial realization of the Christian Angel of Death'. Even if we cannot pin it down, some such symbolic message must surely have been intended, and once more the theme relies on the pathos aroused by baffled yet trusting children (those dispirited by such reflections might like to note that John Tenniel's drawing of the White Knight in Lewis Carroll's *Through the Looking Glass* is a caricature of Sir Isumbras).

Ruskin's vehement yet sorrowful denunciation of the picture did Millais an injustice, particularly with regard to its colour. It has the same twilight as *Autumn Leaves*, and there is a brooding mystery in the deep russets of the trees, the blue hills, the black birds, the dark cypresses and the crumbling stonework of the ruined bridge, a foil to the brilliant peacock feathers and the gold of the knight's armour. But perhaps the most remarkable passage is the painting of the water on the extreme left of the canvas, which magically progresses from the brown bull-rushes of the nearer bank, though blue, yellow, white, and a touch even of pink, to settle into greens and browns once more on the further bank, a warm and shifting progression so unusual in the painting of water at that time that it hints even at a comparison with the Impressionists. And if *Sir Isumbras* is finally a disorganized painting, with its oddness of scale, uncertainty of purpose, and bumpy composition (derived, surely, from Dürer's *The Knight, Death and the Devil*), it remains as a reminder that Millais's ability (and in a man who was

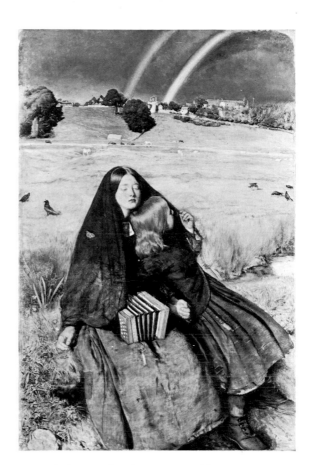

51 JOHN EVERETT MILLAIS
The Blind Girl 1856

still very young) was of the greatest, and that in the short years of his
Pre-Raphaelite career he caught up or created all the strands that made
their painting searching and progressive, even producing in these last
three works the very first paintings of European Symbolism, a movement
which was to be much indebted to the later stages of Pre-Raphaelitism.

The Vale of Rest was to be practically his last painting of note, again *48*
concerned with death, but now appealing to a kind of nudging
Protestant curiosity about nuns and enclosed orders. The future
baronet's wild oats had been thoroughly sown, but they were as
thoroughly rejected. He began to paint little girls asleep in sermons,
society ladies, popular historical subjects like *The Boyhood of Raleigh*,
weak pastiches of Reynolds. England had lost, at the age of twenty-eight,
the most talented painter, apart from Turner, that she had ever produced.

17, 16 Just as Hunt's *Rienzi* had hung with Millais's *Isabella* in the previous
 19 year, so was *Christ in the House of his Parents* accompanied by Hunt's
 26 large and ambitious *A Converted British Family Sheltering a Christian
 Missionary from the Druids* in the Royal Academy exhibition of 1850.
 This Early Christian subject had originally been suggested by a Royal
 Academy Gold Medal competition with the theme 'An Act of Mercy',
 27 and Hunt was already engaged on his design for the subject in the
 early spring of 1849. As has already been suggested, Hunt was
 stylistically very close to Millais at that time, as they worked together
 on their new Early Christian paintings, encouraged by their success at
 the 1849 exhibition, and now with the confidence that the future of
 English art was to be their future.

 A Converted British Family is very like Millais, despite its reversion
 76 to the kind of enclosed space used in Hunt's earlier *Eve of St Agnes*.
 The two women behind the missionary are especially reminiscent of
 Millais's painting. And there is the same use of symbolic material, the
 vine and the corn being introduced to suggest the 'civilizing influence
 of divine religion', just as the net hangs at the door of the hut for the
 double reason that it appears in the Bible, and that the Druids held
 fish to be sacred. These symbolic touches are done neatly enough. But
 one's lasting impression must be that the painting of such an exciting
 subject totally fails as a scene of action. What is successful is the fresh,
 clean, crisp handling of the paint, and this picture is one of the triumphs
 of the characteristically Pre-Raphaelite oil technique which employs
 the wet white ground.

 Hunt, alone of the Pre-Raphaelites, hardly changed the basic pro-
 cedures of his painting as he grew older, but stubbornly and undeviat-
 ingly clung to what he believed to be 'the true principles' until his death
 in 1910. The quality of his later painting is not high, and we can find
 the reasons for this by examining his progress during the five or six years
 during which he produced his best-known work, the years between
 the archaizing, Gothic, Millais-inspired *Converted British Family* and
 his departure for the Holy Land in January 1854.

 It was during this time, as the first Romantic urge of the movement
 began to give way to a more realistic approach, and to examination of
 contemporary social problems, that Hunt assumed the role of the great

84

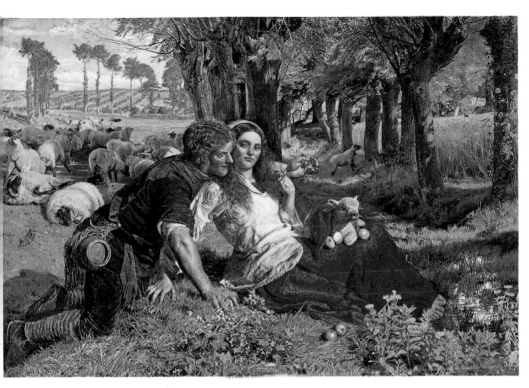

52 WILLIAM HOLMAN HUNT *The Hireling Shepherd* 1851

moralist. But his approach to this position was gradual, and followed a somewhat curious route. His next two paintings were of Shakespearean subjects: *Claudio and Isabella* and *Valentine Rescuing Sylvia from Proteus*. In the renewed interest in Shakespeare illustration that was characteristic of the group as a whole, Hunt's objectives were unique. Millais, broadly, was interested in a new naturalism of approach, paralleling a contemporary trend in the theatre itself, where the actor-manager Macready was turning away from stylization, reverting to the original text, and producing with archaeological accuracy. Hunt, on the other hand, attempted a dramatization, through Shakespeare, of certain types of moral problems. This use of literature had already been noticeable in his illustration of Keats's 'Eve of St Agnes', a poem in which he – alone of all men – had found 'the sacredness of honest responsible love and the weakness of proud intemperance'. We now

53, 25

85

find that the Shakespearean scenes which fascinate Hunt are those in which are displayed a strong sense of sin and sexual guilt.

53 This is first seen in *Claudio and Isabella*, which retains many traces of the first Pre-Raphaelite style (it was begun in 1850), and is carefully painted, with a delightful glimpse of may-blossom through the prison window. But the situation is a sinister one, that of a youth pleading with his sister to exchange her virginity for his life, in no sense a poetical subject. Hunt must have searched through Shakespeare for similar situations, for we next find him illustrating what is actually the most preposterous scene in one of the least known of the plays, *The Two*

25 *Gentlemen of Verona*. *Valentine rescuing Sylvia* represents that moment at the end of the play when the hero rides up just in time to prevent his best friend from raping his girl, crying 'Ruffian! let go that rude and uncivil touch!' But without a text of the play, or a knowledge of what is going on, it would be difficult here to determine exactly what the situation is, for while shame and contrition lie heavily in the air, the very Victorian-looking miss in the centre is ill-conceived pictorially, while the girl on the left exhibits an oddly languid half-attention to circumstances which one might fairly expect to be of great interest.

 Hunt refers to Shakespeare again in the label to his next painting,

52 *The Hireling Shepherd*, which quotes a catch sung by Edgar in the third act of *King Lear*. But the intention is obviously to carry a more genera-lized moral message, and to do so in a contemporary setting. As the artist later explained, 'Shakespeare's song represents a shepherd who is neglecting his real duty of guarding the sheep. . . . He was the type of muddle-headed pastors, who, instead of performing their services to the flock – which is in constant peril – discuss vain questions of no value to any human soul. . . . I did not wish to force the moral, and never did till now.'

 There is certainly no sign that Hunt did wish to force that moral, and in point of fact the idea of a 'muddle-headed pastor' would not spring to mind unbidden; this jolly red-faced country lad is far too tangible for translation into such a figure. But a more general lesson is plain for all to read. One sheep lies (in so far as is possible with that animal) in an attitude of abandon; another lumbers away from its pasture, wrecking the ripening corn; a lamb ruins its health by eating green apples; while

86

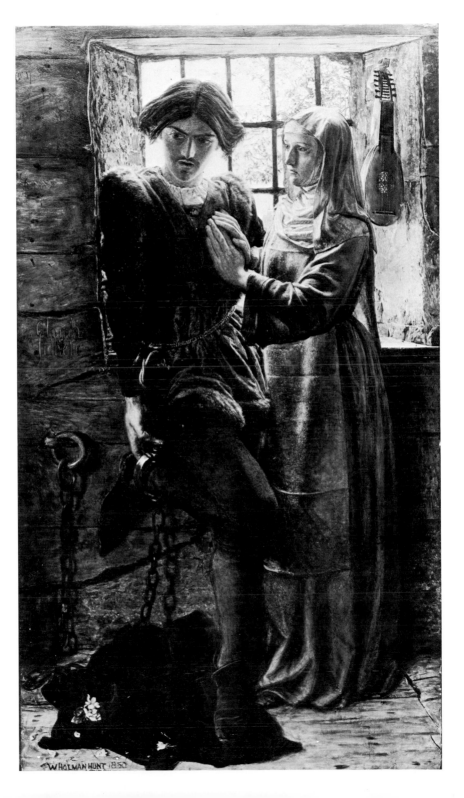

in the centre, careless of their charge, the hearty youth of England pursue their rural sports. Hunt, in fact, is painting the obverse of that idealized Romantic pastoralism, in which sheep and shepherds play such a large part, familiar from the work of Samuel Palmer and John Linnell; and he uses every realistic device to deny a basic assumption of that type of English picturesque landscape, that the land and those who tend it exist in a rustic harmony untroubled by human passions or desires.

One has only to reflect that Samuel Palmer's idyllic Shoreham years were shattered by the rioting of Kent agricultural labourers to realize that the picturesque landscape mode could not adequately deal with the realities of mid-Victorian country life. And indeed, by this time the great age of English landscape was exhausted. Turner had died in 1851, and left no successors.

The Pre-Raphaelites, with their emphasis on social action and emotion, were only incidentally landscape painters. Thus, Rossetti's only comment on country life (*Found*) takes place in a town, in a gutter, beside a brick wall; a country girl has become a prostitute. Millais paints the irreconcilability of gentry and rural working class, in *The Woodman's Daughter*; and his only other comment on landscape is that it cannot be seen by a blind beggar. Brett painted a stonebreaker above Box Hill; but the point of the painting is that this was notoriously the worst type of physical labour, and no job for a boy. Hunt, in *The Hireling Shepherd*, his finest major painting, makes his attempt at what we might call social landscape; and in this case the attempt is vitiated by the nagging moralization that he found impossible to exclude from his art. This is to make an exception of *Our English Coasts*, which, significantly, has usually been known by the title Hunt never gave it, *Strayed Sheep*; and this wonderfully advanced exercise in prismatic colour gives one the feeling that Hunt's only way of liberating his gloomy and guilt-ridden spirit was in such a pure painting of sunlight on grass and sea.

This reinforces the next point that must be made about Hunt, that he developed an unpleasant obsession with night-pieces, with the absence of the sun, and combined this, not with any spiritual grace, but with a strangely dispiriting religiosity.

The first of these night-pieces was his next production, *The Light of*

88

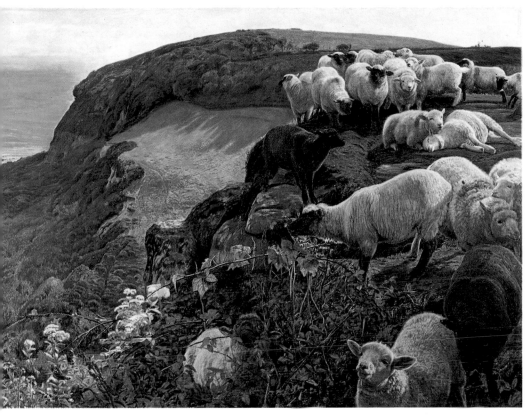

54 WILLIAM HOLMAN HUNT *Our English Coasts* 1852

The World. It is the best known of all English religious paintings, and over how many school and convent corridors has it spread its tenebrous influence! Here, the light of the world does not illuminate; it lowers. Nominally a painting about God's favour, this actually comes very near to being a picture about despair. Hunt began the painting in 1851 at Worcester Park Farm, and Millais has left us, in a letter of the time, a memorable vision of Hunt at midnight, 'cheerfully working by a lantern from some contorted apple-tree trunks, washed with the phosphor light of a perfect moon'. A disused hut in the neighbourhood, abandoned by some gunpowder workers, its door overgrown with ivy and brambles, was the objective of further nocturnal expeditions, in order there to paint the weeds that, in Hunt's scheme of symbolism,

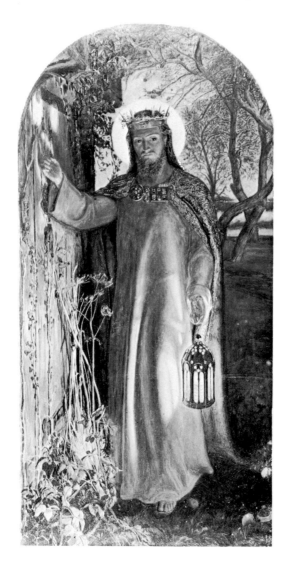

55 WILLIAM HOLMAN
HUNT *The Light of the
World* 1853–56

separate man from his Saviour. The painting was finished in ludicrous circumstances: 'The oil lamp belonging to the lantern does not give enough light, so I have had a gas fitting made, *only* the lantern becomes red-hot . . . then I take to camphor . . . but this either smokes so much as to make the room unbearable . . . or goes out entirely.'

On exhibition in 1853, *The Light of the World* was not well received, the *Athenaeum* being particularly ill-disposed towards it. Ruskin wrote

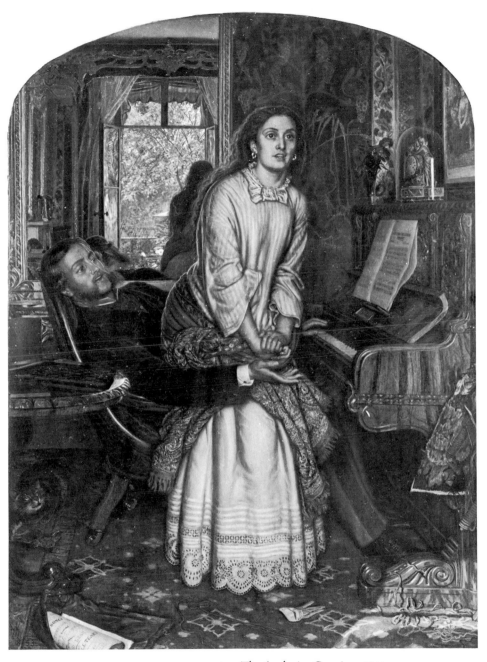

56 WILLIAM HOLMAN HUNT *The Awakening Conscience* 1852

to *The Times* giving an elaborate interpretation of the meaning of the painting. But the whole character of the work necessarily forced him to dwell on the door to the human soul, 'fast barred, its bars and nails are rusty; it is knitted and bound to its stanchions by creeping tendrils of ivy, showing that it has never been opened. A bat hovers above it; its threshold is overgrown with brambles, nettles, and fruitless corn.' Ruskin's eye did not deceive him, of course; such matters determine the aura of the painting, and no amount of insistence on the saving power of Christ, represented in any amount of symbolic detail, could alter it.

With *The Light of the World*, Hunt exhibited the work that he considered its material counterpart, *The Awakening Conscience*. He spent some time searching for a 'suitable' subject, and found it after reading about Peggotty and Emily in Dickens's *David Copperfield*, and after frequenting the London streets where fallen women could usually be found. Then, 'in scribbles I arranged the two figures to present the woman recalling the memory of her childish home, and breaking away from her gilded cage with a startled holy resolve, while her shallow companion still sings on, ignorantly intensifying her repentant purpose'. The source of light, which illuminates the girl's repentant face, is actually outside the picture in spectator space, but can be seen in the large mirror at the back of the room. The wallpaper design is symbolic. As Hunt explained, 'The corn and vine are left unguarded by the slumbering cupid watchers, and the fruit is left to be preyed on by thievish birds.' Under the table, a cat kills a bird. As Ruskin saw, 'there is not a single object in all that room, common, modern, vulgar, but it becomes tragical, if rightly read'. But one must add that the detail is eloquent not only as pointed representation – the cheap rosewood lustre on the piano, the embossed books unmarked by use, the picture above the piano of the Woman taken in Adultery – but also as a most vividly grasped sight of a special kind of Victorian ghastliness. It is hard not to feel that there is something of relish in the way Hunt paints such a scene, in the way he pores over the detail. The niceties become nastiness. And this is felt in the paint itself, for it assumes a dryness, a distastefulness; the heightening of Pre-Raphaelite colour has been transformed into harshness; the delight in detail has become niggling.

56

The reasons why *The Awakening Conscience* is a displeasing painting (for such it is, if one takes it seriously, and does not merely say, with a sophisticated and cynical acceptance of its demerits, that this is where Pre-Raphaelitism becomes risible) lead inevitably to a more generally damning criticism of Hunt's art. We should not ignore, as one is apt to do when discussing meanings, influences, historical parallels, the devastatingly obvious fact about him. His paintings are not good-looking. For there is a way in which Hunt, intent on being the great moral painter, came to deny himself the ravishments of paint, the ability it has to bring a sudden smile, to strike simple pleasure in a beholder. He denied himself all those effects of art for which writers about painting quite naturally and spontaneously use the metaphors of physical love; that it charms us, it bewitches, it seduces. We are justified in resenting this. Sternly, dutifully, unswervingly, Hunt robbed paint of its power to please. And who can say that painting which makes no effort to be lovely is not impoverished?

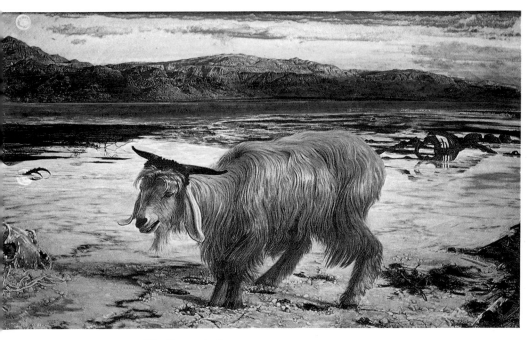

57 WILLIAM HOLMAN HUNT *The Scapegoat* 1854

While Hunt and Millais had been pressing on with their own dis⁄
coveries – and it is worth noting that they were moving quite fast,
progressing, making differences – Dante Gabriel Rossetti was pursuing
a very individual path, one that eventually was to have greater relevance
to the history of the movement than the work of his more accomplished
and industrious Pre⁄Raphaelite brothers.

29 *Ecce Ancilla Domini*, the second of his early Christian paintings, was a
13 natural sequel to *The Girlhood of Mary Virgin*. But there is less of this
picture; there are fewer things, more space, little detail; and a large
part of it is painted simply in white. The unaffected tone of the painting
was much appreciated by other Pre⁄Raphaelites, who liked the way
that the subject of the Annunciation had been stripped of its traditional
pomp and gaudiness. Technically, the painting gave Rossetti some
difficulty. The only passages with any assurance are in the portrait head
of his sister Christina, who sat for the Virgin, and in some parts of the

94

58
DANTE
GABRIEL
ROSSETTI
*Hist! said Kate
the Queen* 1851

59
DANTE
GABRIEL
ROSSETTI
Hamlet and Ophelia
1858

60 DANTE
GABRIEL
ROSSETTI
*The Tune of
the Seven Towers*
1857

95

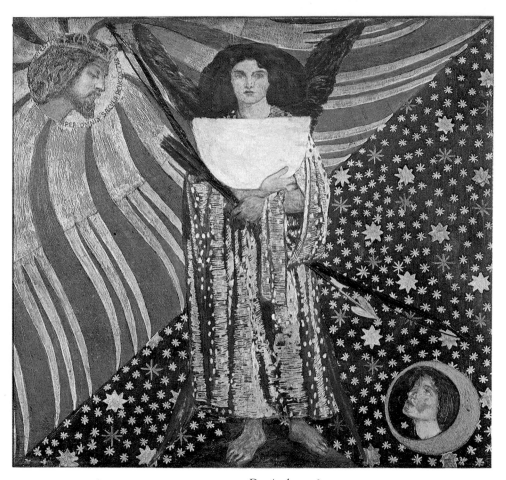

61 DANTE GABRIEL ROSSETTI *Dantis Amor* 1859

draperies. Hunt, Brown and Stephens all offered their help with the perspective, but to no avail; the floor of Mary's bedchamber rises to merge in one plane with the wall behind her. But this kind of elementary blunder and, for instance, Rossetti's total failure to paint the fire round the Angel Gabriel's ankles, somehow serve to intensify the painting's real air of innocence.

31 Together with Deverell's *Twelfth Night*, it was sent to the Free Exhibition in April 1850. The critics were unfriendly, an omen of what was to come when, a few weeks later, Hunt and Millais sent their own

Early Christian pictures to the Royal Academy. Rossetti was deeply shocked, and then infuriated, by this public setback, and especially by some scathing remarks in the *Athenaeum*. It initiated a lifelong distaste for showing his work in mixed public exhibitions. *Ecce Ancilla Domini* remained unsold for three years, which probably contributed to his decision not to paint any more religious pictures.

Rossetti was troubled. He was not managing to keep up with the other members of the Brotherhood. He went on holiday with Hunt, to Paris and Belgium, and they agreed about all the paintings they saw. Memling and Van Eyck were wonderful, Rubens fatly ugly and generally reprehensible. But when Rossetti then went painting with Hunt, near Sevenoaks in Kent, he floundered. Natural scenery meant nothing to him. He couldn't paint it, nor did he much want to. He preferred to stay indoors.

He was writing a lot of poetry, and his thoughts naturally turned towards literature and romance. He had always wanted to illustrate Browning, and in *Hist! said Kate the Queen* did so, though of course 58 the picture has nothing of the atmosphere of Browning's poetry. Here again there are difficulties with perspective, which can now be seen as part of a total uncertainty about pictorial space. Not only the building represented, but the painting too, is broken into separate compartments that, conceivably, are derived from Hunt's *Eve of St Agnes*. 76 Here we first encounter something that is to be characteristic of Rossetti's art for the next few years, and which gives it an enclosed and claustrophobic quality, especially as his pictures are usually small in size. They do not have a single and continuous spatial system, but instead are composed of different boxes of space, with differences of scale that emphasize the discontinuity. The eye is jolted as it moves from one part of the painting to another. This is the case with *Hamlet and* 59 *Ophelia*, *Fra Pace*, *The Tune of the Seven Towers*, and, especially, with 60 *Mary Magdalene at the Door of Simon*. And so, in *Kate the Queen*, before 62 this oddity developed – as it certainly did – its own queer validity, the most satisfactory part of the picture is in the line of attendants behind the maidservants who comb out the Queen's hair. These figures, derived surely from Blake, exhibit Rossetti's nice sense of rhythm, of artistic interval, when composing on a flat plane rather than in depth.

62 DANTE GABRIEL ROSSETTI *Mary Magdalene at the Door of Simon the Pharisee* 1858

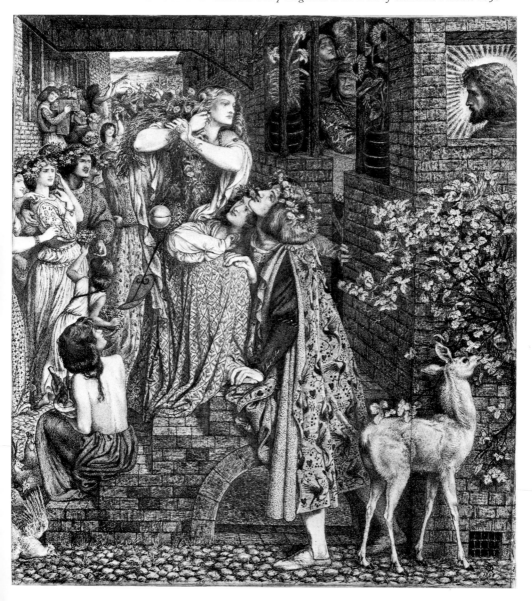

At this period Rossetti fell in love with the woman who was later
to become his wife, Elizabeth Siddal. In the spring of 1850, shopping
with his mother, Walter Deverell had seen this beautiful shop assistant
at a milliner's in Cranbourn Street. She agreed to pose for Viola in his
Twelfth Night, and became a favourite model of all the Brotherhood, *31*
appearing, for instance, in Hunt's *Valentine Rescuing Sylvia* and – *25*
having posed in the most uncomfortable of circumstances, for hours in a
tepid bath – as Millais's *Ophelia*. The Pre-Raphaelites called her *45*
'Guggums'. So did Rossetti, but he adored her too.

64 DANTE GABRIEL ROSSETTI
Miss Siddal standing next to an easel

65 DANTE GABRIEL ROSSETTI
Rossetti sitting to Miss Siddal 1853

In time, he came to take possession of her. He guarded her jealously and handled her preciously. He allowed her to model only for his closest friends. He never introduced her to people, and least of all did he introduce her to his parents. In 1852 he moved out of his family home to live in Chatham Place, near Blackfriars Bridge. There was a party a week after he moved in, but after that visitors were few, and discouraged. Rossetti and Lizzy, alone, lived together, slept together, and created together, for Rossetti taught her to draw and encouraged her enthusiasm for writing verse.

This enclosed world of love, this *égoïsme à deux*, this self-protective concentricity, is expressed in many of the pictures of these Chatham Place years. There are, first of all, a very large number of portrait drawings, some of them claiming a place as the most beautiful works *63* that Rossetti ever produced. There is the often-repeated motif of the touch, the caress, the encircling arm, the embrace; and then, beyond sight, the kiss, their eyes closed. The reciprocity of the artist-model relationship is now that between lover and beloved, and is dramatized in drawings like *Rossetti sitting to Miss Siddal*, and one of Lizzy by an *65, 64* easel, in front of a window. On the easel rests a canvas, and she gazes into it as if it were a mirror – and as if she were the Lady of Shalott, but without her curse. Another mirror-image, both doubled and concentrated, is in Rossetti's version of the *Doppelgänger* legend, *How They* *Met Themselves*, which was begun in 1851 and worked on and repeated *68* for some years after that. Two lovers, walking through a wood at night, come face to face with their own likenesses.

Rossetti continually played on such themes, as if possessed by them, and at the same time was developing an interest as an illustrator of Dante, not Dante the theologian but Dante the poet and lover. His early drawing, dedicated to Millais, of *Dante Drawing an Angel on the* *20* *Anniversary of the Death of Beatrice*, was followed in 1853 by a water- *67* colour of the same subject, and then by *Beatrice Denying her Salutation* and – the artist-model theme again – *Giotto painting Dante's Portrait*. The *66* twin inspirations of Dante and Lizzy enabled Rossetti to dig deeply into a totally new and deeply personal field of art. When Lizzy died, Rossetti finally combined these two strains in *Beata Beatrix*. *114*

66 DANTE GABRIEL
ROSSETTI *Study for
'Giotto Painting Dante's
Portrait'* 1852

67 DANTE GABRIEL
ROSSETTI *Dante
Drawing an Angel
on the Anniversary of
the Death of Beatrice* 1853

68 DANTE GABRIEL ROSSETTI *How They Met Themselves* 1851–60

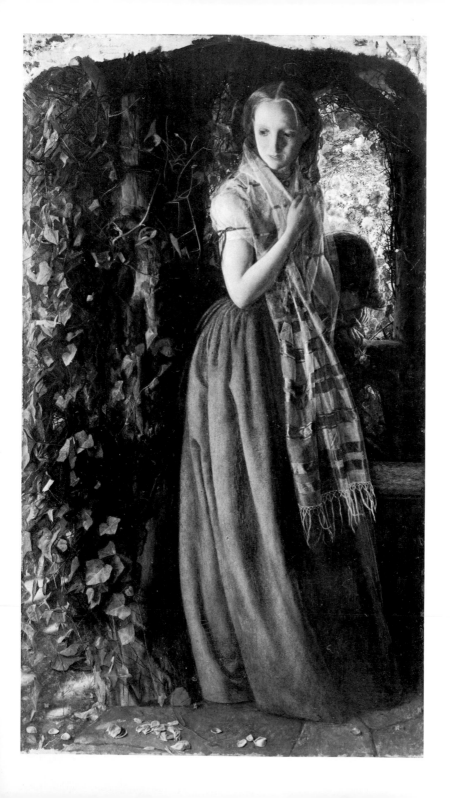

The Movement

It was inevitable that the Brotherhood, as a cohesive unit, should soon begin to break up, and not only because there was little artistic unanimity among its members. Collinson was the first to go, in July 1850, and nobody greatly minded when he did. The defection was announced in a muddled letter to Rossetti, in which Collinson attempted to explain that the sincerity of his Catholicism made continued membership of the Brotherhood impossible. But having said this, the letter goes on to maintain the opposite, and ends with what is perhaps a give-away remark: 'it is not from any angry or jealous feeling that I wish no longer to be a P.R.B.'.

Probably as a result of Collinson's departure, it was felt that another member should be selected, and William Michael Rossetti, in his entry to the P.R.B. journal for 24 October of that year, was able to record that 'Deverell has worthily filled up the place left vacant by Collinson.' However, this nomination, even though backed by a very Pre-Raphaelite painting, Deverell's *Twelfth Night*, was not supported 31 by all members of the Brotherhood, and as William Michael pointed out at a later date, 'it could not be said that Deverell was ever absolutely a P.R.B.'. It was probably Millais who objected to Deverell's nomination, or who at any rate withheld his approval, for he was eager for his friend Charles Allston Collins to be elected. Millais was living with Collins that summer in and around Oxford; he was at work on *The Woodman's Daughter* and *Mariana,* and Collins was painting his 38, 36 *Convent Thoughts*, in the garden of the Clarendon Press, and his 35 portrait of Mr Bennett (Ashmolean). These works, one would have thought, would surely qualify Collins for membership. But divisions within the Brotherhood itself were to prevent this. William Michael recorded them thus: 'A letter has been received from Millais urging the admission of Collins into the P.R.B. . . . Hunt acquiesced in Millais's suggestion, Stephens in Hunt's consent, and Gabriel in that of them

69 ARTHUR HUGHES *April Love* 1855–56

two. Woolner himself fought the point savagely; being of opinion (in which I fully agree with him) that Collins has not established a claim to the P.R.B.-hood, and that the connexion would not be likely to promote the intimate friendly relations between all P.R.B.'s.'

This indicates personal animosity as much as artistic differences. But difficulties of both types were brushed under the carpet. In January 1851 an important meeting of the P.R.B. was held. The question of new members was raised, but nothing decided. There seems to have been a complete division of feeling about the functioning of the Brotherhood. On the one hand, there was a determination to keep it going by a kind of self-imposed coercion; there was to be a fixed meeting on the first Friday in every month, and fines (fines!) imposed for non-attendance. On the other hand, Millais coolly questioned the whole basis of the Brotherhood; what did they have in common that made them brothers at all, and if they did have anything in common, what use was it to them? And so it was decided that each member should write a personal manifesto 'declaring the sense in which he bears the name' of a Pre-Raphaelite. William Michael wrote his out, but lost it. No other member seems to have bothered.

The continued existence of the Brotherhood was precarious. Woolner was the next to leave, smashing his clay models, infuriated at his failure to obtain the commission for a Wordsworth memorial. He sailed to Australia in July 1852, and remained there for some years. He found very little gold, but was able to make a living from supplying thriving colonists with medallions and busts.

During 1853 there was only one meeting of the Brotherhood, when they drew portraits of each other to send to Woolner, and in that year William Michael made only a couple of entries in the P.R.B. journal. He noted that 'not one of the new rules had been acted on, and the falling off of that aspect of P.R.B.-ism dates from just about the time when those regulations were passed in conclave'. And William Michael was surely correct in his suspicions that it was the very success of the Pre-Raphaelites that led to the dispersal of the Brotherhood; he also noted that 'our position is greatly altered. We have emerged from reckless abuse to a position of general and high recognition.'

Millais, especially, was doing astoundingly well, the crowds flocking

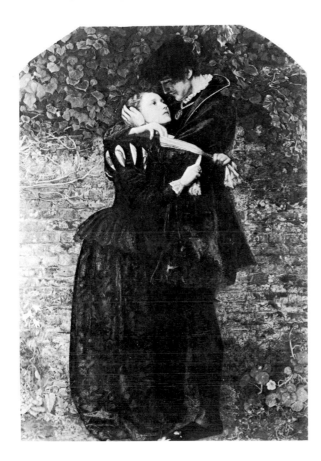

70 JOHN EVERETT MILLAIS
The Huguenot 1852

in huge numbers to see his *The Huguenot*. The next year, when he was 70
elected an Associate of the Royal Academy, Rossetti wrote to his sister
Christina: 'Millais, I just hear, was last night elected associate, so now
the whole Round Table is dissolved.' Millais had no more time for
the Brotherhood; he was busy with his career, and with Effie Ruskin.
Rossetti was busy with Lizzy Siddal. And Hunt was packing his
bags and brushes, preparing to leave England.

Hunt's move to the Holy Land, given his theoretical premisses,
was a logical one. But it cut him off from artistic life in general, as
well as from the more particular support of the members of the Brother-
hood. And, considering the kind of painting which emerged from the
experiment, it seems to have been a case of a dogmatic sliding into
eccentricity: not the mild English eccentricity associated with the

country clergy, but the gleaming-eyed variety of a man whose beliefs have become obsessive. No other interpretation of his behaviour can ever explain the touch of the madman in such a totally uncompromising image as *The Scapegoat*.

The idea of going to Palestine had been in Hunt's mind for some time; he had discussed the project with his Pre-Raphaelite Brothers, expecially Millais, and with Edward Lear, with the avuncular Thomas Combe, with the traveller Austin Layard, with the painter Augustus Egg. Egg advised him against it, but Hunt was able to quote the experience of David Wilkie and David Roberts, painters who had come to no harm out there, and he also made the less answerable point that, 'as the Divine Master in Syria never ceased to claim my homage', therefore 'the pursuit of painting only gave my Palestine project distincter purpose'. Art should serve Christ. Art had often illustrated the life of Christ, and his teaching, but had done so in an untruthful way, and with 'enervating fables'. The answer was to go to the Holy Land itself, and paint there. Though Rossetti, Ruskin and many others were vehement in their disapproval of the trip, Hunt could not be shaken from his purpose. He finished some things in London, and then departed suddenly. Millais threw provisions from the station buffet through the window of the moving train.

Hunt crossed France, and as his steamer left Marseilles he looked towards Italy, the traditional home of art, and comforted himself with the thought that 'residence in Italy in early life had often been the prelude to a career of total non-vitality'. As the ship steamed towards Malta an added reassurance was found in the company of Indian officials and their ladies returning to their stations, to Hunt's mind 'a tangible illustration of the greatness of the British Empire and of the vast trusts it held towards the advancement of the world'.

Through Egypt he travelled, from Alexandria to Boulak, and finally to Cairo; and thence into the Isbeykia, a dense jungle of palm trees and sugar cane. Around him were bazaars, jugglers, nimble brown children, fellahin, Bedouin, serpent charmers ringing their brass *tazzi* and crying out the name of the Prophet. This plenitude of foreign annoyances delighted and excited Hunt, and he began to paint: a number of watercolours, and an oil of a lovely dusky girl that was to become *The*

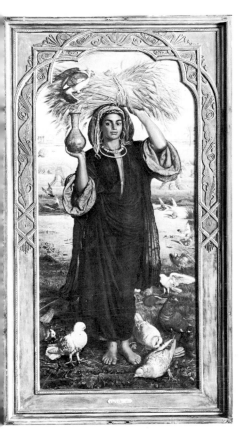

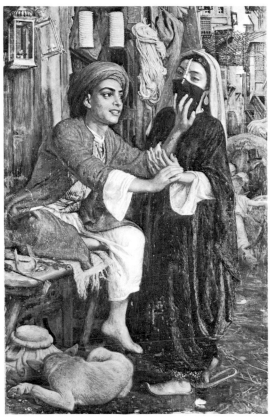

71 WILLIAM HOLMAN HUNT
The Afterglow in Egypt 1854–63

72 WILLIAM HOLMAN HUNT *A Street Scene in Cairo;
the Lantern-maker's Courtship* 1854

Afterglow in Egypt. However, Hunt's deeply tasteless character had the 71
capacity to vitiate the fresh interest in an alien culture that Cairo aroused
in him, and the first of his Egyptian paintings, *A Street Scene in Cairo;* 72
the Lantern-maker's Courtship, is a shameful example of the English
incapacity to adjust to foreign ideas. Hunt fixed on a subject which is
the very opposite of the romantic courtship scene of Millais or Brown.
In Egypt it was forbidden to lift the veil of a prospective bride. Hunt
shows a young tradesman doing just this, his face a mask of prurient
Oriental glee. The painting's effect is disagreeable, for on the face of
it these young Arabs seem to be delighting in the arrangement of some
particularly sordid contract.

In the summer and autumn of 1854 Hunt was at work on two major paintings, *The Finding of the Saviour in the Temple* and *The Scapegoat*. The first elaborates Hunt's new-found interest in Hebraic learning. Its composition seems to be derived from Millais's *Isabella*. But for the second picture there is no precedent, and its explanation must lead us into the most unhappy of speculations.

There never before was a picture like this, either as an example of naturalistic painting, of symbolic painting, of religious painting, or of animal painting. Hunt bought a white goat, and took the unfortunate beast with him to his camp at Oosdoom, where the shallows of the Dead Sea become grey saline marsh and skeletons of dead animals litter the shore, where the turgid currents of a tideless sea deposit on the strand the rotting trunks of trees which never could have grown in that sour and friendless soil, under the desolate site of Sodom, a place that stank of God's curse. The goat died. One wonders if Hunt ate it, in his tent. He procured another, and painted on. By June 1855 the completed canvas, a pink monument to folly and waste, was packed, no doubt among rats' nests, in the hold of a steamer from Jaffa, and was on its way home to Oxford.

Oosdoom, the hideous destination of Hunt's travels, was the fitting background for a painting whose overriding characteristic is the articulation of inhumanity. It is an inhuman painting, first of all, because lifeless. Here is a sea without swell or surge, shunned by men, without boats or harbours, where fish cannot live. Here are only skeletons and driftwood; there are no people, there is no agriculture. It is inhuman, too, because considered as an animal painting, *The Scapegoat* totally fails to make use of the revolution effected by Edwin Landseer (to whom Hunt once thought of recommending the subject), through which animals could be made to represent human emotions. And it is finally inhuman because of its theme, the Jewish practice of driving a scapegoat into the wilderness, to take with it their sins into a place uninhabited and forgotten. The possible interpretation of the scapegoat as a type of the Saviour did not escape notice at the time.

With what rapture Thomas Combe, at home in Oxford, unwrapped this horrid parcel, this dead letter, this *grande machine infernale*, we cannot conjecture. Surely he saw the hard nastiness of Hunt's art? And yet it

would seem that he did not, that he, like so many other Victorians, buried any consideration of the import of a painting in simple wonder at painting's capacity for mimesis. *The Scapegoat*'s reception at the Academy, and the puzzled plaudits of the critics, would suggest as much.

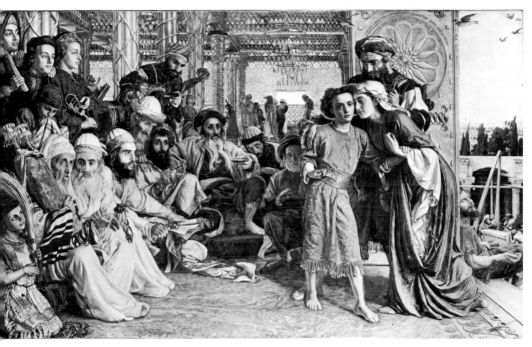

73 WILLIAM HOLMAN HUNT *The Finding of the Saviour in the Temple* 1854–60

'The so-called Pre-Raphaelite school has made no converts; that is evident; Mr Hunt stands this year almost alone as its high priest; and notwithstanding the eager advocacy of the 'Oxford Graduate', no class of the public will give their admiration or their sympathy to the works of this artist – the one incomprehensible and the other earnest.' So spoke the *Art Journal* in reviewing the Academy exhibition of 1854,

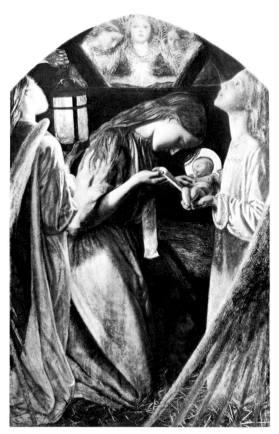

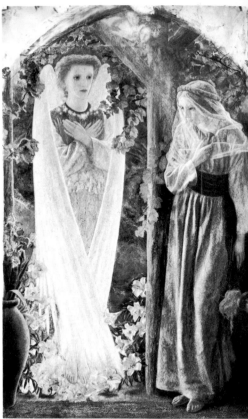

74 ARTHUR HUGHES *The Nativity* 1858 75 ARTHUR HUGHES *The Annunciation* 1858

55 unaware of the immense popularity that Hunt's *Light of the World*
 was to enjoy, and seriously underestimating the effect of Ruskin's
 writings ('A Graduate of Oxford' was the pseudonym with which
 he originally signed *Modern Painters*). And by this time, the Pre-
 Raphaelite movement was indeed making many converts, some of
 whose paintings we should now examine.

 The influence of Pre-Raphaelitism in the 1850s and 1860s is perhaps
 best seen in the art of Arthur Hughes, since his first characteristic as a
 painter was an ability to absorb and reproduce the innovations of
 others. He was a born follower, and at no time more so than during his
 best period, between about 1853 and 1870; just those years when the

 112

realistic phase of Pre-Raphaelitism was most diffused, and before Rossetti and Burne-Jones took the movement away from earthly concerns. That later kind of painting Hughes could not pursue, for he was a sentimentalist, not a visionary, and thus depended on life on this earth. He is a painter of love, and sometimes of marriage, but most of all of trysts and *tristesse*, of sweet sadness rather than grief, and rarely of happiness.

Hughes was born in 1832, and so was three years younger than Millais, whom he met, together with Hunt and Rossetti, while he was still at the Royal Academy Schools. Almost all his best paintings can be traced back to a precedent in the work of the members of the P.R.B. itself. *The Eve of St Agnes* is typical of his art, and here he 77 actually produced a painting better than its prototype. Hunt, it will be recalled, had illustrated Keats's poem just before he became a Pre- 76 Raphaelite. It was the painting which Rossetti so much admired at the 1848 exhibition, and which led to their friendship. Stylistically, Hunt's

76 WILLIAM HOLMAN HUNT *The Eve of St Agnes c.* 1848

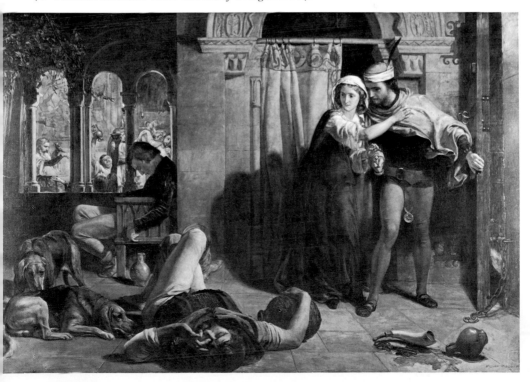

77 ARTHUR HUGHES *The Eve of St Agnes* 1856

picture belongs to the mid 1840s, with touches of William Etty and the bombastic Daniel Maclise. The lovers look like actors, and the central figure surely had its origin in some academic exercise in fore-shortening. Hughes's interpretation adopts a triptych, and uses that quintessentially holy format to relate the most successful abduction in English literature. There are three scenes from the poem, Porphyro's stealthy approach to the castle, his awakening of Madeline in her bed-chamber, and, as in Hunt's painting, their escape, tiptoeing carefully over the drunken porter. The colours have great depth and richness;

in the first panel the shadows cast by moonlight – by no means an easy thing to paint convincingly – are exceptionally finely handled, and in the centre the stained glass and silken finery glow with life through the darkness. That stained glass we have seen before, of course, in Millais's *Mariana*, and Madeline's embroidery frame might well have come from *36* Rossetti's *The Girlhood of Mary Virgin*. *13*

Rossetti was certainly the medium through which Hughes was briefly influenced by Blake, in his *Nativity* and *Annunciation*, and his *74, 75* experience of collaboration with Rossetti at the Oxford Union in

78 ARTHUR HUGHES *The Brave Geraint* c. 1859

1857 led to the Arthurian subject and soft, undefined working of
78 *The Brave Geraint.* But Hughes took most from Millais, in *The Long
Engagement, April Love, Ferdinand and Ariel* (which is almost a straight
copy), *Home from Sea, Home from Work, The Woodman's Child* and *The
Mower.*

69 *April Love* and *The Long Engagement* are romantic rendezvous.
Home from Work and *The Woodman's Child*, exhibited in 1860 and 1861,
79 are touching genre scenes. In the first, the labourer father kisses his small
80 daughter, already in her nightdress for bed. In the other, a stubby little
girl is asleep under a tree. Her parents are working some yards away,
far enough away not to disturb a squirrel and a robin that sit near her.
Both pictures have great feeling for what was certainly a characteristic
of Pre-Raphaelite painting in the years round 1860 – the texture of
rough, country things, the thick wickerwork of a basket or trug, clothes
made of corduroy or linsey-wolsey, the unpolished earthenware of a
cruse.

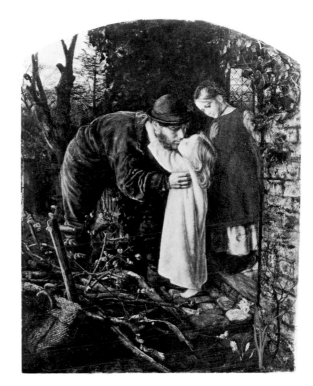

79 ARTHUR HUGHES *Home-from Work*
1861

80 ARTHUR HUGHES *The Woodman's Child* 1860

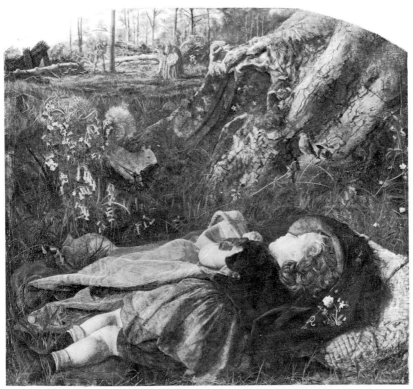

81 But Hughes's best-known picture is *Home from Sea*, painted out of
doors on the best Pre-Raphaelite principles, and showing a sailor
boy who returns from a man's world to fall in sorrow across his mother's
fresh grave, not praying but crying. The motif was adapted from Hol-
man Hunt's etching *My Lady in Death*, which had appeared in the
30 first number of *The Germ*. It is a painting which, admittedly, is very
precariously balanced on the indefinable borderline in Victorian art
between the moving and the mawkish; and its exact position there is
perhaps one of personal taste, for sentimental people find it poignant,
while others may regard it as merely soppy. Hughes's art did indeed
lose what decision it once possessed by the late 1860s, as *The Mower*,
which is a loose reworking of the theme of Millais's *Autumn Leaves*,
would tend to suggest.

Naturally enough, as he wrote and talked about it so much, it is in
landscape painting that Ruskin's influence is most apparent, and a

81 ARTHUR HUGHES *Home from Sea* 1863

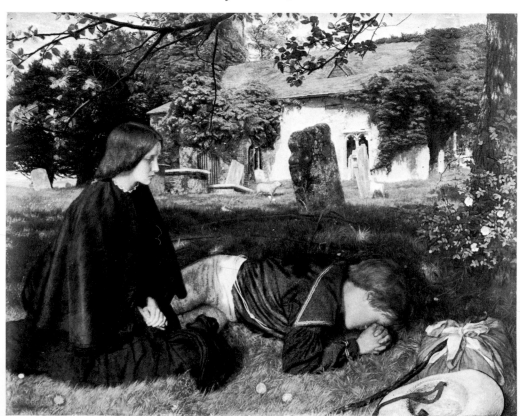

82 JOHN WILLIAM
INCHBOLD *Early Spring* 1870

number of works by artists who attended to his teachings are among
the most interesting of pictures close to Pre-Raphaelitism. J. W. Inch-
bold produced one or two lovely Ruskinian paintings under the tute-
lage of the critic, such as *Early Spring*; but a far more important figure 82
was John Brett. Born in 1831, Brett began to exhibit in 1856, with a
portrait of Mrs Coventry Patmore. He was not close to the Pre-Raphaelite
painters socially, and they seem not to have liked him very much, but
Ruskin considered him 'one of my keenest-minded friends'. Ruskin
must have appreciated his scientific interests – Brett was a member of
the Royal Astronomical Society, and a keen amateur geologist – and

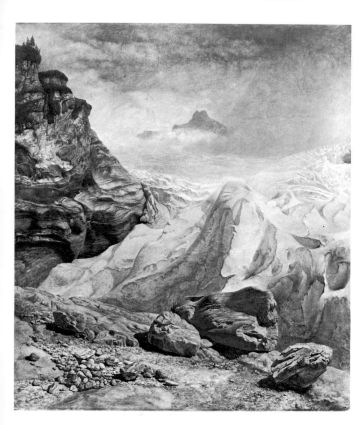

83 JOHN BRETT *The Glacier of Rosenlaui* 1856

84 JOHN BRETT *The Val d'Aosta* 1858

the minute attention to geological detail in such a painting as *The*
83 *Glacier of Rosenlaui*, exhibited in 1857, must also have commended
him to the critic. Ruskin was with him in the Val d'Aosta, a good
place for cyanometer readings, in the summer of the following year, and
sent his father a humorously intended yet still blood-curdling account
of the way in which he was teaching his new protégé: 'He is much
tougher and stronger than Inchbold, and takes more hammering;
but I think he looks more miserable every day, and have good hope of
making him more completely wretched in a day or two more. . . .'

One is inevitably reminded of Ruskin's relationship with Millais,
and the circumstances at Glenfinlas in which the Ruskin portrait was
produced; and this is perhaps why Millais himself so detested the
84 painting which emerged from this holiday, *The Val d'Aosta*. Yet it is a
weirdly beautiful picture, with its chilliness of approach and fantastic
accuracy. Ruskin felt the cold in it, its unblinking lack of emotion, but

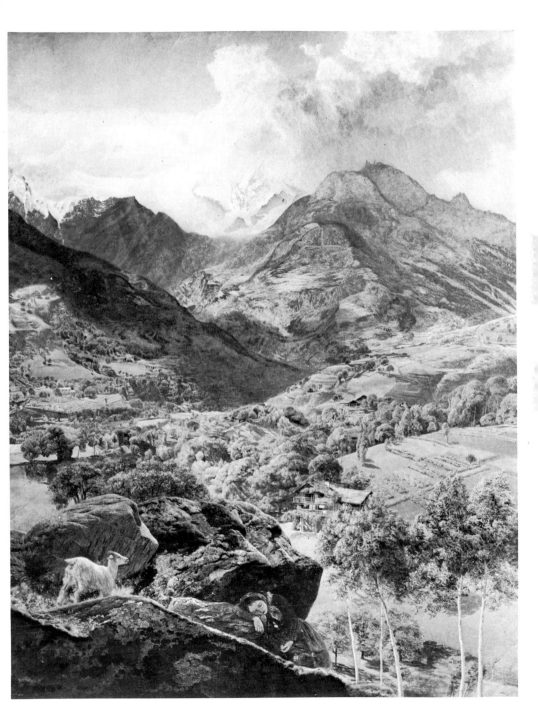

remarked with some awe that 'for the first time in history, we have by help of art, the power of visiting a place, reasoning about it, and knowing it, just as if it were there'. That was precisely the object of his own *4* similarly angled drawing of a Swiss valley, *Fribourg*, though the drawing was a personal memorandum, not something to be exhibited. Both works must be considered as an English development of the German and Nazarene *Erdlebenbildkunst*, landscape art that sets out to provide not only visual knowledge of the landscape itself, but also an understanding of its ecology, both botanical and human. Ruskin's long analysis of the painting in *Academy Notes*, with its insistence on peasant agricultural method, shows that he appreciated this. Brett painted a few other landscapes, among which a watercolour, *Spring in the Isle of Wight* (Birmingham) is notable, and finished his days as a marine artist. His only other major work with a relationship to Pre-Raphaeli-*102* tism is *The Stonebreaker*, already mentioned as an example of social landscape, light and flinty in tone and potentially tragic in its message.

Or so his contemporary Henry Wallis would suggest in his parallel *85* *Stonebreaker*, which was exhibited in the same year, 1858. Little is known of Wallis, apart from a usual apprenticeship in the Royal Academy Schools, and an unusual period in Paris at the Ecole des Beaux-Arts. None of his Parisian training seems to have had any effect on him – though is it conceivable that he saw Courbet's 1849 painting of a stonebreaker? What few paintings we know to be from his hand are very much in the Pre-Raphaelite mode. *The Stonebreaker* has Millais's colour, and, apart from the only weasel in English art, Carlyle's message, for it was exhibited with a quotation from *Sartor Resartus*, the angry passage condemning the effects of hard labour on the human frame. Wallis, like Carlyle, well knew that the fatuous saw (at this date, incidentally, first coming into common use) that 'hard work never hurt anyone' is an odious untruth.

But dead poets usually get more sympathy than dead labourers, especially if they die young, and in garrets, and the *réclame* enjoyed by *The Stonebreaker* did not quite equal the success of Wallis's *Chatterton*, which had been exhibited two years before, in 1856. The artist had *87* searched out the very same attic in Gray's Inn in which the poet had killed himself, and used the wan light of dawn to shed lustre on this

122

purple-trousered cadaver, its flesh lily-livid, and the pose that of a secular *pietà*, a lonely single bed replacing the embrace of the Virgin Mother. This shocking image had considerable potency, and years later was to be repeated in the memorial to Shelley, dead, naked, and washed up, in University College, Oxford. Wallis's archaeological concern and interest in literature is also found in *The Room in which Shakespeare was Born* (Tate Gallery) and *A Sculptor's Workshop,* 86

85 HENRY WALLIS *The Stonebreaker* 1857

Stratford-upon-Avon, 1617 in which a sculptor, presumably Gerard Johnson the Younger, is carving, from a death-mask, the monument to Shakespeare which is in Stratford parish church.

The influence of Pre-Raphaelitism was not confined to London and the Royal Academy, for by mid century the artistic world was moving wide as well as fast. It was easier to see new paintings. There were more galleries, and more exhibitions. Reproductions of one sort or another were far more common than had previously been the case. There were more newspapers and journals to report on paintings, and more illustrated magazines to reproduce them. Furthermore, the patrons of Pre-Raphaelitism, successful members of a new middle class, were largely provincial people, with money in manufactures, and not infrequently a guiding hand in the cultural life – as propagated through institutes, museums, libraries, galleries and the like – of such cities as Birmingham, Manchester and Liverpool.

86 HENRY WALLIS *A Sculptor's Workshop, Stratford-upon-Avon, 1617* 1857

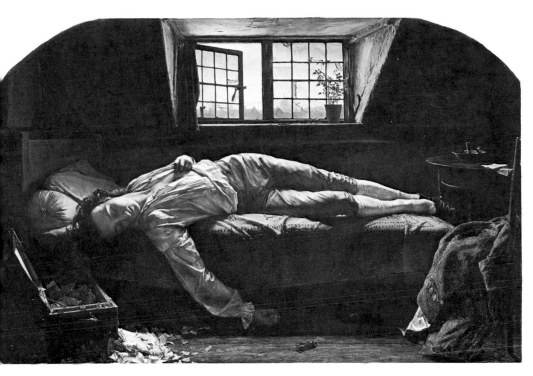

87 HENRY WALLIS *The Death of Chatterton* 1856

At Liverpool, for instance, where Holman Hunt's *Valentine* 25
Rescuing Sylvia had won a £50 prize in the hard days of 1851, there
was a strong and open-minded interest in the visual arts. There was
an enlightened patronage, and a flourishing group of minor artists
influenced by the Pre-Raphaelite paintings exhibited during the
1850s at the Liverpool Academy. William Davis painted landscapes
rather like those of Ford Madox Brown, and John Lee had an original
approach in, for instance, his pictures of comings and goings in the
Liverpool Docks. James Campbell, in *The Poacher's Wife*, produced 103
a scene, depicting the troubles of the English rural working class, that
for many years was taken as being the work of Millais. William
Lindsay Windus, who had been greatly moved by seeing *Christ in the* 19
House of his Parents in 1850, was the first and most important of these
artists. His best-known works are *Too Late* and *Burd Helen*, but we 89
should not overlook his small picture *The Outlaw*, not only for its 88

125

own charm but also – perhaps inadmissibly – for its hint at what might have been, had anyone ever thought of it, the most natural of Pre-Raphaelite subjects, embodying all the medieval, literary, green-wood-tree and democratic aspects of the movement: Robin Hood.

But perhaps it is, after all, permissible to speculate in such a way on what would have made an appropriate Pre-Raphaelite subject, since this was so much discussed at the time, in precise terms by the artists themselves, and more generally by Ruskin and other critics. The con-temporary importance of such discussion, and its effect on one painter, can be seen in the career of William Dyce.

Dyce's contact with the Nazarene painters in Rome had formed his early style, though he still painted a number of very conventional portraits deriving from Lawrence and Raeburn. As a Superintendent of the Schools of Design set up by the State in 1836, Dyce travelled on the Continent to study teaching methods, and when commissioned to do a fresco in the House of Lords went to Italy to learn more about fresco technique. He it was who took Ruskin's arm at the 1850 Academy exhibition and wheeled him round to look twice at *Christ in*

88 WILLIAM
LINDSAY WINDUS
The Outlaw 1861

89 WILLIAM LINDSAY WINDUS *Too Late* 1858

the House of his Parents. Dyce was, in fact, an experienced, cultured and widely travelled man, and one with a very extensive knowledge of the early Italian masters. But once the Pre-Raphaelite movement was under way, Ruskin was certainly not going to be guided by Dyce, nor necessarily to respect his work.

In 1855 Dyce exhibited his *Christabel*, now in Glasgow, which no doubt illustrated Coleridge's poem. Ruskin disapproved of it. To him, it seemed one of 'the false branches of Pre-Raphaelitism' in that, in adapting a figure from Botticelli, it merely imitated the early Italians; what was needed was their spirit, not their forms, together with a care ful study of nature, as found in the 'true school'. Such criticism had its effect on Dyce; he seems to have tried to right himself in *Titian's First Essay in Colouring* (1857), and a number of landscapes and religious scenes in the late 1850s seem to derive from a combination of Ruskin's teaching and the example of the Pre-Raphaelites. His *Welsh Landscape with Two Women Knitting* was painted with the aid of many geological studies: Dyce's letters of the time are full of references to the difference

12

90

90 WILLIAM DYCE *Welsh Landscape with Two Women Knitting c.* 1858

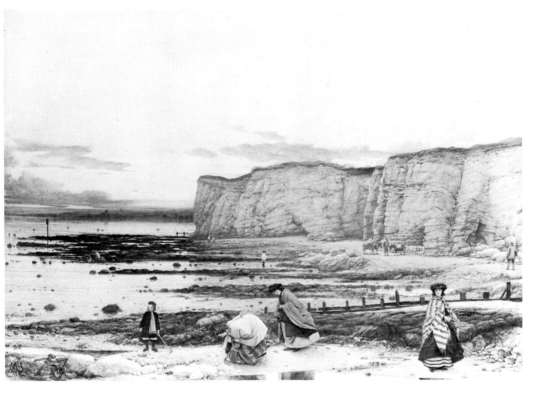

91 WILLIAM DYCE *Pegwell Bay, Kent, a Recollection of October 5th, 1858* 1859–60

between Scottish granite and Welsh slate. The knitters look somewhat out of place, but they do not have the desolation of the people in Dyce's famous *Pegwell Bay, Kent, a Recollection of October 5th 1858.* By arrang- 91 ing his composition so that the foreground begins at some distance from the easel, Dyce suddenly dwarfs his figures. They are a family group, and yet not a group, for they stand apart from each other, and nobody looks at anyone else. In the sky, unnoticed, is Donati's comet.

Dyce's other large Pre-Raphaelite work, *George Herbert at Bemerton,* 94 shows the poet in his garden near Salisbury, the spire of whose cathedral can be seen in the background. As the *Art Journal* commented, 'if these trees, and ivy leaves, and grass and wild flowers, be all painted in oils from nature, without the aid of photography or watercolours, then must this picture be considered a marvellous triumph of manipulative success and skill'.

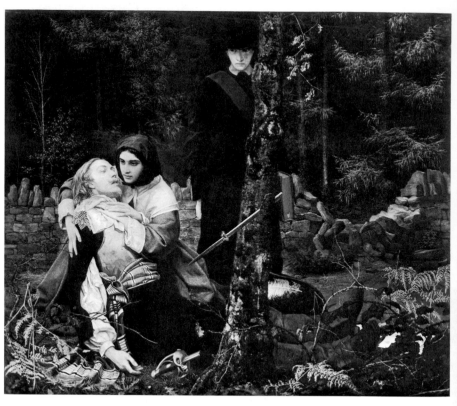

92 WILLIAM SHAKESPEARE BURTON *The Wounded Cavalier* 1856

Much the same could have been said for another seventeenth-century subject, a painting much favoured when exhibited in 1856, but
92 rarely seen since, William Shakespeare Burton's *The Wounded Cavalier*. One cannot but feel a certain kind of admiration for an artist who, for the closer observation of flowers and grasses, dug a deep hole for himself and his easel, so that the daisies, as he painted them, would be only inches away from his penetrating gaze. The subject is of a cavalier whose despatches have been stolen. Left to die, he is succoured by a Puritan lady whose jealous lover, carrying an enormous Bible, looks on with pursed lips. This was Burton's only work in the naturalistic Pre-Raphaelite manner, though he later switched to a strange anticipation
93 of European Symbolist painting in *The World's Gratitude*.

130

93 WILLIAM SHAKESPEARE BURTON
The World's Gratitude

94 WILLIAM DYCE *George Herbert at Bemerton* 1861

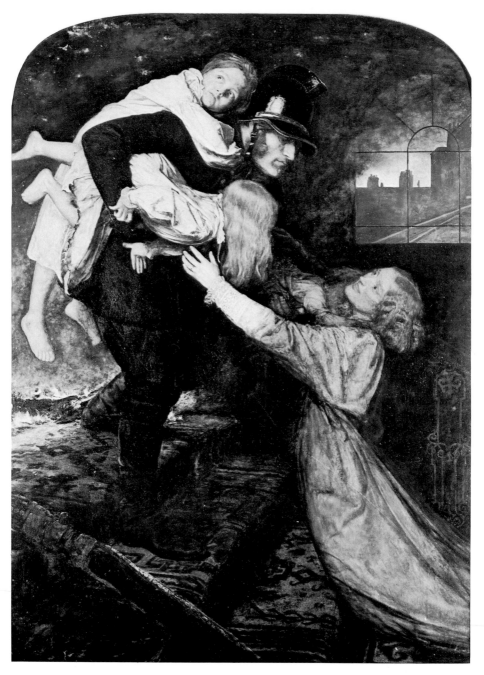

95 JOHN EVERETT MILLAIS *The Rescue* 1855

Work

As we have seen, Ruskin's involvement with Pre-Raphaelitism was not just a fortuitous conjunction. Theirs were not separate paths that happened to cross at a particular moment. The accepted interpretation, that he descended to the Brotherhood like some *deus ex machina*, ignores the real similarity of artistic purpose that bound him to the group more as a companion than as a commentator. He was a mover, an active force, and all the more so because he, more than any of the artists, could see beyond the next canvas, could feel all the implications of the new painting. We know from his art-historical writing how well he understood the abiding impetus of tradition. Understood it, and often felt like smashing it, for he knew what it was to be a contemporary (actually not a rare quality among Victorian sages), and had a generosity of interest that led to his determination to found a whole Pre-Raphaelite school in England.

This ambition, and the social interests inspiring it, were expressed in the Pre-Raphaelite educational experiment at the Working Men's College in London. The College was founded by the Christian Socialist F. D. Maurice in 1854. At an early *conversazione* held to raise funds and publicize the enterprise, Ruskin's chapter 'The Nature of Gothic', from *The Stones of Venice*, had been given away as a pamphlet, with the words 'and herein of the true function of the workman in art' significantly added to the title. Ruskin himself agreed to teach drawing at the College, although his own beliefs – indeed, his whole cast of mind – were singularly at variance with those of its Principal. The tone of the place was heavily muscular-Christian, and perhaps set not so much by Maurice as by the smug James Furnivall and the absurd Thomas Hughes (the author of *Tom Brown's Schooldays*), who assumed the role of guardian of the working men's physical and spiritual morale with a bouncy programme of boxing classes and healthy advice.

It is surprising that Ruskin, whose gentleness of character naturally

shied away from such wholesome man-to-man zeal, felt himself able to contribute to such a place; certainly he never concealed his contempt for its administration, and always refused to attend any official meetings. Nor would he ever comment on its educational policy. He left the College alone; it left him alone, and the result of this isolation was that he was free to pursue a remarkably radical method of art education.

Such workmen as came to the College for instruction in 'art' were simply left to him. The people who attended his classes, analysed by occupation, reveal themselves to be furniture-makers, jewellers, gold-smiths, draughtsmen, lithographers, engravers, bookbinders and the like. One can think of them as having the kinds of occupation that actually produced all the exhibits in the 1851 Great Exhibition, three years beforehand. The point is that they were all professions that demanded some kind of skill in drawing. The Government-sponsored Schools of Design of some years earlier had been intended to serve them.

However, any workman attending Ruskin's classes would have been disappointed in thinking that he was going to learn any of the practical skills of commercial design. Nor was he to learn how to do the tamely pretty landscapes so typical of the nineteenth-century cultivated amateur. It would be nearer the truth to say that the workmen were to learn to become Pre-Raphaelites, and Pre-Raphaelites at the grass-roots level, where grasses, stones, flowers, leaves and water were pictured in an amalgam of Ruskin's own drawing style and the hair-splitting fidelity 47 to the natural world evidenced in such a work as Millais's *Ophelia*. 35 Remembering Ruskin's commendation of Collins's *Convent Thoughts*, one can be sure that his pupils too would not have to wait long before acquiring such knowledge as 'a special acquaintance with the water plant Alisma Platago'.

Ruskin's teaching at this time is encapsulated in one of the most beautiful of his books, *The Elements of Drawing*, whose preface scorn-fully rejects the methods of the immense numbers of drawing manuals published since about the turn of the century, calculated – and here are Scylla and Charybdis – to meet the requirements of either artistic girls or industrious apprentices. These manuals, as Ruskin neatly put it, 'propose to give the student a power of dexterous sketching with pencil or water colour, so as to emulate (at a considerable distance) the

134

slighter work of our second-rate artists; or they propose to give him such accurate command of mathematical forms as may afterwards enable him to design rapidly and cheaply for manufactures'.

To Ruskin, these were dreadful alternatives, and both had to be rejected. He would not teach art that consisted of idle tricks of composition, leading to a facile expressiveness that reproduced sub-picturesque styles at second hand. Representational painting dependent on such formulae must be meretricious. Neither would he teach mathematical, *calculable* drawing, designed only to serve the Mammon of mid-Victorian bad taste.

What, then, were the workmen to learn? The answer could only be a very basic one, and would have to subvert a whole development of the post-Renaissance tradition. For Ruskin's solution is not only basic; it is almost primordial. Its implications, visually, are more deeply radical than any other pronouncement on the nature of the painter's task during all the long centuries when it was held that his function was to reproduce reality. 'We shall obtain no satisfactory result', said Ruskin at the opening of the Cambridge School of Art, 'unless we set ourselves to teaching the operative, however employed – be he farmer's labourer, or manufacturer's; be he mechanic, artificer, shop-man, sailor or ploughman – teaching, I say, one and the same thing to all; namely, Sight.'

This totally subversive statement is the logical, though deeply imaginative, conclusion of a man who desperately wanted to believe that, in contemporary painting, some things were true, and that it was the duty of the artist to pursue these, and always to exclude untruth. This gives us some idea of what Pre-Raphaelitism meant to Ruskin, and his intimate response to the innovations of one part of the move-ment. For his argument, at the Working Men's College, that 'the whole technical power of painting depends on the recovery of what may be called the *innocence of the eye* . . . of a sort of childish perception . . . *as a blind man would see if suddenly gifted with sight*', is quite obviously related, not only to his own ecstatic vision when drawing on the road to Norwood, but also to his experience of the painting of Hunt and Millais.

Ruskin's argument proceeds by a discussion of colour, which, of all

the components of art, is the one most closely connected with the immediate realities of perception, and is at the same time less susceptible to criticism and evaluation than is drawing. An accomplished artist, says Ruskin, continuing to use the metaphor of childhood, reduces himself to 'infantine sight', and sees the colours of nature as they really are. He does not accommodate them to any overall system of tones in his painting. He therefore 'perceives at once in sunlighted grass the precise relation between the two colours that form its shade and light. To him it does not seem shade and light, but bluish green barred with gold.'

54 Ruskin here must be referring to Holman Hunt's *Our English Coasts* of 1852, a major innovation in the history of colour, though one largely unrecognized since the time, years later, when Ruskin explained, 'it showed us for the first time in the History of Art, the absolutely faithful balance of colour and shade by which sunshine might be transported into a key in which the harmonies possible with material pigments should yet produce the same impressions on the mind which were caused by the light itself'. A similar work, not quite so thoroughly
96 new in its colour, was Madox Brown's *The Pretty Baa-Lambs*, painted in the open air at Stockwell and on Clapham Common, and avowedly a simple and straightforward attempt to paint sunlight.

These innovations in contemporary painting had their counterpart in the way in which, at the College, Ruskin encouraged his students to look at whatever piece of landscape they wished to paint through a piece of white cardboard with a small hole cut in the centre. Bit by bit, mixing colour immediately to make a precise match, this colour was dabbed on to the cardboard and always exactly reproduced in the actual painting. This obviated the temptation to compromise the real colours of nature into an overall scheme that would rob each individual hue of its true integrity.

This colour theory, as might be expected, was accompanied by an insistence on minutely accurate technical ability to draw, using the leaves, flowers, grasses and feathers that were brought into the class each day, and supplemented by frequent trips to draw in the Surrey countryside, everyone having tea at the Ruskin home on Denmark Hill afterwards. Ruskin put his students through a pretty rigorous course.

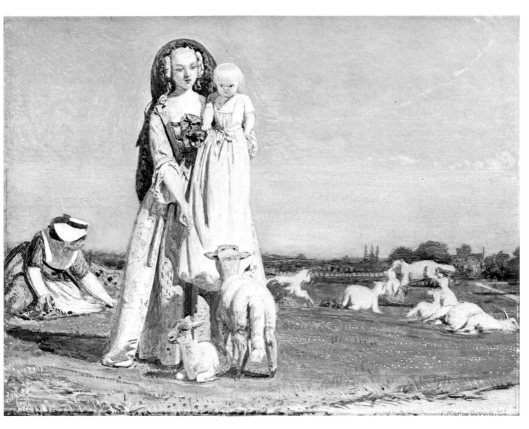

96 FORD MADOX BROWN *The Pretty Baa-Lambs* 1852

With such a programme, it might seem odd that he should have chosen Rossetti as his fellow teacher at the College. For how could there be a more different artist? Rossetti taught figure and watercolour painting, on alternate evenings, often failed to turn up, captivated all his students, and, according to William Michael Rossetti (who attended the College but preferred to be taught by Ruskin), instructed his students 'on a rather peculiar system, which amounted to regarding the object to be copied as a series of planes varying in their degrees of lighting or shadowing, and drawing it as such without much, or without any, preliminary outlining'. But this is to give Rossetti's system a dignity it did not really possess. We can guess that it was far from being a rigid discipline, and Rossetti's own lack of executant

ability would have prevented him from transmitting to others the sort of skills that Ruskin insisted on. The stories about Rossetti's teaching often border on the farcical, and make it apparent that his whole method so closely resembled those makeshift procedures known to artists as 'fudging' that his tuition was hardly taken seriously – although his evident dedication to the artistic life was the inspiration of many, and notably, as we shall see, of Burne-Jones.

Rossetti gave up the attempt to teach in 1858, and was replaced by Ford Madox Brown, who stayed at the College for nearly three years. Ruskin remarked darkly, according to one of the students, that Brown 'was equal to [Rossetti] as a painter, but would probably be superior as a teacher, as he had given more attention to teaching than Mr Rossetti had'. The same student recalled that Brown's teaching was as systematic and precise as Rossetti's had been free. Unlike Rossetti, he insisted on the importance of a firm outline, and said, 'Always know exactly what you mean by every line you draw on the paper; have a thorough idea as to which form of the model you intend to represent by the line you are drawing. Don't scuffle about with a great number of random lines, as many do, trusting to get something out of them by some chance, but be clear in your own mind and you'll best advance your work.'

No doubt this was a most useful corrective to those who had studied with Rossetti. Brown differed from Ruskin in making a special point of asking each new student why he was studying drawing, 'whether as an accomplishment, with a view to becoming an artist or as an assistance to his own daily occupation', and would then give him the sort of instruction he thought most suitable.

In the years between 1854 and 1860, then, with the slackening and final dissolution of the ties between the original members of the Brother-hood, accompanied by a gradual dissemination of Pre-Raphaelite principles though a widening circle of painters, the Working Men's College provided a testing-ground for the application of differing artistic impulses – the more readily because these were the years when Victorian painting was at its most socially conscious.

The contrast between the teaching of Ruskin and Rossetti dramatizes the growing split between two opposed trends in Pre-Raphaelitism, as

138

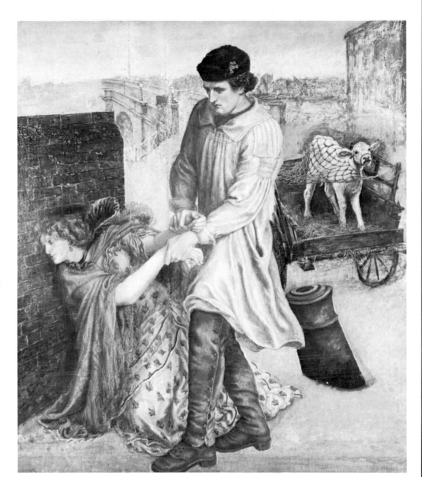

97 DANTE
GABRIEL ROSSETTI
Found 1854

indeed in nineteenth-century art as a whole. The 'hard-edge' style of
Holman Hunt and the early Millais is followed by the 'soft-edge'
painting of Rossetti and Burne-Jones. Against the real is posed the
ideal; against examination, intuition. A firmly limited delight in the
facts of nature is replaced by an aspiration to represent the insubstantial,
the ethereal. Naturalism gives way to symbolism. In all these equations,
Rossetti represents the latter impulse, Ruskin the former. Ruskin,
Rossetti and Brown, in their attitudes to the business of teaching, imply
varying ideas not only about what art should look like, but what it
should *do*.

An aspect of Pre-Raphaelitism which one might expect to predominate at the Working Men's College, and which was indeed a concern of most Pre-Raphaelite painters during these years, was the attempt to paint contemporary social life and its problems, especially its problems – what they called the 'Modern Moral Subject'. We have seen how Holman Hunt came to involve himself in such matters. He was the great moralist of the movement, but, despite Hunt's fervent claims to the contrary, Rossetti actually has a good claim to be the originator, within the Pre-Raphaelite circle, of this type of painting.

97 His *Found* was first conceived in 1851, and work on it was begun long before Rossetti ever went to teach at the Working Men's College. Its theme is described by Helen Rossetti as follows: 'A young drover from the country, while driving a calf to market, recognizes in a fallen woman on the pavement, his former sweetheart. He tries to raise her from where she crouches on the ground, but with closed eyes she turns her face from him to the wall.' The subject may well have come from William Bell Scott's poem *Rosabell*, though of course the theme of the fallen woman was becoming increasingly popular at this time. Rossetti made dutiful attempts at applying Pre-Raphaelite realist principle, going down to Chiswick, where he had found a splendidly genuine brick wall to paint from nature, and to Ford Madox Brown's (where he blithely overstayed his welcome) to paint the calf in the cart which the countryman is bringing to market. But the subject was not really congenial, and moreover the problems of painting an open-air subject from nature were, quite simply, too difficult technically. For years he tinkered with the painting, trying to get the perspective right, trying to finish the background, calling in friends to help him. He was still trying twenty years later. After his death Burne-Jones brought it to some sort of completion, washing in a blue sky where a churchyard railing was meant to come.

In the mid 1850s, for obvious reasons, Millais was very interested in sex, and while more official and saleable paintings, like *The Black* 98, 70 *Brunswicker*, *The Order of Release* and *The Huguenot* are historical paintings of good brave girls and brave handsome men in difficult situations, a number of drawings, obviously of a personal nature, dramatize the effects of passion in contemporary life. Some of these,

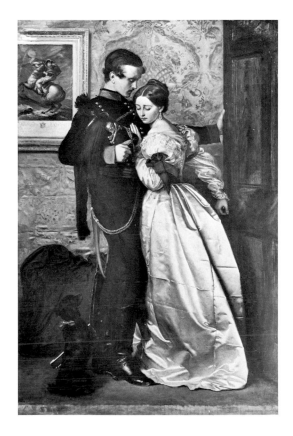

98 JOHN EVERETT MILLAIS
The Black Brunswicker 1860

such as *Woman in Church Watching her Former Lover Married* and *The Ghost at the Wedding Ceremony*, which bears some similarity to Rossetti's *The Sleeper* (an illustration to Poe), may even have been planned together with Effie Ruskin. *Retribution*, a pen and sepia ink drawing of 1854, is a classic example of the head bowed in shame. *The Race Meeting*, a very careful and highly finished drawing (whose style may be contrasted with the earlier mode of *The Disentombment of Queen Matilda*), is a potent image of ruin. Nobility, either personal or heredi-tary, is shattered by weakness and vice. The next race away, the flags flying and the woman weeping (they are leaving before the end of the meeting, so capital must be exhausted); champagne for some and sudden poverty for others; the contrast between beggars and gents in toppers: here are all the stage properties of a typical mid-Victorian distress painting.

100

99
23

141

99 JOHN EVERETT MILLAIS
The Race Meeting 1853

100 JOHN EVERETT MILLAIS
Retribution 1854

101 ROBERT BRAITHWAITE
MARTINEAU
*The Last Day in the
Old Home* 1862

With the general revival of interest in Victorian art, we have come
to know pictures of this sort rather well, though we seldom take them
seriously. To the modern mind, they are more amusing than moving.
They belong to just that type of Victorianism whose emotional style
seems most remote from our own, and are too recognizably a part of
that dispiriting nineteenth-century sag in which sensibility becomes
sentimentality, what was funny becomes jocose, and seriousness is
replaced by earnestness. They have none of the intelligence or subtlety
of the way in which the great Victorian novelists approached the
problems of ethical behaviour in a complex society.

What was the relationship of Pre-Raphaelitism to such painting?
It was not a Pre-Raphaelite invention – far from it – for this was
something that evolved from the domestic genre of such painters as
Wilkie, Webster, Mulready and Frith; the trick was to inject a depth
of interest and moral significance by casting such scenes in highly
charged emotional situations. *The Last Day in the Old Home*, by Hunt's *101*

pupil R.B. Martineau, which is sometimes described as a Pre-Raphaelite painting, may be taken as a paradigm of this sort of art. But the strangely gloating quality of the painting puts it outside Pre-Raphaelitism, for those painters who were nearest to the Pre-Raphaelite ideal seem to have been at their best when expressing compassion rather than reproof, and in such cases the emotion is less likely to seem overblown: Millais's *Blind Girl*, for instance, does have some quality of restraint. Its pathos is controlled, as also is that of Arthur Hughes's *Home from Sea* – just.

There is a good deal of sentiment in Millais's *The Rescue*. Here again are the helpless children familiar to us from his other paintings of the time. But the emotion is of a rather different sort, for the situation is one in which relief is felt, gladness that danger has been conquered. The genesis of the painting seems to have been in an actual incident, when Millais saw a fire in Porchester Terrace; but it is noteworthy that he was also motivated by irritation with a current vogue for drum-beating and uniforms. 'Soldiers and sailors have been praised a thousand times. My next picture shall be of Firemen', he wrote to Hughes. Although the painting was completed much more rapidly than had been Millais's practice – he worked on it night and day to be ready for the 1855 Royal Academy exhibition, and Collins was called in to help him – much care was taken with the choice of subject and the lighting effects. Millais discussed the subject with Dickens (whose attack on *Christ in the House of his Parents* had been smoothed over and forgiven), and became a connoisseur of conflagrations, travelling all over London to watch fires. He burned planks in his studio, and achieved his effect of glare by placing a sheet of coloured glass between the window and his models. According to his son, Millais considered this his best picture.

But the Modern Moral Subject was most often produced by concentrating on some social evil. Here we find some significant though never hard-and-fast differences between the Pre-Raphaelite painters and their less imaginative contemporaries. For instance, the contemporaries often pretend to illustrate a novel; their paintings not only have the flavour of illustrations, but seem to crystallize some crucial moment in a highly emotional plot, though the plot itself does not exist, and has to be constructed by the spectator. It is not difficult to imagine the

144

102 JOHN BRETT
The Stonebreaker 1858

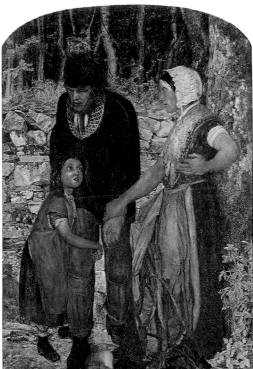

103 JAMES CAMPBELL
The Poacher's Wife

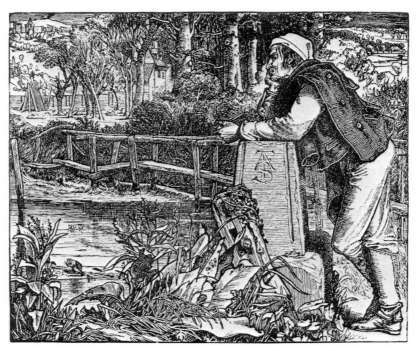

104 FREDERICK SANDYS *The Old Chartist* 1862 (wood engraving by Swain)

101 story which would surround Martineau's *Last Day in the Old Home*.
A diverting half-hour could be spent planning a novelette – or melo-
89 drama – round W. L. Windus's unexplained *Too Late*, with con-
sumption and illegitimacy no doubt to the fore. This sort of anecdotal
and moralistic ploy had a natural outcome in a fad for series of paintings,
like Augustus Egg's three-piece *Past and Present*, whose inspiration was
clearly a combination of bad contemporary novels and the tell-tale
sequences of Hogarth. In so many of these pictures, so popular, and so
widely disseminated through the sale of engraving rights, the relentless
emphasis on downfall becomes tediously unpleasant.

But if one looks at the Pre-Raphaelite artists and their affiliations, it
seems that the movement, often thought of as being insistently righteous
and moralistic in this sort of way, was socially conscious with a
significant difference. Downfall was not a special concern of the

Pre-Raphaelite imagination, though it does figure in Millais and Rossetti and, admittedly, was the obsession of William Holman Hunt. Generally, it belongs more to painters who were on the very periphery of the Pre-Raphaelite circle, or to astute academic hacks with an eye for the fashionable and profitable. Nearer to a Pre-Raphaelite ideal seem to have been those works, on the contrary, which describe the harmful effects on very ordinary people of an unjust society, and here again compassion rather than emphasis on retribution seems to mark the difference. To take two striking examples, the Pre-Raphaelites John Brett and Henry Wallis both painted – dreadful trade – stone-breakers, the one young and toiling, the other dead through toil: the former with some of Inchbold's light, delicate, vivid feeling for spring- *102* time, the latter with the twilight depth of colour of Millais's *Autumn* *85* *Leaves*, and a reminder of Sandys's *The Old Chartist*. A political *104* movement which failed, dedicated to the emancipation of working people, and a labourer who died of his labour: in an area where the choice of subject-matter, quite apart from the manner of painting it, is all-important, are we not justified in feeling that this sort of sympathy, though overblown in its expression, has nevertheless a tact and dignity quite absent from the purveyors of social nemesis?

Ford Madox Brown's was the most noticeable contribution to the socially motivated painting of the period. He looked at personal shame in *Take Your Son, Sir*; he painted a contemporary social problem in *The Last of England*, the unemphatic life of the suburb in *An English Autumn Afternoon*, and finally attempted to apotheosize the whole social system, and the place of labour within it, in *Work*, the most fully socially conscious of all English nineteenth-century paintings.

In 1852 he began a painting that, true realist that he was, is about what life is like; its subtly uncompromising subject is none the less given a sort of elegance by the long ellipse of its format (the most successful of Brown's numerous experiments with shaped canvases). *An English Autumn Afternoon* shows a pertinacious attempt to paint *105-6* what was there, and at the same time a nice feeling for lower-middle-class romance – non-literary, non-passionate love. The artist was living in Hampstead at the time. His lodgings looked out over the Heath, no longer the rural spot that Keats had known thirty years before, nor yet

105–6 FORD MADOX BROWN *An English Autumn Afternoon* 1852–54

the approximation to a public park that it was soon to become. It was where Middlesex, with its lanes, its farms, met the houses of London. Neither rural nor urban, here – and where before so honestly captured in paint? – is real suburb. And here in the foreground, shyly hand-locked, are a very suburban young couple, looking down over the red-tiled roofs and planted trees, over the last remaining fields and the new streets of Kentish Town and Islington towards St Paul's, resting and talking on the scrubby grass. He is just a bit of a sprig; he sprawls, but she must sit more formally. To their right, domestic doves flutter round the cote that someone has built for them. It is Sunday, and three in the afternoon, and in an hour they will go home to tea, at her parents', in Finchley, and he will help her over the stiles. Ruskin – who knew little of such matters – was annoyed at the painting, but Brown was unmoved. 'What made you take such an ugly subject?' he asked the painter. 'Because it lay out of the back window', was the retort, and in his 1865 catalogue Brown was again insistent on the quality, and validity, of the work as 'a literal transcript of the scenery around London, as looked at from Hampstead'. What was there was worth painting.

148

Brown's slightly stolid, alert, worried, honest character is an attractive
one, and movingly documented in the diaries he kept at this period,
one of severe financial trouble and a certain amount of artistic in-
decision, this latter perhaps exacerbated by his practice of simultaneous
work on paintings in very different styles; *Lear and Cordelia*, *The Pretty
Baa-Lambs*, *Christ Washing Peter's Feet* and *An English Autumn After-
noon* were all in progress more or less concurrently. One day in the late
summer of 1854 he was sick, tired, 'uncontrollably disgusted with
everything'. His wife Emma suggested a trip to St Albans. They
walked to the station at Colney Hatch, took a train to Hatfield, and
'got a ride on the top of a 'bus in the most lovely weather . . . one
field of turnips did surprise us into exclamation, with its wonderful
emerald tints. And then we passed a strange sight: two tall chimneys
standing separately in a small space of ground (about a rood, I suppose);
the rest of it covered with black-looking rubbish, some of it smoking,
and some children looking at it.'

There is something of Brown's attitude to art in these diary jottings,
written as he sat up that night in their inexpensive inn. Turnip leaves
do have a remarkable colour, but it takes a realist of a special order to
be stirred by a field of them, seen from a bus on the way to St Albans.
The ordinariness of the counties round London, notoriously the most
boring of English counties, and scattered with industrial waste, seems
to have awakened poetic feelings in Brown. His landscapes of the
1850s show this; with uncompromising material, and shunning the
usual devices of *repoussoir* trees and the conventions of aerial perspective,
he painted Hendon and Brent, Walton-on-the-Naze and the Isle of
Sheppey. Brown was particularly sensitive to unusual colour effects
in nature, and in landscapes like *The Hayfield*, which was painted at
Hendon in 1855, he attempted a wet twilight when the hay seemed
'positively red and pink'. Turnips appear in the foreground of a related
canvas, *Carrying Corn*, and in *Walton-on-the-Naze* red and pink tones
are again used to original effect. Such innovations, together with those
of Hunt's *Our English Coasts*, are now recognized as occupying a
significant place in the liberation of colour from academic convention.
Brown probably intended these landscapes – all are quite small – as
pot-boilers, pictures to pay the rent with, but found that he was

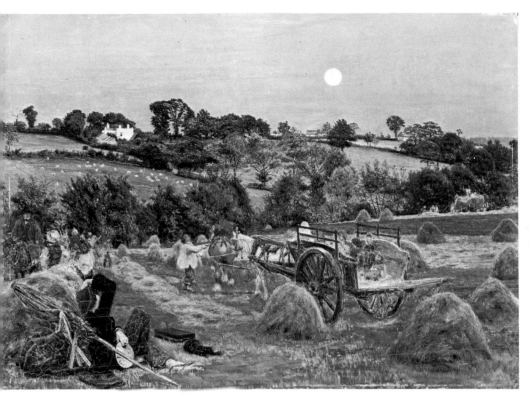

107 FORD MADOX BROWN *The Hayfield* 1855

spending a great deal of time and effort on them. His journals record the painstaking struggles with technique and special effects, often involving the treatment of light and his attempts to catch the subtle changefulness of English weather.

In his description of *The Last of England* he stated: 'To ensure the peculiar look of *light all round* which objects have on a dull day at sea, it was painted for the most part in the open air on dull days.' So here is a dull day, unspecial, cold and leaden, and yet a momentous day for those people who are leaving home. The origin of this picture is well known, though its general import is so far removed from its genesis that this is not necessarily illuminating. It grew out of the departure of Thomas Woolner, the sculptor and founder-member of the Brotherhood, for Australia in 1852. But, as Brown points out, the

109

picture is not just a personal salute to Woolner. 'It treats of the great emigration movement, which attained its culminating point in 1852', said the artist, and he gave the central position to a middle-class couple, 'bound to their country by closer ties than the illiterate'. With these are seen 'an honest family of the greengrocer type', while in the background 'a reprobate shakes his fist with curses at the land of his birth'. These secondary characters, however, are constricted and lopped off by the oval, almost round form of the canvas. Our attention is centred on the couple, and in particular on their expressions, for the message of the painting depends greatly on the ability of portraiture to convey emotion. Their expressions are indeed very well managed, and one feels for the determined, hurt and troubled husband and his regretful yet trusting wife. A nicely deflating touch is in the glimpse of those funny fists that infants have, peeping out from mother's sensible shawl. This, though sentimental, is realistic, whereas the 'reprobate', less firmly painted, and given a subsidiary role, seems to have strayed into the picture from his natural habitat in melodrama. The grave disposition and careful painting of the husband and wife emphasize the straightforwardly honest aura of the work.

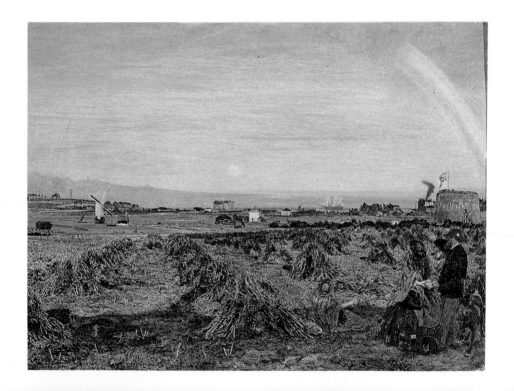

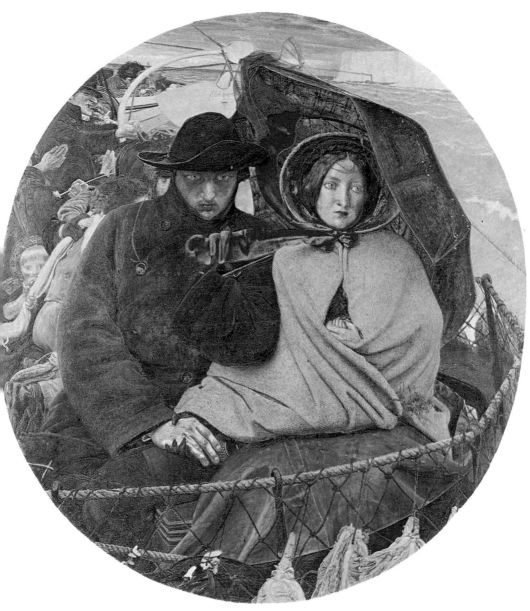

109 FORD MADOX BROWN *The Last of England* 1855

108 FORD MADOX BROWN *Walton-on-the-Naze* 1859–60

To understand this one needs to emphasize the artistic context within which the painting should be considered. It is, again, a question of subject-matter. Brown's picture, like Millais's *The Rescue*, is an implied comment on a common theme of nineteenth-century English art, in this case one that was widely diffused through such media as Baxter's coloured prints of colonials and their families: the theme of British imperialism spreading a beneficent influence round the globe (a popular belief later served by such paintings as Millais's *The Boyhood of Raleigh*, *The North-West Passage*, and many others). Brown's painting deliberately says the opposite, for the colonist's position is totally different

95

110 FORD MADOX BROWN *Take Your Son, Sir!* *c.* 1857 (detail)

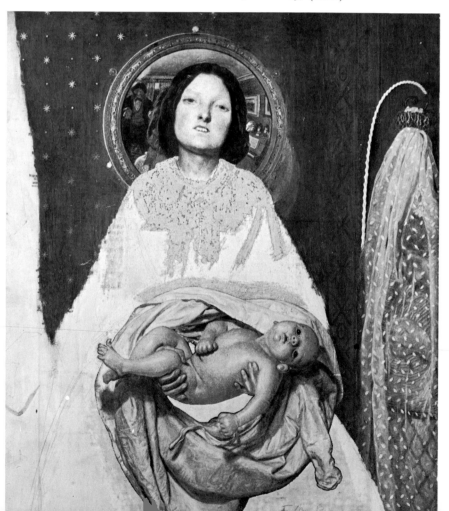

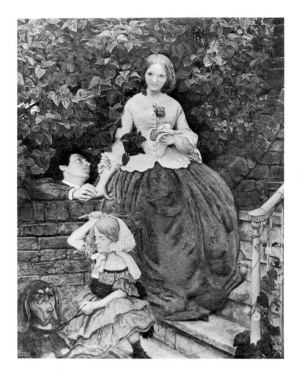

111 FORD MADOX BROWN
Stages of Cruelty 1856–90

from that of the emigrant. The one expands economic advantage at home at the expense of the natives of foreign parts, the other, financially unsuccessful at home, is driven to deny his native culture and upbringing and move to some awful place like Australia.

Brown's own worries about feeding and clothing his family, his meagre success at making a living as an artist, may have contributed to the theme of *The Last of England*. It is possible that he himself considered emigration. His precarious financial position was not helped by two very different paintings, one unfinished, both unsold, that occupied him during these years. *Take Your Son, Sir!* is an illegitimacy painting, *Stages of Cruelty* a sour oddity. In the first of these we have, again, a fallen woman and her child. But the emotion of the painting is primarily one of pride. It is very uncompromising. The mother and child – and what a defiant attitude they have, forcing even the spectator into the role of perpetrator – are not at all like their counterparts in other Victorian paintings. Here is no shameful bundle, no regretful weeping,

110

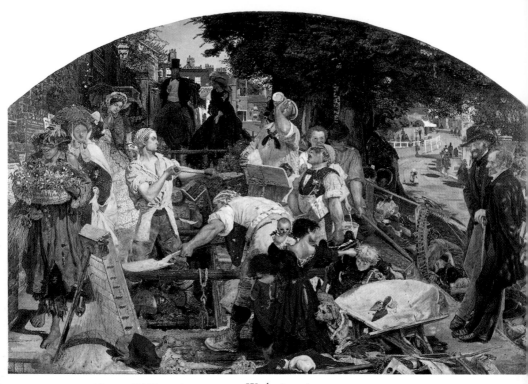

112–13 FORD MADOX BROWN *Work* 1852–65

but a straightforward appeal to the bewhiskered seducer glimpsed in the mirror, and as much a demand as an appeal: this is what we did, here is our child; what will you do about it now? It is another example of his independent, no-nonsense attitude to the themes of contemporary painting. But it is difficult to determine what thoughts lay behind *Stages of Cruelty*, which seems to have begun as a very standard Pre-Raphaelite subject; two lovers, a brick wall, foliage. The title was originally *Stolen Pleasures are Sweet*. Sweet they may have been in an earlier version, but there is nothing of that in its completed state, and little pleasure to be found in it. We are perhaps meant to feel a parallelism, some connection between the grown woman's treatment of her lover and the idle viciousness of the thoughtless child striking a (very untroubled) dog with a switch of love-lies-bleeding. In any case, it is a singularly unromantic vision.

111

156

It is hard to find anything useful to say about *Stages of Cruelty*. *Work*, on the other hand, cries out for elucidation, for it is that kind of *112–13* painting. With respect, we must first of all recognize, however, that it is the wrong size and in the wrong medium. For its antecedents, and its inspiration, are in the Renaissance, in large-scale tempera paintings on the walls and ceilings of public buildings; it is a Pre-Raphaelite painting that owes something to Raphael. The workmen have just that posed amplitude of gesture (they even look like quotations, though they are not) that belongs to the great decorators of the Vatican, and in particular to Raphael's *School of Athens* (whose general shape Brown reproduces), where, in a spacious hall dominated by the statues of Apollo and Minerva, surrounded by figures representing the sciences, Plato and Aristotle gravely dispute their philosophy. That is to say, intellectual themes are portrayed by a variety of representative figures. But *Work*, only four and a half feet high (a replica is even smaller), with its large array of figures and accumulation of significant

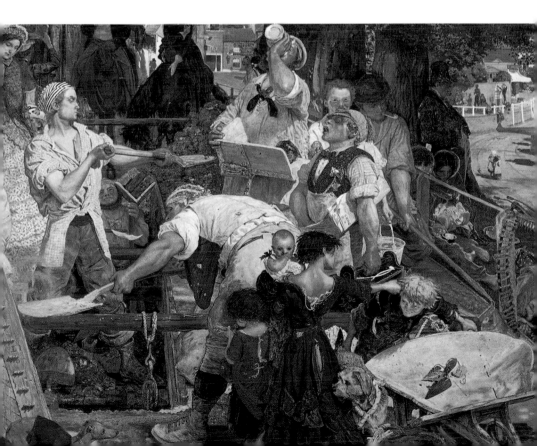

detail, seems cramped and bunched up, and as if it were really meant for large-scale treatment on the walls of some institution, ideally perhaps at the Working Men's College itself.

Its theme is the place of labour in contemporary society, and the larger significance of different types of work. In the centre are what Brown called 'the British excavator . . . the young navvy in the pride of manly health and beauty; the strong, fully developed navvy who does his work and loves his beer; the selfish old bachelor navvy, stout of limb, and perhaps a trifle rough in those regions where compassion is said to reside . . . the Paddy with his larry and his pipe in his mouth'.

On the left, in contrast, is a beggar, and to the right are the philo-sophers, the 'brain workers', Carlyle and F. D. Maurice. Other figures include the rich, on horseback behind, their way barred, tract distri-butors, orphans, policemen and an election parade. On the wall are posters relating to the Working Men's College and the Boys' Home in Euston Road (from which source, incidentally, William Morris was currently recruiting cheap labour for his firm). These variegated figures do not constitute an argument. The painting has a theme rather than a message, though its final impression is of a celebration of the life of the English labouring man, of his necessity and worth. This, together with such paintings as the Brett and Wallis *Stonebreakers*, may be regarded as a notable extension of the subject-matter of painting, especially when considered in relation to the exalted themes of *Work*'s Renaissance prototypes.

On a larger historical plane we should note the place of Brown's *Work* in the development of a continuing concern in Victorian art, one that is interwoven with the development of Pre-Raphaelitism. This is the relationship of art to work. Early in the century William Collins, an Irishman, a fair painter, the kind father of a Pre-Raphaelite (Charles), remarked to his friend Benjamin Robert Haydon, 'Depend upon it, Sir, were it not for the Academy we should all be treated as carpenters.' He was anxious to assert the dignity of his profession, and grateful to the Academy (whose function this certainly was) for providing eco-nomic security and an entrée to the Athenaeum. But at the end of the century, with the rise of an Arts and Crafts movement, one of whose watchwords was the meaningfully hyphenated and equated 'art-work',

with the collapse of the Academy as a meaningful centre of artistic activity, we find William Morris asserting that artists are just like carpenters, that their activities should be undifferentiated, that art and work should be one and the same thing.

How did this momentous change of attitude come about? The first landmark on the route is certainly Ruskin's somewhat muddled 'Ideas of Power', in the first volume of *Modern Painters*, which expressed his conviction that the value of a work of art is in some way dependent on the amount of labour involved in its production. This belief had a decisive effect on his admiration for Pre-Raphaelitism, and for an artist whom he might otherwise have found antipathetic, the harem painter J. F. Lewis; it was to be the basis of his famous attack on Whistler. Of Italian painters before Raphael, Ruskin therefore admired those whose technical skills seemed to derive from apprenticeship, from a training in workmanship: Botticelli, who by this account is not effete, but gained precision and firmness from his early years as a goldsmith, and Giotto, the shepherd boy who yet could paint a perfect circle freehand, and whose quiet ability made him scorn the emissary of a Pope.

Not only in Ruskin, but in a widening circle of thought, industry and application came to have a place nearly equal to that of inspiration. The artist should be a workman as well as being an artist. Workmanship was therefore inculcated at the Working Men's College, though with the difference that Ruskin, utopian and anti-capitalist that he was, refused to concede that the workmanship relevant to industrial manufacture could at the same time be relevant to true art or the life of anyone really concerned with beauty. Brown was more conciliatory than this, as his record at the Working Men's College shows, and as is haltingly expressed in *Work*. An intransigent attitude to the relationship between industrial capitalism and the impulses of the artist could henceforward be the prerogative only of utopians; and in particular of William Morris, whose career we must now consider.

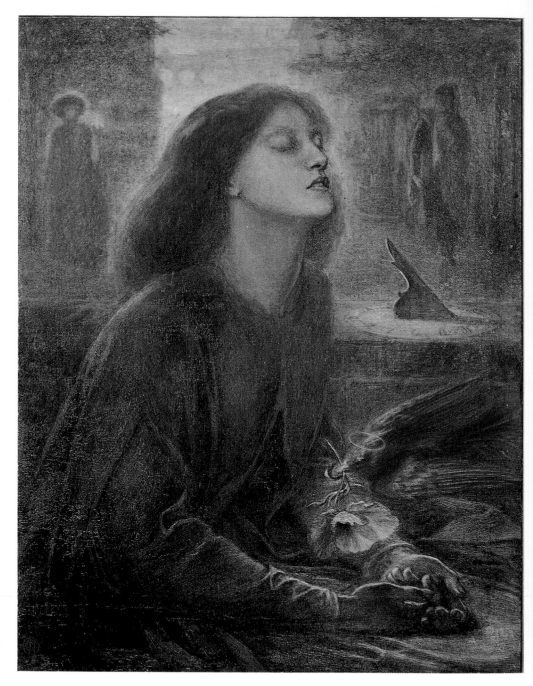

114 DANTE GABRIEL ROSSETTI *Beata Beatrix c.* 1863

A Palace of Art

William Morris was shaped by Oxford, the most medieval of English cities – and for that reason one that held a special place in the Victorian imagination. There, one could easily feel, was a retreat from the stresses of modern life. There too were preserved certain standards that had been lost in the industrial city. Matthew Arnold put it most clearly, in his poems *The Scholar Gypsy* and *Thyrsis* and in that famous rhetorical pronouncement, 'Who will deny that Oxford, by her infallible charm, keeps ever drawing us nearer to the true goal of all of us, to the ideal of perfection, to beauty, in a word, which is only truth seen from another side?' It was appropriate that the medievalizing strain in Pre-Raphaelitism, as well as a new emphasis on environment, should gather from Oxford its two most fervent supporters, in the persons of William Morris and Edward Burne-Jones.

Morris was the stronger of the two, the leader. He went up to Exeter College in 1853, and there met Burne-Jones, a poetic and High-Church inclined youth from Birmingham. Their friendship was based on similarity of taste and the shared excitement of new discoveries. Morris was already familiar with the first two volumes of *Modern Painters* and, like all reading men, was a Tennysonian. They stayed up all night, Morris thunderously chanting from Ruskin and 'The Lady of Shalott'. They admired Keats, Shelley, Carlyle, and Charlotte M. Yonge's recently published *The Heir of Redclyffe*. They discovered Malory, and immersed themselves in the world of medieval romance. They were ignorant of pre-Renaissance painting (Burne-Jones knew hardly anything of painting at all), but pored over the illuminated manuscripts in the Bodleian Library, visited churches, took brass rubbings, were struck by woodcut reproductions of Dürer engravings. They and a group of like-minded friends called themselves 'The Brotherhood'.

At first, they knew nothing of the London group of Pre-Raphaelites.

The publication of Ruskin's Edinburgh Lectures (which had been written while he was at Glenfinlas with Millais) was to change this, and in the collections of Combe and Windus they were to see examples of the work of Hunt, Millais and Brown, and, most importantly, Rossetti's 1853 version of *Dante Drawing the Head of Beatrice*. They gave up their plans for entering Holy Orders. Morris determined to become an architect, finding himself a position in the Oxford offices of G. E. Street, one of the most original and forceful of the architects of the Gothic Revival. Burne-Jones wanted to become a painter, but had no idea how to do so, apart from trying to make contact with the man who, at a distance, and through repute, had become his hero.

'I was two and twenty,' he later recalled, 'and had never met, or even seen, a painter in all my life. I knew no-one who had ever seen one, or had been in a studio, and of all the men that lived on earth, the one that I wanted to see was Rossetti. I had no dream of ever knowing him, but I wanted to look at him, and I had heard that he taught at the Working Men's College.'

In Great Ormond Street, where the College then had its premises, he not only saw Rossetti ('his face satisfying all my worship'), but was introduced to him, and then visited him in the studio near Blackfriars Bridge. It was revelatory, and not revelatory in the way it had been to look at manuscripts; for this was real. Rossetti's enthusiasm and interest in the younger man soon exacted a total devotion, and under his wayward guidance Burne-Jones began to paint. Meanwhile, Morris remained in Oxford, working for Street, and travelling to London once a week to see them.

It was inevitable that Rossetti's influence on the young apprentice architect should deepen, especially when Street's practice moved to London, and Morris and Burne-Jones moved into rooms in Red Lion Square that had been occupied by Rossetti and Walter Deverell in the later days of the P.R.B. Rossetti cared little for architecture, and one cannot doubt that he took Morris out of the profession and started him painting. With a private income of £900 a year, Morris could afford to do this, and was easily swayed to Rossetti's conviction that 'if a man has any poetry in him he should paint, for it has all been said and written, and they have hardly begun to paint it'.

Morris had adopted the badge of the artist from the day he took his degree, throwing away his razor, growing his hair long (the members of the Pre-Raphaelite circle, though not the originators of this mode, were certainly among its pioneers); and the artistic life, with its bohemianism, its late hours, its unrestrained friendliness, must have been infinitely more attractive than the restrictions of an apprenticeship. But what sort of an artist was he to be? The answer emerged in the spring and summer of 1857. He worked hard at his drawing and painting, but when he started on his first full-scale oil, a subject from Malory's *Morte d'Arthur*, the results were disappointing. At the same time, as the rooms in Red Lion Square were unfurnished, the friends set about making decorated furniture to their own designs. Rossetti planned oil-paintings on the doors of cupboards, Burne-Jones covered his wardrobe with scenes from Chaucer's *Prioress's Tale*, and Morris discovered that his talent was inclined towards pattern-making and design, and that his enthusiasms were most fully served by the planning and execution of an environment.

This was the background to the famous episode of the Oxford murals. At about the time that they were engaged in setting up their artistic home in Red Lion Square, Rossetti made a trip to Oxford to see his friend the Dublin architect Benjamin Woodward, who was working there on the new University Museum (which had been designed in accordance with Ruskinian principles), and was also engaged in building a new debating hall for the Oxford Union. At Woodward's Rossetti met John Hungerford Pollen, an interesting figure whose career in some ways ran parallel with the course of Pre-Raphaelitism. A High Anglican, Pollen had been at Christ Church at the same time as Ruskin, and in subsequent years had devoted himself to art largely under the influence of the critic's early writings. In 1850 he painted the roof of Merton College Chapel (managing to introduce a Pope), where his scaffolding was shared for a time by the young Millais, then copying the stained glass for his *Mariana*. At the 36 time when Rossetti met him, he had been taken up by Cardinal Newman ('he wears a beard, like other men of genius', said the Cardinal), and was Professor of Fine Arts in the Catholic University of Dublin. This was the man whose example in Merton College prompted

Rossetti to persuade Woodward that he and his Pre-Raphaelite friends should be entrusted with the decoration of the Union debating hall. Morris and Burne-Jones were summoned from London. Rossetti and Pollen led the way, and were assisted by Spencer Stanhope, Val Prinsep and Arthur Hughes.

Thus began the most happy and youthful Pre-Raphaelite summer since the formation of the original Brotherhood in 1848. 'What fun we had! What jokes! What roars of laughter!' reminisced Prinsep, who on first arriving at Oxford station had asked a cab-driver to take him to the Union, only to find himself deposited outside the Workhouse. Rossetti's personality spurred them all. 'He was the planet around which we revolved', said Prinsep. 'We copied his very way of speaking. All beautiful women were "Stunners" with us. Wombats were the most beautiful of God's creatures [an animal most attractive to Rossetti; he painted them on the Union walls, and later even kept them]. Medievalism was our *beau idéal*, and we sank our own individuality in the strong personality of our adored Gabriel.'

Indeed, the group did develop a collective personality that was an extension of Rossetti's own; boisterous, yet touchingly Romantic; fun-loving, yet deeply idealistic. It was perhaps not the right combina-tion to deal with the job in hand, and actually the project was never completed.

What had to be painted was the wall above the gallery which circles the Union debating hall; this was divided into ten bays, pierced by twenty-six round windows. There were to be ten distinct paintings, illustrative of the *Morte d'Arthur*. However, with the exception of Pollen, who rather faded out of the proceedings, not one of these young men knew anything about fresco technique. The walls, newly built, had damp plaster on them. No ground was used apart from a coat of whitewash. Some of the paint sank in, some of it flaked off. The hall was lit by gas lamps, whose fumes badly damaged what was there. The *Morte d'Arthur* faded away: Launcelot's Vision of the Sangreal, Sir Pelleas and the Lady Ettarde, King Arthur and Excalibur, Sir Gawaine and the three damsels, all perished, Morris's work being the first to disappear. After six months all that was visible of his painting was a portion of Sir Tristram's head, and a little row of sunflowers.

128

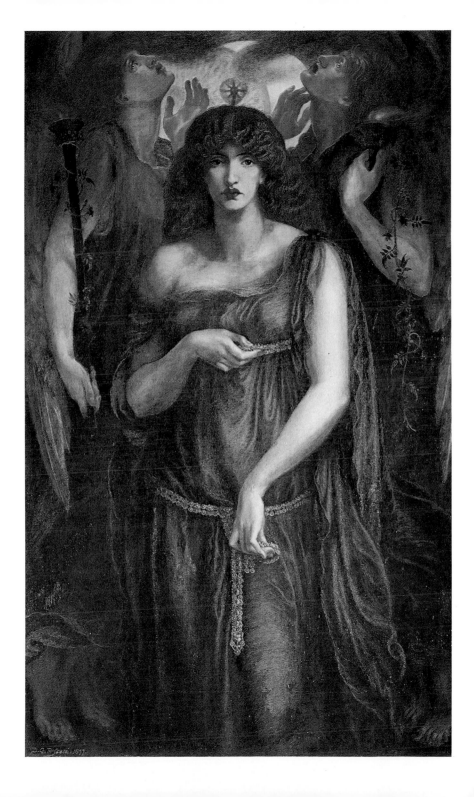

As the summer ended, most of the young painters left Oxford. Morris had good reason to stay on. Rossetti and Burne-Jones had one night been at the theatre, where they made the acquaintance (as the biographers put it) of two girls sitting behind them. The girls were 'stunners', and the elder of them, Jane Burden, was a particularly striking beauty. She was persuaded to sit for them, and Rossetti's portrait drawing of her at the time, when she was eighteen, establishes what from now on is to be the very type and paradigm of Pre-Raphaelite beauty; the long thick neck, the large eyes, the full and shapely mouth, and perhaps above all the abundant, long, flowing, wavy hair. That this was not an invented artistic type is apparent from a near-contemporary photograph. Jane was real; art and beauty were real.

116

Morris loved her. 'I cannot paint you but I love you', he is said to have written hopelessly on his canvas as one day she sat to him. His portrait of her as Queen Guinevere has the constricted, unreal space of some of Rossetti's early paintings, and in this space she appears as flattened, lifeless. In fact, the painting's only real liveliness is in the treatment of the rich tapestries of the Queen's bedroom, in the vivid delicacy of her chamber's accessories. It is sometimes said that at this stage Morris had exhausted his talents as a painter. But the truth is that he was rightly unwilling to develop his talents (which, after all, were as substantial as those of Burne-Jones) in this field. He realized that his path led elsewhere, and that his artistic gifts were in some way to revolve about Jane, whom he married in 1859.

118

116 Jane Morris, posed by Rossetti, Kelmscott Manor 1865

117 DANTE GABRIEL ROSSETTI *Jane Burden as Queen Guinevere* 1858

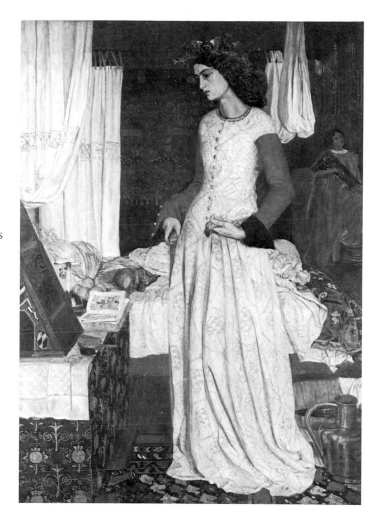

118
WILLIAM MORRIS
Queen Guinevere
1858

It has long been realized that this remarkable and mysterious woman was responsible for the direction of Rossetti's later painting. What must now be suggested is a simple but overlooked point: that in this crucial early stage of their marriage she also determined the alignment of her husband's artistic interests. Mackail, Morris's official biographer, puts it this way: 'A new kind of life opened up vaguely before him, in which "that small palace of art of my own" long recognized by him as one of his besetting dreams, was now peopled with the forms of life

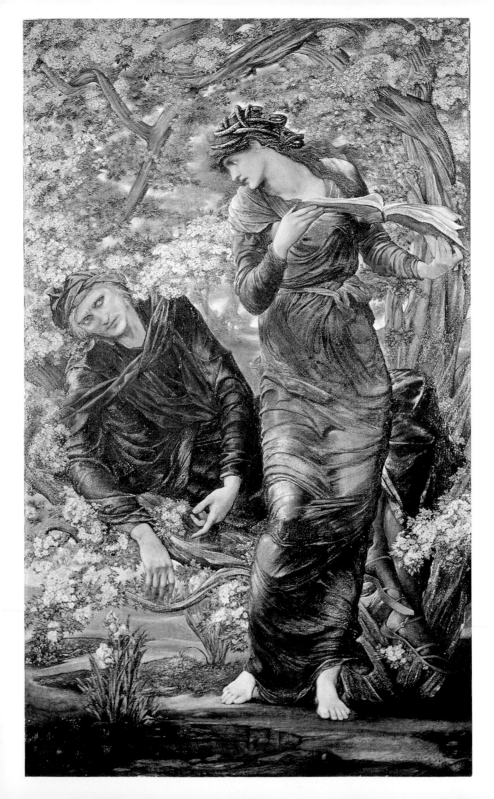

and children, and contracted to the limits of some actual home, in which life and its central purposes need not be thwarted by any basis of ugliness of immediate surroundings.'

Let us restate Mackail's polite interpretation of the situation more bluntly. Morris, young, rich, talented, artistic, had made, in terms of his social background, a most unorthodox marriage, and not a welcome one; his parents, it seems, did not attend the wedding ceremony. Jane was a working-class girl, the daughter of an ostler, and had been picked up at a theatre. Her staggering beauty, her unique ability to represent in her person all that Morris and his friends aimed at in art, could be reconcilable to the social fact of marriage only if that marriage were totally removed from the upper-middle-class Victorian milieu in which Morris had been brought up. This was the only way in which he could be married and follow art, the only way in which art and life could be combined. Hence the importance, first adumbrated in the Red Lion Square ménage, and now to be fully developed, of the totally artistic environment. (There is a striking parallel to this situation in the case of England's other great nineteenth-century utopian, Ruskin. Separated from the person he loved, not by class, but by age and an old scandal, his vision of the 'Guild of St George', the society where there were to be no rich, no poor, no steam-engines, only a pleasant and useful agricultural life, was quite clearly determined by the notion that this was the only environment in which he, a fifty-year-old divorced man, could live in untroubled happiness with a child of twelve.)

Temporarily in lodgings in Great Ormond Street, the young and ill-matched couple waited for Philip Webb, an architect who had just left Street's practice, to complete their Palace of Art (the phrase, incidentally, is Tennyson's), the Red House at Bexley Heath in Kent, in which all the furniture and household goods were to be designed and made by Morris and his friends, and at the centre of which Jane was to live, not only as the presiding genius of the place, but also as the ever-present focus of genius. The idea was entirely characteristic. William Morris was gregarious by nature, and he was to become a socialist. Just as Ruskin's Guild of St George was supposed eventually to take over all English land, so was Morris's Palace to expand through all English society.

119 EDWARD BURNE-JONES *The Beguiling of Merlin* 1874

Ironically enough, this process was started by a capitalist enterprise. The Brotherhood became the Firm. Art was registered under the Companies Act when Morris, Marshall, Faulkner & Co. grew out of the co-operative effort to build and furnish Morris's home. Their premises were in Red Lion Square, with an impressive apparatus of showrooms, offices, and prospectuses, all emphasizing the need for close and constant supervision by artists over all aspects of the production of furniture, stained glass, metalwork, jewellery, wallpaper and embroidered tapestries. Morris found a stained-glass craftsman at the Working Men's College and employed lads from the Boys' Home in Euston Road, and a large circle of friends helped with designs and odd jobs. Morris worked harder than anyone, and worked at everything. He seems almost never to have stopped or relaxed. When he did, he was probably morris dancing. His energies ensured that commissions came in, and that finished work went out – to a clientèle which largely consisted of architects, either progressive dilettantes or the moneyed builders of High Anglican churches.

What was the nature of all this activity? How do the objects which Morris's firm produced seem to fit into Pre-Raphaelite art? In one way, of course, they fit very well, for they often look like the props of a medievalizing Pre-Raphaelite painting, as if they had been plucked out of such a painting and given a real and substantial three-dimensional existence. The first point about these pieces of furniture, tiles, tapestries and so on, is that their inspiration, if not always their design, was almost totally historicist. Morris made anew what really belonged to a world of five hundred years before. Objects are more real (in a way) than pictures, and while it does not seem totally abnormal to paint medieval subject-matter in the estranged world of a picture, here, in Morris, the things are made actual. His material is material. This move towards having everything in an environment, in one's own home, of this archaizing type is one of the high points of that Victorian cast of mind which looked back to an idealized Middle Age in which everything was uncorrupted, harmonious, good. And so Morris, in effect, was making new old things.

There is something so totally beside the point in such an operation that Morris has often been criticized for his refusal to come to terms with

his times, for his failure to perceive that the new world could not be built in such a way. These criticisms are not totally fair: one well understands the causes of Morris's aversion to the nineteenth century and his reversion to an unearthly, non-existent paradise. One sympathizes with his rejection of the low standards of work in the Great Exhibition of 1851, and in the International Exhibition of 1862, where his own firm had a stall, surrounded by acres of glistering rubbish. One is sympathetic to his hatred of the industrial city, the soot-blackened pilings of social voracity, and the destructiveness of capitalist society, its callous and money-directed disregard of culture, and the old material of culture; as buildings were ripped down to make way for railways and factories, as dismal streets were built over fields, forcing the countryside away, it seemed that there were fewer old things on the earth than there had been before, and that antiquity no longer carried its own validity or sanctity.

Such feelings were to lead to such enterprises as the Society for the Protection of Ancient Buildings ('Anti-Scrape'), which Morris founded in 1877. The Society was directed as much against unsatisfactory restoration as against destruction, which was sensible, but in such an area we find a clue to a particular failing in Morris, his totally static sense of history. Despite all his personal energies, despite his conversion to a political position based on a socialist dialectic of history, there is never in Morris's art, whether in his poetry or in his handiwork, any sense of energy, of movement or progression. This is what makes him, in comparison to Ruskin, such a bloodless utopian, and is surely the reason why Morris's art is so repetitive and so boring.

For boring it is, and the reasons why help us to illuminate, in this crucial area, the differences between work that is merely 'artistic' and real works of art. The classic elements of tedium in art are all present. First of all, it is largely anonymous: while the style is recognizable, there is no feeling of a single distinct artistic personality. The methods of production would in any case have precluded this, since the work was done by corporate enterprise, but Morris's firm levelled all the different artists who designed for him and worked for him into a single namelessness. Secondly, it is repetitious. There are variations of style, certainly, but they are small, and not at all like the variations of style in painting.

The ability to reproduce is the enemy of any impulse to progress. And there is no progression, least of all in the limited area of the artifact itself, for Morris's objects always assume the inertia of the endlessly echoic, willingly abandoning the ability of art to surprise. Thus the classic method of Morris's art is patterning, and his classic production is wallpaper, wallpaper. As is often glibly said, the human eye delights in pattern; but pattern is not an adequate substitute for composition. Furthermore, pattern is only pleasing when kept within bounds. The bounds need to be those of a picture-frame, not those of a whole room. Just as rooms need windows, they need pictures; but no picture could properly exist in a room draped in Morris paper. The whole concept of wallpaper is an insult to the human eye's ability to distinguish one thing from another. So too is Morris's poetry, so very like wallpaper in that there is no reason for it ever to stop, and so too is the third major aspect of Morris's boringness, the fact that his productions, though not entirely (for nothing is) meaningless and unemotional, all tend in that direction.

120　Morris began designing wallpapers in 1862, and the first group of them were issued in 1864. They included the 'Daisy', the 'Trellis', and the 'Fruit', of which the 'Daisy' was probably the most popular. Over the years these designs were followed by many others, the patterns sometimes doubling for use in chintzes. In 1877 Morris got hold of a loom and started weaving, his ambition being to produce great illustrative tapestries. He did the background, and the figures were normally by Burne-Jones. Among the best known of them are the *Adoration of the Kings* in Exeter College Chapel, the *Angeli Laudentes* and *Angeli Ministrantes*, several adaptations of paintings by Burne-Jones, 121　the *Forest*, and the *Woodpecker*, this last the only one to be entirely designed by Morris himself. None of these tapestries has much artistic merit.

As so much of Morris's patronage came from the architects of the Gothic Revival, it was natural that the Firm should make a speciality of stained glass. Rossetti, Burne-Jones and Brown all made designs for windows. Burne-Jones was especially adept at this, and had indeed designed a Pre-Raphaelite window for Bradfield College as early as 1857. He then taught stained-glass design at the Working Men's

120 WILLIAM MORRIS
'Daisy' Wallpaper
c. 1866

I once a king and chief · now am the tree-barks thief :

ever twixt trunk and leaf · chasing the prey ·

121 WILLIAM MORRIS
'Woodpecker' Tapestry
1885

College, or at least discussed it there, and by the time that the Firm was founded was almost an experienced craftsman in this field. He was generally responsible for the figures in Morris windows. They are to be found in many churches throughout England.

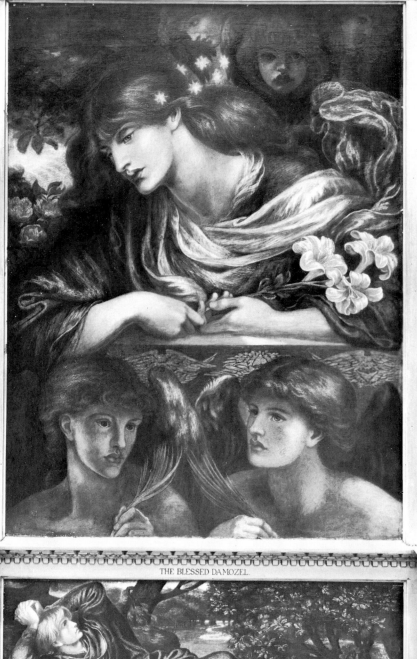

THE BLESSED DAMOZEL.

Beata Beatrix

Dante Gabriel Rossetti was one of the original shareholders in Morris's firm when it was founded in 1861. He contributed one or two designs, but his interest in the venture was desultory, for the past few years had seen the consolidation of his artistic methods, and he was painting and drawing with more confidence and ease than previously – especially since he found it easier to work in watercolour than in oils.

We have noted how much he drew, drew on, Lizzy Siddal, whom he finally married in 1860, and the personal feeling he was able to inject into the illustration of Dante. To the latter part of 1855 belongs an interesting triptych-like picture, which, like much of Rossetti's work, exists in several versions, *Paola e Francesca da Rimini*. On the left, the 123 lovers kiss, in a windowed niche reminiscent of the box-room space of other drawings. In the centre are Dante and Virgil, against a flatly painted background; and they look towards the third portion of the painting in which the souls of the lovers, clasped together, float through Hell. Here the background is painted in a system of large flecks of lighter colour against a darker background; one cannot tell if they are meant to be purely decorative or a schematic representation of the atmosphere of Hell, though they are probably both. Above Dante and Virgil appears the exclamation *o lasso!*, and under the right-hand portion is the phrase *meno costoro al doloroso passo*. As always, the addition of painted letters to the surface of a picture has the effect of nullifying space, and Rossetti's *Dantis Amor*, with its flatness, its faces in 61 profile, takes this process much further. Many of Rossetti's paintings have this flatness, especially when they consist of a single figure; the background to the main figure does not recede but belongs equally to the surface of the painting.

In 1855 Rossetti began – somewhat against his natural inclinations – to make designs for woodcut illustrations. The first of these was *The Maids of Elfin-Mere*, illustrating a poem by his Irish friend William

122 DANTE GABRIEL ROSSETTI *The Blessed Damozel* 1871–79

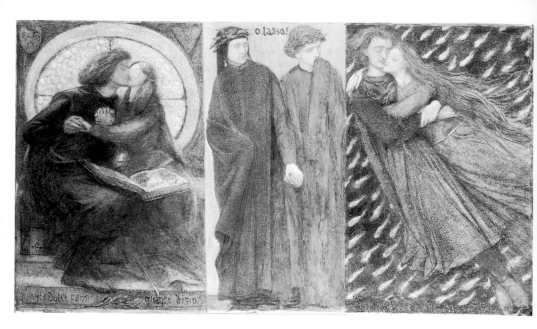

o lasso!

124 Allingham. To compare the first drawing of this subject with the
125 finished, published block is to realize how much of the personal
mystery of Rossetti's style could be lost by the discipline of this new
medium, in which lines are finely cut, not softly drawn, in which there
can be no rubbing, and in which chiaroscuro, taken to a melting limit
in Rossetti's pencil drawings, binding figures together and denying
space, needs now to be formalized and stiffened by regular cross-
hatching.

More important than this particular woodcut were to be the illustra-
tions to Moxon's edition of Tennyson. This enterprising publisher was
producing, at the high price of one and a half guineas, a special edition
of the Laureate's poems, and had engaged both the best and best-
known artists of the day to illustrate it. As an illustrator, Rossetti was
happy enough at the prospect of being in the company of such as
Millais and Hunt, though he had reservations about his work appear-
ing in the same volume as such *démodé* artists as Maclise and Creswick,
who were also to be contributors. One of Rossetti's designs, *The*
126 *Palace of Art (St Cecilia)*, is a strange little masterpiece. The spectator
must thread his way through its maze-like space, from the broken-
nosed, apple-munching guard, past and round the strange bridge or

176

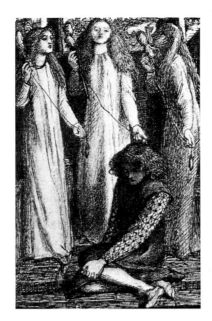
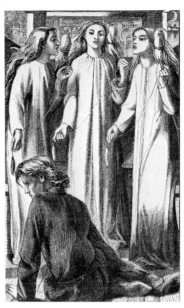

123
DANTE GABRIEL
ROSSETTI
Paolo e Francesca
1855

124–25
DANTE GABRIEL
ROSSETTI
*The Maids of
Elfin-Mere* 1855
(pencil drawing
and wood
engraving by
Dalziel Brothers)

platform whose structure merges with an organ played by an ecstatic beauty. The space then plunges into a middle ground and background in which men, ships and castles seem both near and immeasurably distant. Rossetti had written to Allingham that the idea of illustrating 'The Palace of Art' was an attractive one to him, for there 'one can allegorize on one's own hook, without killing for oneself and everyone else a distinct idea of the poet's'. Rossetti is indeed on his own hook here; but the attraction of Tennyson's poem, for him as for other Pre-Raphaelites, was an obvious one, especially since the 'soul' in the poem is externalized and dramatized as a woman.

Like Tennyson, Rossetti turned to Arthurian themes. Malory's treatment of Arthurian legends was to provide a large pool of subjects for Victorian writers and later Pre-Raphaelites, all attracted by his intensely medieval, chivalrous and romantic atmosphere. Bold knights and fair ladies were much appreciated by Victorians, but of course to think of Malory only in such terms is to falsify him: his knights were bold and bloody, and his ladies were fair and desirable. As the humanist schoolmaster Roger Ascham had first pointed out many years before, 'those be accounted the noblest knights that do kill the most men without any quarrel and commit foulest adulteries by subtlest shifts'. In a

general sort of way, it often seems that Malory provided an outlet for those Victorians who were not primarily social realists to paint or write about violence and lechery. And what generally happens in the illustrators of Malory is that the medieval manners are so mannered, the gestures are so formal, and the demeanour so stilted and elegant, that the depiction of human action has a remote, almost absent quality, and the actions seem to take place in a moral as well as historical non-world.

127 His first subject from Malory, *King Arthur's Tomb*, was one of the vivid little watercolours, sold to friends such as Ruskin, which provided a large part of his income during these years. It shows the guilty lovers, Launcelot and Guenevere, in an emotional confrontation actually over the grave of the man they have wronged. He is beseeching her; she, repentant and in mourning, rejects him. Such a scene could not easily be painted in contemporary terms without seeming absurd. A few years after this, at much the same time that he was working on the Oxford Union frescoes, Rossetti made a series of watercolours on Arthurian themes which were bought, as he painted them, by William Morris (who later had to resell in order to raise capital for the Firm).

129 *The Wedding of St George* is not actually an Arthurian subject, but was painted at the same time, and is of higher quality. It greatly impressed the fringe Pre-Raphaelite James Smetham, who described it as being 'one of the grandest things, like a golden dim dream . . . love "credulous all gold", gold armour, a sense of secret enclosure in "palace chambers far apart" – quaint chambers in quaint palaces where angels creep in through sliding panel-doors, and stand behind rows of flowers, drumming on golden bells, with wings crimson and green'.

However, we may prefer the way that Rossetti achieves a real and more spacious grace when designing with the large surfaces of the Oxford Union walls in mind, especially in two drawings of people
128 with their arms outstretched, *Launcelot's Vision of the Sangreal* and *Sir Galahad receiving the Sangreal*.

There can be little doubt that Rossetti gave Lizzy Siddal a hard time, and that she suffered from it. He neglected her. The rooms at Chatham Place were dark, cold and damp. Her health deteriorated. There was seldom enough money. Rossetti was unfaithful, and there had been

178

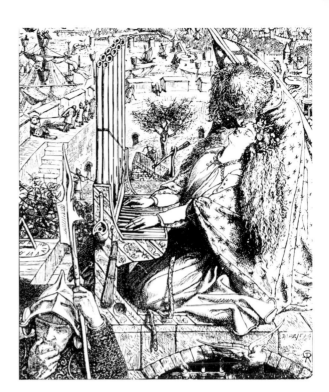

126 DANTE GABRIEL ROSSETTI
The Palace of Art (St Cecilia)
1857 (wood engraving by
Dalziel Brothers)

some especially unpleasant intriguing round Annie Miller, a model
with whom Holman Hunt also had an affair. Lizzy's child was still-
born. One evening in 1862 she and Rossetti dined with Algernon
Charles Swinburne in Leicester Square, and Rossetti went on after-
wards to the Working Men's College. When he got home later that
night he found her dead, an empty phial of laudanum by her side. The
official verdict was accidental death, but it felt like suicide.

Rossetti, for a time, could not believe that she was dead. Then he
grieved, and threw the manuscripts of his poems into her grave. He
could no longer sleep in Chatham Place, and moved into a house in
Chelsea, in Cheyne Walk. There, in 1863, he painted what is perhaps
his best picture, *Beata Beatrix*, nominally a painting about Dante's *114*
Beatrice but actually a picture about Lizzy. It is Rossetti's tombstone
to his wife. And so it is easier to understand the achievement of this
painting, and its very un-English quality, if we think of it as a monu-
ment rather than as a painting about Dante. The urge to commemorate
the dead is a basic human impulse. In art, it has usually been expressed

179

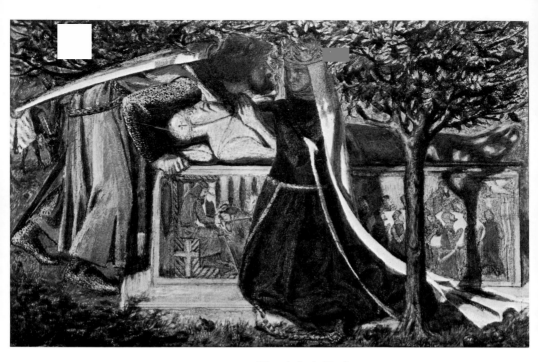

127 DANTE GABRIEL ROSSETTI *King Arthur's Tomb* 1855–60

128 DANTE GABRIEL ROSSETTI *Launcelot's Vision of the Sangreal* c. 1857

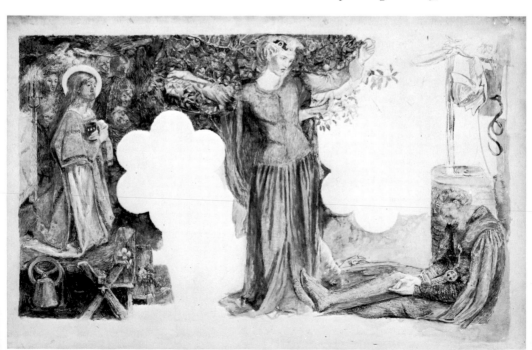

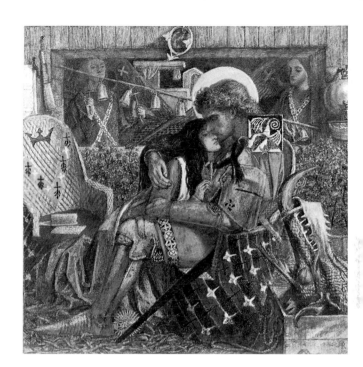

129 DANTE GABRIEL
ROSSETTI *The Wedding of
St George and Princess Sabra*
1857

in funerary sculpture, the raising of monuments above tombs. As a
result the expression of mourning in art has generally been mixed with
religious themes, and specifically with the religious belief in an after-
life. The best tomb sculpture is in Renaissance Italy, where it is fortified
and energized by an intense feeling for the transmutation from the
human to the spiritual; this eschatological vigour is not an English
quality, and is totally absent in the commemorative sculpture of
Anglicanism.

Rossetti paints powerfully here. He revivifies as he mourns, testifying
his belief in undying art as he grieves for the mortal. The ground had
already been well prepared for the basic theme of this painting, in
Rossetti's long-standing identification of himself with Dante, and of
Lizzy with Beatrice. *Beata Beatrix* is a portrait of Lizzy as Beatrice, at
the moment of her death. She looks as if she is in ecstasy; and, as for
instance in Bernini's *St Teresa*, it looks as much a sexual as a religious
ecstasy. (Rossetti used a give-away word when describing his picture,
saying that she is 'rapt from earth to heaven'.) Behind Lizzy are two
figures, one of Dante and the other of Love, looking at each other, and

into her hands a malignant haloed bird drops a flower. The bird of the Annunciation has become the messenger of Death, and the flower is not a lily but a poppy, the red flower of passion which is the symbol of sleep and death and also the source of opium, the drug from which she died. In the rich, heavy atmosphere of this painting, with its thick luscious paint and melding of the real with the unreal, is a unique wedding of the sensuous and the ethereal.

When Rossetti moved to Cheyne Walk he gave up Arthurian subjects, gave up writing poetry, and broke his connection with Ruskin, who only a few months before had financed his volume of translations from the early Italian poets. He was to work on only one more major subject-picture from Dante, *Dante's Dream*, which is obviously connected with the theme of *Beata Beatrix*. It refers to that moving passage in the *Vita Nuova* in which Dante dreams of Beatrice's death and of the women who came to cover her with a white veil.

Cheyne Walk was an unworldly, unlikely household. Rossetti started buying animals, as other people would buy furniture or tend their gardens. The ménage became a menagerie. There were owls, rabbits, dormice, wombats, woodchucks, kangaroos, wallabies, a racoon, parrots, peacocks, lizards, salamanders, a laughing jackass and a Brahmin bull whose eyes reminded Rossetti of Jane Morris. He kept animals and he painted only women; they were real painted women sometimes, like the whorish model Annie Miller, or like Fanny Cornforth, the original model for *Found*. To Cheyne Walk came friends of different types, like the tiny, gesticulating, dirty-minded Swinburne, always drunk, and the thieving trickster Charles Howell.

Rossetti himself was no longer gay and handsome as he had been a few years earlier. He was growing into a fat little man, going bald, no longer bothering to trim his straggling and unlovely beard. Rossetti started dying. It took him some time, but there is no doubt what he was doing, and that the process began now, with the move to Chelsea. He became a drug- and drink-sodden wreck. The debilitating effects of addiction exacerbated and deepened his despair. His health, both mental and physical, cracked beyond redemption, and almost beyond solace. He developed a morbid fear that, like his father, he might lose his sight. The doctors said, as they always do, that he was suffering

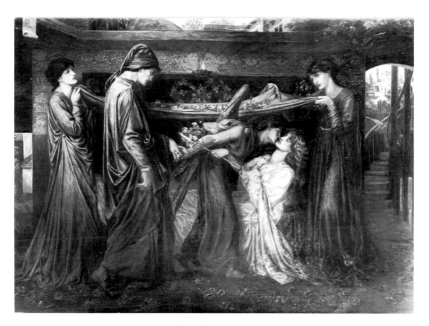

130 DANTE GABRIEL ROSSETTI *Dante's Dream* 1871

from overstrain and nervous tension. So he was, but he felt it more than most. To ease his insomnia he began taking chloral, ten grains at bedtime with a whisky chaser. It was a habit he never abandoned, and at the end it had reached a point where he was able to boast with a kind of gloomy pleasure that he was up to 180 grains a day. Robert Buchanan's attack on him in the famous pamphlet *The Fleshly School of Poetry* (1871) confirmed paranoid delusions that the world was out to get him. In 1872 he attempted suicide, following the method used by his wife ten years before, swallowing a bottle of laudanum. Thenceforward he became more and more of a recluse, and increasingly dependent on the deadeners to which his doctors finally abandoned him. For some time before he died, his partially paralysed body had been rotted with chloral, laudanum, morphia by injection, and unlimited quantities of whisky, claret and brandy.

This long and terrible decline Rossetti, in a way, kept private. He hugged it to himself. There are few indications in his letters, for instance, of what he had become. There were some reliefs to his misery. There was the friendship with Ford Madox Brown; and above all there was Jane Morris. Rossetti fell in love with the wife of his former protégé

and partner at some indeterminable time in the 1860s, though she had been a subject of his art since they first met in Oxford years before. Soon Rossetti stopped painting Annie Miller and Fanny Cornforth and concentrated on her, just as, socially, he relied on her company. It was not a piercing kind of love, but an extended, hopeless one, that kind of love in which long periods of lonely despair are enlightened by occasional meetings and the kindness of the loved one. Jane Morris appears time and time again in the paintings of Rossetti's last years. They are subject pictures but, generally, the subject does not greatly matter. For, more than they are 'about' a certain subject, be it an illustration of literature or a symbolic motif, these are paintings about love, and about a particular love.

Love is always with us, though its role as an artistic determinant varies. This is especially true of painting, for while literature continually testifies that love makes us sing, or weep, it is able to do so because these responses can be *verbalized*. In painting, this is less likely to be the case; any form of art whose method depends on depiction, on representation, is necessarily going to be biased towards what one sees rather than what one feels. Painting is dumb, and for that reason partially handicapped as a vehicle for the emotions. Thus we have many love poets – but how can we have a love painter?

Rossetti is the nearest thing we have to a love painter, and this is the simple clue to his art. Inevitably, one is reminded of Morris's plaintive scrawl across his canvas, 'I cannot paint you but I love you'. Morris couldn't, but Rossetti could, and did. The Morrises' marriage had long since fallen apart in mutual indifference, and Rossetti took to loving this lonely woman as he took to painting her. They formed a selfsufficient couple, though an unequally balanced one. Rossetti is a love painter because he plays so continually on the only two ways in which this can be possible; by portraiture, and by a special use of illustration. Of course, one can paint the portrait of the woman one loves, and in the end it remains a simple portrait. But there is something in the way that Rossetti does it, something in the endless repetition, as we see that same face reappearing in canvas after canvas, that is a witness to the totally obsessive quality of Rossetti's love for this woman, the woman who quite clearly dominated his life and gave him what

glimpses of happiness he was allowed during the years of his decline. At Kelmscott, Morris's house in the Cotswolds, while Morris was away, in that grim, grey house set amidst grey sedge, on a sort of low wold, *Haystack in the Floods* country, surrounded by overwhelming tapestries of Samson's eyes being gouged out and spine-breaking medieval furniture, Rossetti could be alone with Jane. 116

At this stage it must be admitted that we do not know very much about Mrs Morris. Was she the spirited, intelligent and sympathetic woman that some people claim, or only a dull sort of person who just happened to look so splendidly pallid and worshipable? This latter view of her derives largely from some memoirs of Bernard Shaw's. Apparently the only thing he could ever remember her saying was some remark about suet pudding. Shaw was so tickled by the disparity between this remark and the distantly adored goddess of the paintings that it might not have occurred to him that she simply didn't want to talk to the bumptious young socialists her husband brought home. Nor did she much like talking to her husband; how could she see his qualities, living as she had to with all that boyish noisiness, the sudden rages and inexplicable enthusiasms? She liked Rossetti. And Rossetti worshipped her. He needed her too, for if he could hardly live without her, he certainly could not paint without her. If there have been many artists with favourite models, there can have been few so absolutely dependent on one face and figure, and few models so fully embodying in their own aspect all the principles of a style. Jane's unrivalled conjunction of the fleshly and the poetic, that look which is both intense and languid, are superbly conveyed by Rossetti's rich flow of paint, unreal lighting, and uncertain definition of space. The drugged melancholy of these canvases, with all their resigned longing and 115 feeling for the lost or the unattainable, is obviously close to the facts of Rossetti's own life, in which the adoration and expression of beauty was the only possible response to the unbeautiful broodings of his own mind.

This is the explanation of the great differences in quality and feeling between portraits of Jane Morris and other work during Rossetti's last period. It is tempting to skip over such paintings as the group formed by *Lady Lilith*, *Helen of Troy*, *The Beloved*, and *Monna Vanna*. They have

none of the conviction or intensity of the paintings of Jane, though the intention in each was to paint the Beautiful. *Helen of Troy* is a portrait of Annie Miller, a woman in whom Rossetti quite rightly perceived a capacity for destruction; she reappears in *Lady Lilith*, which Rossetti was later to call 'Body's Beauty' in contrast to the 'Soul's Beauty' of *Sibylla Palmifera*. Lilith, in Talmudic legend, was the wife of Adam before Eve, and a lovely but evil woman. Here she is represented as cold and unresponsive. This element is present too in *The Beloved*, whatever the picture's intentions, and, with contemporary and

131 fashionable overtones, in *Monna Vanna*, icily aloof, and a strong contender for the distinction of being the nineteenth century's nastiest painting. When Rossetti, as here, approached fashionable academic portraiture, the results were disastrous.

In 1867 Rossetti posed Jane Morris for some photographs, and recast one of them into a very fine crayon drawing which he entitled *Reverie*, almost as soft and dreamy as the better-known *Anna Catena* and *La Donna della Fiamma*. The power of concentration on Jane alone, so evident in these drawings – where she always appears as being slightly more than life-size – was both exclusive and a matter of some delicacy; it could be destroyed, as for instance in the oil *Mariana*, whose atmosphere is shattered by the intrusion of a female-lipped pageboy, actually a portrait of the buyer's son.

132 *The Bower Meadow*, a very popular Rossetti picture, is an example of a painting that carries no meaning, although it looks as if it might. Rossetti, short of money in 1872, took up an old canvas on which he had made his abortive attempt to paint natural scenery, in Surrey with Hunt in 1850. To this background he added two women playing musical instruments, and a group of figures in the centre who, even when dancing, seem to droop. He then gave it a resounding medieval title, and sold it immediately. A more considered picture was *The*

122 *Blessed Damozel*, illustrating the early Rossetti poem which had first appeared in *The Germ*. The Damozel herself is at the gold bar of heaven, looking towards earth. Behind her and round her are angels and lovers (these details vary in different versions). This painting was commissioned in 1871, and by 1879 Rossetti had given it a predella showing the earthly lover lying under a tree and looking up towards the departed.

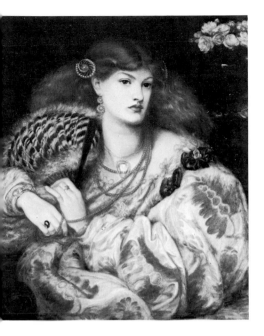

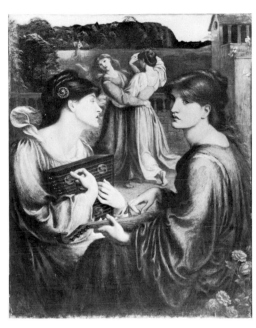

131 DANTE GABRIEL ROSSETTI
Monna Vanna 1866

132 DANTE GABRIEL ROSSETTI
The Bower Meadow 1872

At this time Rossetti was at work on his most powerful tribute to
Mrs Morris, *Astarte Syriaca*, which was developed from another sinis- 115
ter-looking sea-green portrait of her, *Mnemosyne*. Astarte was the
Syrian Aphrodite, and Rossetti's aim was to give her more of the
qualities he found in Love than Venus herself possessed – as he makes
clear in a sonnet that accompanied the picture. And so she is dusky,
sombre, mysterious, and to give oneself up to her worship is to abandon
the world of light. The conception of this painting is so massive, and so
intense, that most other Rossetti pictures rather wilt beside it, even the
beautifully painted *Proserpina* of 1874-77 and the startling *Day-Dream*.
Indeed, *Astarte Syriaca* must be regarded as the summation of Rossetti's
career as an artist; legend, religion, art and love are all combined in
this awe-inspiring Hymn to Her. Alone in Rossetti's work, alone
perhaps in the whole of Pre-Raphaelitism, it is one of those paintings
that have a genuinely humbling quality.

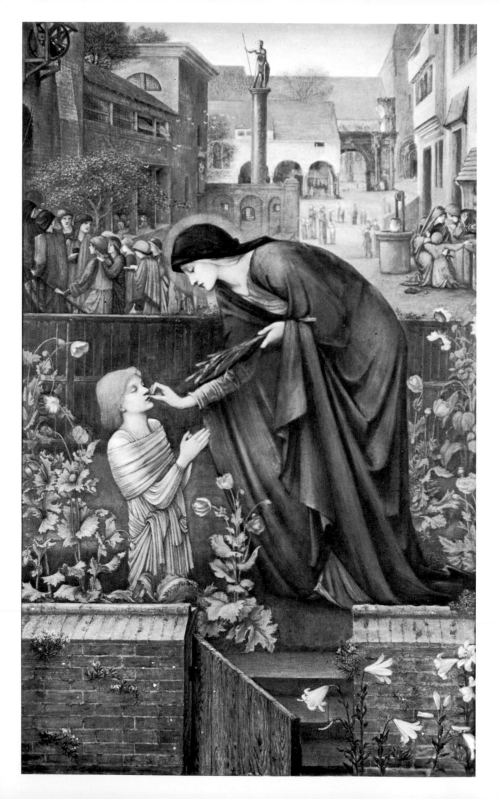

Standstill

Victorian writers often referred quite naturally to Burne-Jones's home in Fulham as his 'abode'; he carried that sort of aura with him from a surprisingly early age. As we have seen, by the time his Oxford career came to an end he had abandoned his plans for an ecclesiastical life and fallen in love with painting. The example of the Pre-Raphaelite paintings in the collection of Thomas Combe was enough to turn his head; above all, Rossetti's *Dante Drawing the Head of Beatrice* and his illustration to *The Maids of Elfin-Mere* were deeply thrilling to Burne-Jones, and answered to tastes already formed for medievalism and the repeated observances of an art that seemed to correspond to the ritual of the Church. When he moved to London, Burne-Jones met most of the other Pre-Raphaelites and saw current works such as Millais's *Sir Isumbras at the Ford*, on show to friends in the artist's studio. In fact he must have seen more paintings at this time than ever before in his life. There are some indications that at this early stage Burne-Jones occasionally tried his prentice hand at a kind of painting that belonged to the naturalistic mode of Pre-Raphaelitism. In his very early attempt to paint *The Blessed Damozel*, for instance, he shivered in orchards as he tried to paint apple blossoms from nature, continually blown from his sight by the bitter winds of May.

But his artistic career really begins as a simple imitator of Rossetti. In two little pictures, *Clara von Bork* and *Sidonia von Bork*, he duplicates Rossetti's style in illustrating a favourite book of Rossetti's, Wilhelm Meinhold's *Sidonia the Sorceress*. While painting the walls of the Oxford Union, he did a number of small Arthurian subjects in pen and ink on vellum, like *Alice la Belle Pelerine, Going to the Battle* and *Sir Galahad*.

The best of these drawings is *Going to the Battle*, which has many of the qualities of Rossetti's woodcut illustration *The Palace of Art*, except that it is much quieter, less emotional. Three ladies, two of them with their back towards the spectator and a third in profile, are in the castle

125

50

135

134

126

133 EDWARD BURNE-JONES *The Prioress's Tale* 1865–98

garden, watching a procession of knights going forth to fight. The tradi-
tional way of dividing space into foreground, middle ground and back-
ground is transformed here into three compartments. There is no feeling
of recession towards a horizon, but rather that sensation, which we
often have in Rossetti, of an *enceinte* in which things are nearer together
or further apart than would ever seem likely in an ordinary kind of
representational drawing. Nothing is real; bars of light sweep over the
surface of the picture both as a part of the pattern of a dress and at the
same time as part of the lighting system. This strong criss-cross is
repeated on a diminished scale in the trellis-work, as one looks closer;
and to look closer is to look further into the depth of the picture, where,
suddenly far away, are spears and halberds in sequence, and one calm
face of a knight, leaving the castle to which the ladies belong, to do or
die.

Both doing and dying are recurrent themes in Burne-Jones's art,
but with this difference from real life, that they are hardly occurrences,
for here action is without agitation, and death is like sleep. When we
enter Burne-Jones's world – and it is a different, self-contained world –
all is still, and all disturbance has been hushed. He is the painter of
calm, but he is not soothing, for it is not soothing to be becalmed.
There is little force in his paintings, however much he represents
deeds, and their temperature is always the same, whatever kind of
light or colour there might be. It is never warm, for there is no weather;
or if there is, the moon rules it, not the sun. If Burne-Jones's colours are
sometimes lutescent, they never glow. Sometimes, early on, he has
warm contrasts and quite high colouring, but this is always the result
of copying Rossetti. Similarly, there is a particular airless quality in his
paintings; in no sense is their atmosphere that of the real world. No-
thing is emphasized. There is no use of facial expression. Arms hang
limply. There is no tension. Burne-Jones is not nervous and he is not
excitable, for he paints only what he knows. He does not paint to
discover things, and this is why his art does not have a career.

In many artists whose development we can follow, one feels, as pic-
ture follows picture, that in one canvas the artist has found something,
that in another he pushes it a little further, that here he looks back, or
stops to consider, or consolidates, and then that sometimes he has

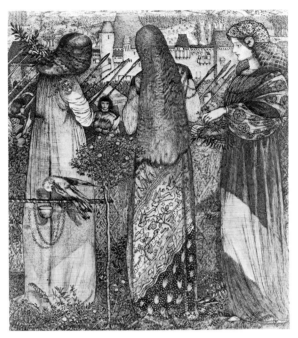

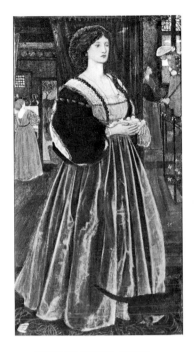

134 EDWARD BURNE-JONES
Going to the Battle 1858

135 EDWARD BURNE-JONES
Clara von Bork 1860

broken through – and we look, and see that he has become something different. In this is the excitement of art history, but it is something that we find in the painters who search, not those who are contented. (René Magritte is a twentieth-century example of this static temperament.) Burne-Jones's course is a very placid one, and the only major step of his career was to free himself from Rossetti; after that, he exists in a world where chronology is of little relevance.

Rossetti's influence began to wane about 1862 or 1863, and the characteristic Burne-Jones style was then developed. In his larger oil productions he hardly ever wavered from it. One reason for this was that he took so long to paint his pictures. He liked to linger over them, and he liked to be painting more than one at a time. Thus, *The Wheel of Fortune* was designed in 1871, begun in 1877, and finished in 1883. One of his last productions, at the age of sixty-five, was a picture of

133 *The Prioress's Tale*, and in it he repeats exactly the same design that he had used forty years before in Red Lion Square, with the single exception that an early Italianate city occupies the portion which had previously been landscape. The space goes up as much as it goes back, as one can feel by reading the painting, from that point, both inside and outside the picture, where the garden door swings open, up three stairs into the central area, and then up and over another wall into the background, which rises steeply, up the stairs on one side, and to the top of a column in the middle. This is exactly the same kind of space, the same kind of composition, that is employed in Burne-Jones's many other

136 vertically-based paintings, like *The Fall of Lucifer, King Cophetua and*
137 *the Beggar Maid*, and *The Golden Stairs*, in which a score of stately maidens in procession descend a spiral staircase – that kind of flight of stairs which has depth only, not length.

But, as far as Burne-Jones was concerned, length is only depth in a different direction, and so we find that another characteristic procedure of his art is the use of the long frieze-like line, usually of women. This was not only a characteristic of Burne-Jones; it was much employed late in the century, especially by classicists such as Albert Moore and Lord Leighton. The originator of the device may well have been Millais, in his *Apple Blossoms* of 1857. Many Burne-Jones pictures are like this: *St Barbara, St Dorothea and St Agnes, Green Summer, The Hours, Mary Magdalene at the Sepulchre, King and Shepherd* and so on.

138, 139 But the best pictures of this sort are *The Mill* and *The Mirror of Venus*, in which we can isolate a significant quality of Burne-Jones's art; his grace, always the special province of artists who are concerned with loveliness.

Burne-Jones takes grace to the point of being ponderous. It is a question of weight, and movement. A comparison will help. A painter much admired by the late nineteenth century was Botticelli, and his mark is seen on English pictures from Dyce's *Christabel* onwards. Sandro was, among other things, the painter of grace, and a particularly lovely thing he could do is a kind of movement, half-gliding, half-trotting, that is the lightest and most delightful delineation of serene female movement in Western art; it is in the *Abundance* drawing, and in his small figures of Tobias and the Angel at the bottom of the

192

136 EDWARD BURNE-JONES
King Cophetua and the Beggar Maid 1884

137 EDWARD BURNE-JONES *The Golden Stairs*
1880

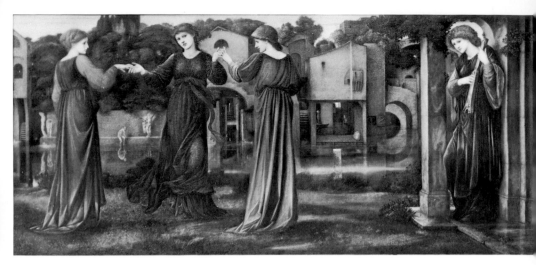

138 EDWARD BURNE-JONES *The Mill* 1870

Courtauld Collection's *Holy Trinity*. Burne-Jones was impressed by such matters, but depresses them. The three dancing girls – reminis-
138 cent of the Three Graces – in *The Mill* have their feet very firmly on the ground; they are hardly able to move at all. They have balance, symmetry, all the felicities of attitude; but they cannot lift themselves from their own heaviness, and if this is a dance, it is a very slow one.
139 In *The Mirror of Venus* all movement has stopped; a row of girls, all looking exactly the same, gaze into a pond, and there is no reason why they should ever do anything else.

Such things were never Rossetti's concern, except in his one mean-
132 ingless painting, *The Bower Meadow*, partly because he had not the space (pictorially) to deal with them, and also because (personally) he had not the expansiveness to emerge from his own obsessions. But Burne-Jones had no obsessions, for they are the product of real life; and he had another life, that of 'art'. So that when he left the *hortus inclusus* of Rossetti's influence, that narrow and enclosed imagination, he expanded his painting. He did this first of all by working on a larger scale, and giving his figures more room; his paintings are big,
119 and some of them, like *The Beguiling of Merlin* and *King Cophetua and the*
136 *Beggar Maid*, are very large indeed, bigger than a man.

As he created his own world he abandoned the singleness of theme that might have led him to express some distinct aspect of human

194

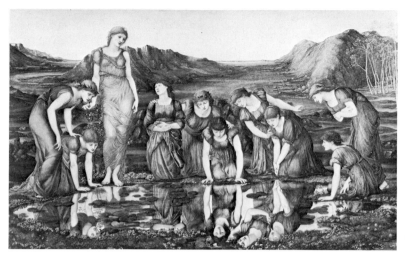

139 EDWARD BURNE-JONES *The Mirror of Venus* 1898-99

existence. Ruskin realized this, and told his students at Oxford about it, saying that Burne-Jones had developed a command over 'the entire range of Northern and Greek mythology' and 'a tenderness and large-ness of sympathy which have enabled him to harmonize these with the loveliest traditions of Christian legend'. This is so, but Greek myths, Northern myths, and Christian myths are all different, both in their feeling and in their intellection, and Burne-Jones is able to roam over the whole field of myth only because he had the sad ability to attenuate them all into one undifferentiated evenness of tone. In another place (the first section of *The Queen of the Air*), Ruskin re-marks about myths generally that they receive their best expression at the height of the culture which believes in them, and this is something that we need to bear in mind when thinking of Burne-Jones. For his art is the result of an interested study of mythology rather than its direct expression, and myth is at its height, artistically and socially, when it is expressed, not used. Burne-Jones used myth, and copied; and copying led to duplication, and to a no man's land in which a real man is no-body. This was the trap of his idealism, and it led to a sham corporea-lity which can never be grasped or held. One proof of this is in his treatment of nudes, as will appear.

In leaving Rossetti, Burne-Jones naturally moved nearer to Morris, and his use of myth is very similar to that of Morris. In the interminable

195

The Earthly Paradise, Morris sets his locale for the relation of various stories in an Atlantic island where Greek and other European cultures intermingle; and his stories are similarly without individual cultural character. *The Earthly Paradise* was the source for many of Burne-Jones's paintings, and the paintings are usually closer in feeling to Morris than to the original stories, but with one interesting exception. From Morris came the subject of *Pan and Psyche*. Psyche, having suffered from the maleficent attentions of Venus, attempts to end her life by drowning; but the stream gently casts her ashore again, where the shepherd Pan is sitting, and he comforts her. The picture shows how Burne-Jones lifted something from an early Italian, for this is a recasting of Piero di Cosimo's *Death of Procris*, in the National Gallery in London, and it reproduces some of the remarkable feeling in that work for the quasi-human mute affection which can sometimes be seen in dogs, and which is actually quite often used in paintings of Pan and his like. *Pan and Psyche* reveals an extremely subtle feeling for the removed world of myth; but it cannot be said that Burne-Jones manages such an individual effect very often.

Piero helped him here, but at other times a dependence on Italian masters led to complete failure, as in such Michelangelesque subjects as *The Wheel of Fortune*. Burne-Jones's relations with the Italian masters were always to be uneasy; he did not know how much to take from them, or in what ways. Sometimes their example could be assimilated, as when Mantegna stiffens his draperies, but Michelangelo in particular was always to have the effect of shattering the stylistic and emotional indifference that Burne-Jones normally maintained. He was better alone; he often feels like a man who never listens to anything that is said to him, and an early excursion to Italy in the company of Ruskin had no appreciable effect on his art.

Through most of his artistic career Burne-Jones painted pictures in series. The most remarkable of these is the Briar Rose series, which was based on the story of the Sleeping Beauty, and painted between 1871 and 1890, when it was acquired by Lord Faringdon for his drawing-room at Buscot Park in Berkshire. Burne-Jones subsequently painted some intervening panels *in situ*. The panel above the fireplace is one of Burne-Jones's finest pieces of painting; the girls, doing that charac-

140

141

196

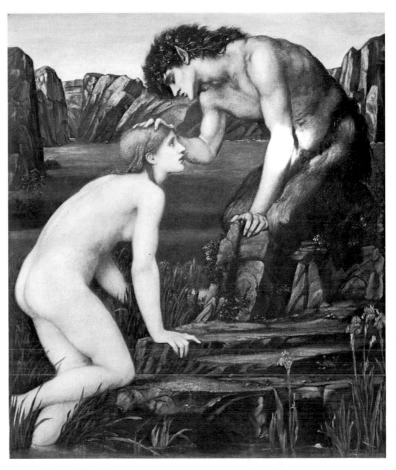

140 EDWARD BURNE-JONES *Pan and Psyche* c. 1872–74

teristic Burne-Jones thing, sleeping, contrast with the vigorous right-
ward implusion of the draperies. An intervening panel of briars, sharp, *144*
pliant, pushing silently in their own way to trap and enclose space, is
typical of the way that, as a formal quality, Burne-Jones liked to put,
behind the untroubled and static pose of his figures, sweeping long
lines, sometimes almost slashing – as in the draperies of *Sponsa de* *142*
Libano, the tanglewood of *The Beguiling of Merlin* and *Love among the* *119*
Ruins, the forms of the mountains in *Perseus in the Garden of the Nymphs,*
and especially in the magnificently bold rhythmic effect of the coils in
Perseus Slaying the Sea Serpent. *145*

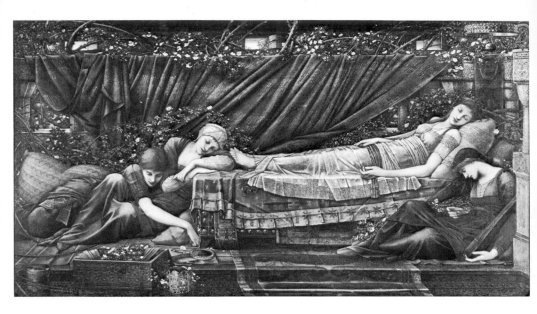

142 EDWARD
BURNE-JONES
Sponsa de Libano
1891

143 EDWARD
BURNE-JONES
The Depths of the Sea
1887

141 EDWARD BURNE-JONES
Panel from Briar Rose series 1871–90

144 EDWARD BURNE-JONES
Panel from Briar Rose series:
The Briar Wood 1871–90

145
EDWARD
BURNE-JONES
Perseus Slaying
the Sea Serpent
c. 1875–77

199

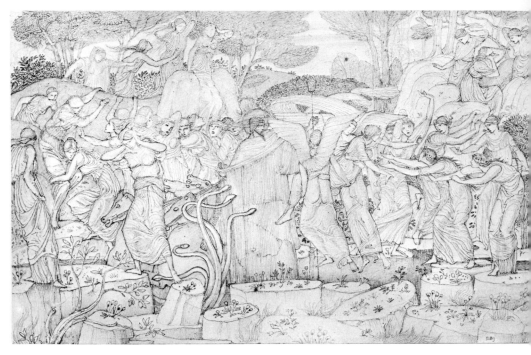

146 EDWARD BURNE-JONES *Pluto and Proserpine*

This last is the most successful of the designs for the Perseus series, others of which bear the marks of the undigested, and perhaps indigestible, influence of Michelangelo and – strangely – Fuseli. *Perseus Slaying the Sea Serpent* has a fine slimy monster, and the added advantage of an extremely fetching naked girl. Here is an aspect of Burne-Jones's art which deserves manly commendation, for even if he did it with something of a sly, voyeurish quality, Burne-Jones did put an end to the latitancy of the mid-Victorian nude. (Nude painting had unfortunately disappeared during the Pre-Raphaelite years; Queen Victoria bought an Etty nude, but nakedness was almost always covered up during the years of her widowhood.) It is always nice to see a breast in a painting, or as delicately glorious a bottom as Andromeda's, like a pale peach at sunrise. There are many such pleasantnesses in Burne-Jones's painting. The historical point is that he painted nudes at a time when naturalism could be combined with idealism, and it is the idealism that makes his nudes so much more shapely than

145

200

those of Etty, but at the same time less tangible. That, of course, is the trouble with ideal girls.

It is also the trouble with ideal art, and we can now see how far removed Pre-Raphaelitism is from the days when, having discarded its initial historicist fancy dress, the movement concentrated on realist principles: attention to detail, resemblance to nature, variety, contemporaneity, warm emotion and so on. Pre-Raphaelitism was running down, and it slackened as it was dispersed. Paintings such as Burne-Jones's are limper, and there could no longer be that tautness of relation between art and its audience that was characteristic of Pre-Raphaelitism in the 1850s.

But if Burne-Jones pushed art so far away from this world that our reactions to some of his paintings are of a merely so-what kind, in others the difference between our real world and his imagined one is astonishing. To some extent this is so of a fully finished, probably rather private drawing of a mythological scene whose wavy, scattered 146 panic animates the eye in pursuit of countless rhythms. At the back of it we are reminded of Palmer; but the whole seems most like Jan Toorop's great Symbolist and Art Nouveau work *The Three Brides*.

Burne-Jones's occasional excursions into wizardry can be taken quite normally by English people (perhaps because of the fairy-stories of their childhood; the very late, derivative Pre-Raphaelites, like Cayley Robinson and Arthur Rackham, were often illustrators of such books; it is one way in which Pre-Raphaelitism sank deep into English consciousness). But what are we to make of a painting like that subaqueous marvel, *The Depths of the Sea*? It is not like the sailors' 143 legend on which it is based; it is not really like anything else in Burne-Jones. It is not like anything, and the manic winsomeness of the mermaid's face, as she stares straight into the spectator's eyes, her arms round the loins of her bubbling captive, is enough to make anyone feel nervous.

Utopia feels like familiar territory after such an excursion, and the woodcut illustration to William Morris's socialist romance *A Dream* 157 *of John Ball*, with its levelling couplet, is a reminder that – even if most of the book production undertaken by Morris and Burne-Jones simply had the effect of making the books impossible to read, like the

Kelmscott Chaucer – yet Burne-Jones did occasionally produce some fine designs. Woodcuts such as these were a great influence on the designs of such artists as Walter Crane, and on the productions of organizations like the Art Workers' Guild and the Arts and Crafts Exhibition Society.

The soft-edged, flowing, unearthly type of Pre-Raphaelitism, as exemplified by Rossetti and Burne-Jones, was followed by many artists. Even Holman Hunt was marginally affected by this strain in Pre-Raphaelitism, as can be seen from his development of an early (1850) drawing of the Lady of Shalott into, first, an illustration for *150* Moxon's Tennyson and, later, a large oil. Hunt's *Lady of Shalott* is *149* rather like the *Morgan le Fay* of Frederick Sandys, although this painting is without Hunt's curving rhythms. Sandys, a largely self-taught artist, came into the Pre-Raphaelite circle in 1857, when he met Rossetti. In the 1860s, he made woodcuts for the magazine *Once a Week*, of which *104* *The Old Chartist* is a fine example.

The crotchety William Bell Scott was, of course, of an older genera-tion; Rossetti had sent him his poems before the Brotherhood was formed, when Scott was the master of the Newcastle School of Design. Scott is often to be found in later Pre-Raphaelite activities, especially among the Cheyne Walk set. He actually lived in a castle, at Penkill, in Ayrshire, where Rossetti stayed in 1868, talking of suicide. He painted one brilliant portrait, of Swinburne, and some interesting *148* pictures of workmen at Wallington Hall in Northumberland.

Apart from introducing Rossetti to whisky, Scott was probably a steadying influence on the Cheyne Walk household. This cannot be said of Simeon Solomon, whose dissipated life ended in alcoholism and beggary. The conditions of Solomon's life obscured what might have been a genuine artistic talent. He painted many women, generally with an unwholesome flavour to them, sometimes, as in his *Asia*, with large symbolic content. His most satisfying work is the very small *151* picture *The Meeting of Dante and Beatrice*, which reproduces the gestures *38* of Millais's *The Woodman's Daughter* in Rossettian space.

Other minor followers of Pre-Raphaelitism deserve brief mention. George Wilson painted symbolic women in a somewhat Pre-Raphaelite manner, and G. D. Leslie attempted to combine the

147 WILLIAM BELL SCOTT
A. C. Swinburne 1860

148 WILLIAM BELL SCOTT
Iron and Coal c. 1855–60

149 FREDERICK SANDYS *Morgan le Fay* 1864

150 WILLIAM HOLMAN HUNT *The Lady of Shalott c.* 1889–92

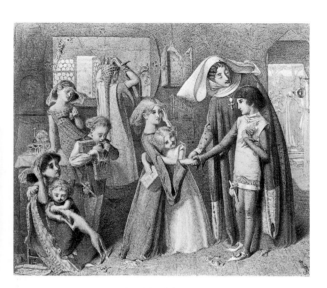

151 SIMEON SOLOMON
The Meeting of Dante and Beatrice 1859–63

manners of Rossetti and Millais in *Dante's Leah*. Val Prinsep, who, it
will be recalled, was at the Oxford Union, was directly influenced by
153 Rossetti in *Whispering Tongues can poison Truth*, as also was Marie
Stillman in *Upon a Day came Sorrow Unto Me*, while J. M. Strudwick
copied Burne-Jones. Evelyn de Morgan combined the influence of
Burne-Jones with that of early masters like Botticelli, as in *Flora*, as
also did Spencer Stanhope. There were many painters of this sort; and
154 a very few, like Byam Shaw, in *The Boer War 1900*, looked back
forty years to an earlier Pre-Raphaelite style.

These painters were imitators. One artist who emerged from the
later stages of Pre-Raphaelitism to form his own distinct style was
Aubrey Beardsley. Born in 1872, Beardsley developed his unique
manner from a number of influences; but of these the example of
Burne-Jones was pre-eminent. Beardsley idolized Burne-Jones, and
it was the example and advice of the older man that made him decide
to become an artist. In 1892 he was commissioned by John Dent to
illustrate a new edition of the *Morte d'Arthur*, and this was followed by

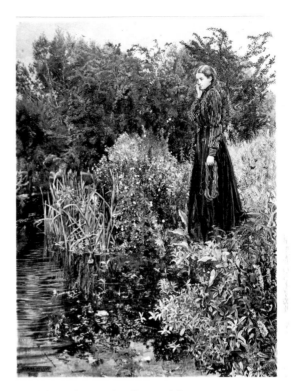

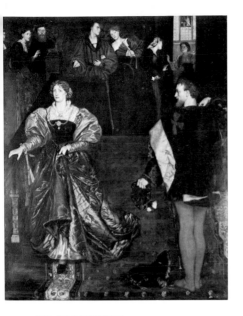

153 VAL PRINSEP
Whispering Tongues can poison Truth 1862

illustrations to Oscar Wilde's *Salome*. In this early work of Beardsley we can see the Pre-Raphaelite influence very clearly, as in *Arthur and the Strange Mantle*, which is indebted to the linearism of Burne-Jones's drawing and the book designs of William Morris; and in *J'ai baisé ta bouche Iokanaan*, in which the Pre-Raphaelite feeling for mysterious women is converted into a fascinated attraction to malignancy. 152

When Rossetti died in 1882, when Burne-Jones was still painting on, repeating himself, and followed by minor artists who simply copied him, what had happened to the original Pre-Raphaelites? Collinson had long been forgotten, and nobody troubled to recall him. Woolner had made money out of dealing. Frederick Stephens had for many years been a competent art critic. William Michael Rossetti continued his literary pursuits, and was a recorder of his brother's work and a historian of the artistic and literary life of which he had once been part. Holman Hunt had twice returned to the Holy Land, and the major work of his last years, *The Triumph of the Innocents*, was largely painted there. Millais was created a baronet in 1885 and became 155

President of the Royal Academy in 1896. Madox Brown had benefited from a period of relative affluence to set up a home in Fitzroy Square which was a famous centre of hospitality for artists and literary men, and was to be amusingly recalled by his nephew and biographer, the novelist Ford Madox Ford. The later part of Brown's career as an artist was dominated by his work in Waterhouse's Manchester Town Hall, in which he painted twelve large scenes illustrative of the history of Manchester; they all exhibit an uneasy balance between heroic history and the small-time realism of local history, and allowed him too much scope for the expression of his own inclinations towards the grotesque, which had been largely subdued in his earlier painting.

By the mid 1870s these were all men whose day as creative artists had passed. Not only art, but the whole atmosphere surrounding art, was changing. The Royal Academy had long since lost its position as providing the best art which was also the most official art. This was very largely the Pre-Raphaelites' doing, but the final break came with the opening of the Grosvenor Gallery in 1877. At the Grosvenor contemporary French painting was exhibited, together with the new avant-garde in English art, as most fully represented by Whistler. It was as a result of a visit to the Grosvenor Gallery that Ruskin wrote his famous attack on Whistler, accusing him, in his series of letters to

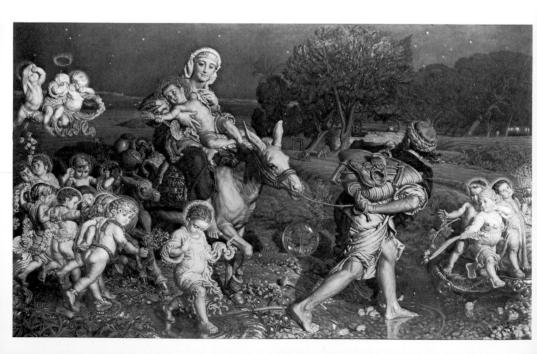

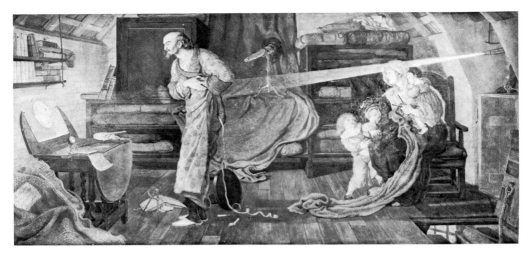

156 FORD MADOX BROWN *Crabtree Watching the Transit of Venus* 1883

workmen, *Fors Clavigera*, of 'throwing a pot of paint in the face of the public'. In the subsequent action for libel all Ruskin's old arguments about realism, workmanship and patience, feebly supported by an embarrassed Burne-Jones, were pitted against an emergent trend towards aestheticism and stylishness. In legal terms, neither side won, though the farthing awarded in damages had its symbolic value. But it was clear that a new generation had taken over. The age of aestheticism had begun.

While Pre-Raphaelitism in its later stages gave a great deal to aestheticism, in particular its artistic self-concern, the history of aestheticism is not a part of the history of Pre-Raphaelitism, though it was often thought to be so at the time; Walter Hamilton used the terms more or less interchangeably in his book *The Aesthetic Movement in England*, published in 1882. The new artist, as proposed by aestheticism, could not have been more different from the Pre-Raphaelite artist as proposed by Ruskin.

Oscar Wilde's descriptions of artists are very familiar. Here is a less-publicized one, by Ernest Dowson, who wrote in *A Comedy of Masks* (1893) of a painter sitting in a Soho café drinking absinthe 'rolling and as rapidly smoking perpetual cigarettes . . . driven back constantly to the dialect of the Paris *ateliers*, which was more familiar to him than his mother tongue . . . his white, lean face working into

207

155 WILLIAM HOLMAN HUNT *The Triumph of the Innocents* 1883–84

strange contortions as he shot out his savage paradoxes, expounding the gospel of the new art.'

Dowson caricatures, but one point is neatly caught, the painter's 'savage paradoxes'; for in the late stages of Pre-Raphaelitism discourse about art notably changed, from the Ruskinian method of long, detailed examination and explanation, to the delight in aphorism, the short, witty, unanswerable, unarguable mode of which both Whistler and Wilde were masters. And as aestheticism took over from Pre-Raphaelitism it also inaugurated the classic era of the connoisseur, the 'art expert' whose fastidious taste and immense store of obscure knowledge makes normal men flinch away in resentful respect, made conscious of their own intellectual shortcomings and general coarseness. Charles Fairfax Murray, once a pupil of Ruskin's and a Pre-Raphaelite watercolourist, later a successful private dealer, was the originator and prototype of this kind of connoisseur – later to become a familiar hate-figure in bourgeois attitudes to art.

Ruskin's crazed and impotent rage at the way the world was moving could be best expressed from a retreat, by removal from London – which had now, after the beginnings of some kind of movement to the provinces, reassumed its position as the one and only centre of art. He went first to Oxford, as Slade Professor, and then to Brantwood, his house on the shores of Coniston Water. In his middle years he had expanded his interests from a study of painting to an examination of architecture and social problems; but in architecture, the most social of the arts, he was bitterly conscious of the failure of his efforts. He was appalled by the rows of suburban villas and public houses (he can hardly have failed to notice the Half Moon, near his old home in Denmark Hill) that copied the Venetian Gothic detail which he had praised; and he effectively gave up architectural theory to return to an older idea of peasant society, attempting to re-create cottage life and cottage industry in the Guild of St George: rather as in his drawing of Fribourg. Ruskin's profoundly imaginative sense of culture, more pungent and more wayward in the years of his madness after 1869, came to associate the furrows of the plough with the incisions of engraving, and finally with the 'sorrowful earth-furrow' of the grave. Artists would not listen to him, and he no longer felt the same urge to

talk to them. His alternations of fierce misery and pathetic gestures of friendship were received only by those who could hardly comprehend, by old ladies and children. On the other hand, he did have followers, who called themselves 'disciples', referred to him as 'a prophet' or 'the master', and talked of his teaching as 'a gospel'. The hymn that was sung at his funeral is frankly idolatrous.

Ruskin's followers were usually affected too by Morris's work, and one way in which the Pre-Raphaelite tradition lingered on was in various forms of the Arts and Crafts movement, and in utopian socialism. A whole complex of progressive, left-wing, and generally rather silly ideas at the end of the last century and the beginning of this have their origins in Pre-Raphaelite environmentalism. They are instantly recognizable by the language used, like the socialist/crafty *art-work*, the vague and exhortatory *life-purpose*, the aesthetic inversion of *The House Beautiful*, deliberate archaisms like *healthful* and the adjectival use of *cleanly*.

'Love and *work*, yes!, *work* and love, that's the life of a man!' shouted Morris one day, and there is a good deal of Pre-Raphaelitism in his exclamation. First of all, nobody can think of Pre-Raphaelitism for very long without reflecting on love – especially since no movement in painting ever gave such an unabashed invitation to the emotions of the spectator. The artists simply painted it so often. There is the Keatsian romance of Millais's first Pre-Raphaelite painting, the stern admonitions in Hunt, the settled domestic affection in Brown, the sentimental trysts in Hughes, and the longing in Rossetti; at the end of the movement are Burne-Jones's caressing examinations of the female form and Beardsley's slyly knowing subversions of the erotic. The reactions of the painters to the theme of love are as various as the personalities of the artists themselves; but this, after all, is as it should be. The fact remains that the aestheticism of Pre-Raphaelitism, its concern with art and the idea of art, is generally subsumed in the image of the beloved. Lovely girls and their lovers are omnipresent, and this is agreeable. But there is one feeling – seldom the province of painting anyway – that is not expressed by any of these pictures, and that is joy. There is love, and sometimes delight, but never untempered happiness; and Pre-Raphaelite painting

sometimes seems to be insistently telling us what we already know, that beautiful things are fine, and we must be grateful for them, but life is still hard.

Hard because of work, not because of beauty, and Morris's attempts to bring the two together, though they have a heroic quality, had no success. Their separation, and the whole question of work, is more a matter of the historical significance of the movement than of its visible content. But art means more than it contains, and the ramifications of the idea of work, of pay and of use, those two old companions of labour, are everywhere in Pre-Raphaelitism, as also are the continual nags and indecisions about the value of art in an industrial society that seemed to care little for it. At the beginning of our period Ruskin was talking about workmanship and extolling the humble activities of the artist as craftsman. In the high realist phase of the movement this was extended to a more general worry about the function of the artist – how could he be arty and at the same time relevant to the problems of society? – and to the glimmerings of a new theme in art, the life of the working class. At the end of Pre-Raphaelitism Morris and Burne-Jones turned themselves into workmen, and Ruskin made undergraduates dig up a road while he talked to them of Fra Angelico. One thinks of Ruskin's admiration for some engravers he once saw working against time to complete a block for the printers, and his feeling that they were as exalted, in their way, as the great masters of the Renaissance.

In Pre-Raphaelitism, which is, after all, however inadequately, the art of the English Industrial Revolution, one is most keenly aware that the history of art is not a grandiose sequence of its masterpieces, any more than the history of men is summarized by the succession of the kings and queens who ruled them. It is also the history of art's effect on men, and we should end by thinking of people who were hardly good enough, as artists, to get into the official history books. Like Frederick Shields, who learnt to draw in a Mechanics' Institute, worked in commercial lithography in Manchester, sketched in the Manchester streets, nearly starved, designed trade labels, scraped a living with countryside watercolours and designs for *Once a Week*, wrote 'wash, prayer, Bible, breakfast' at the beginning of his journal entry every day, agitated on behalf of the Manchester Fenians, was a friend

157 EDWARD BURNE-JONES *Illustration to Morris's 'A Dream of John Ball and a King's Lesson'* 1892

of Rossetti and Madox Brown, and was proud to call himself a Pre-Raphaelite. He was a terrible painter, as it happens, but he lived for art, not only by it, and that is an admirable thing in this world.

Or let us think of someone who would be completely unknown to posterity, were it not for the chance preservation of a letter. In it, Edward Rees James, from an address in Camberwell, explains – it is in his best handwriting: the movements of the pen are very slow and deliberate – 'I am $21\frac{1}{2}$ years of age and a compositor by trade at which I am obliged to work from 8 in the morning until 8 at night but frequently still longer, from ardent love of drawing the human figure I joined the London Mechanics' Institute, but the teacher of the classes there does not attend more than once in six nights.' He was begging for instruction, for some way in which he could get closer to the production of the beautiful, something totally unlike his own life, setting type twelve hours a day.

When we think of Edward Rees James we need not wonder at the devotion of Ruskin's pupils at the Working Men's College; he vividly reminds us that the central moment of Pre-Raphaelitism is located, not at a point where any single artist, alone in his studio, first sketched out a new subject, nor yet when a picture at the Academy private view was received with interest and a mark in the catalogue from a gloved hand, but rather in those evenings in smoky Bloomsbury, at the Working Men's College, when, after work, artisans who loved art talked with men who made art, Pre-Raphaelites: John Ruskin, Dante Gabriel Rossetti, Ford Madox Brown, and Edward Burne-Jones.

WHEN ADAM DELVED AND EVE SPAN WHO WAS THEN THE GENTLEMAN

Bibliographical Notes

The clearest guide through the immense Pre-Raphaelite literature is that provided by William E. Fredeman's *Pre-Raphaelitism: A Bibliocritical Study* (1965), which contains a short discussion of the contents of every book listed. The standard edition of Ruskin is the library edition (1903–12), and a knowledge of its 39 volumes is essential to an understanding of nineteenth-century painting. Editions of separate works by Ruskin abound, and (conveniently) are to be found in every second-hand bookshop. Recent anthologies of his writing may therefore be avoided. Relevant information on the works of Brown, Millais, and Hunt is to be found in Mary Bennett's catalogues of the recent exhibitions of their work held at the Walker Art Gallery, Liverpool. There is a fine biography of Brown by Ford Madox Hueffer (1896), who quotes from the unobtainable catalogue of Brown's 1865 exhibition (which marked a significant development in the history of the one-man show, incidentally). J. G. Millais published a biography of his father in 1899. William Holman Hunt's autobiography, *Pre-Raphaelitism and the Pre-Raphaelite Brotherhood* (1905), is an important source, as also is *Pre-Raphaelite Diaries and Letters* (1900), collected by William Michael Rossetti: this book contains William Michael's 'P.R.B. Journal' (or parts of it), and gives extracts from the diary of Ford Madox Brown. The best biography of Rossetti is that by Oswald Doughty, *A Victorian Romantic: Dante Gabriel Rossetti* (1949). There are useful biographies of Morris by J. W. Mackail (1899), which is weak on the politics, and by Edward Thompson (1955), which is not primarily concerned with Morris's art. The biography of Edward Burne-Jones by his wife Georgiana (*Memorials of Edward Burne-Jones*, 1904) is almost totally unilluminating. Edward Rees James's letter is to be found in the library of the Victoria and Albert Museum.

List of Illustrations

The medium is oil on canvas unless otherwise specified; measurements are given in inches, height before width.

BEARDSLEY, AUBREY (1872–98)

152 *J'ai baisé ta bouche Iokanaan*, c. 1892. Indian ink and watercolour wash. Princeton University Library, Princeton, N.J.

BRETT, JOHN (1831–1902)

83 *The Glacier of Rosenlaui*, 1856. 17½ × 16½. Tate Gallery, London.
84 *The Val d'Aosta*, 1858. 34½ × 26¾. By permission of Sir Francis Cooper, Bt.
102 *The Stonebreaker*, 1858. 19½ × 26½. Walker Art Gallery, Liverpool.

BROWN, FORD MADOX (1821–93)

5 *The Execution of Mary Queen of Scots*, 1840. Oil on panel, 30¼ × 26¾. Whitworth Art Gallery, University of Manchester.
6 *Manfred on the Jungfrau*, 1841. 55½ × 45½. City Art Galleries, Manchester.
7 *Wycliffe reading his Translation of the Bible to John of Gaunt*, c. 1847–48. 47 × 60½. City Art Galleries and Museums, Bradford.
8 *Chaucer at the Court of King Edward III*, 1845–51. 153 × 124, plus frame. Art Gallery of New South Wales, Sydney.
34 *Christ washing Peter's Feet*, 1851–56. 46 × 52½. Tate Gallery, London.
96 *The Pretty Baa-Lambs*, 1852. Oil on panel, 20½ × 26. Ashmolean Museum, Oxford.
105–6 *An English Autumn Afternoon*, 1852–54. Oval, 27½ × 53. City Museum and Art Gallery, Birmingham.

107 *The Hayfield*, 1855. Oil on panel, 9 × 12½. John Gillum Collection. *Photo A. C. Cooper, Ltd.*
108 *Walton-on-the-Naze*, 1859–60. 12½ × 16½. City Museum and Art Gallery, Birmingham.
109 *The Last of England*, 1855. Oil on panel, oval, 32½ × 29½. City Museum and Art Gallery, Birmingham.
110 *Take Your Son, Sir!*, c. 1857. Detail. Unfinished, 27¾ × 15. Tate Gallery, London.
111 *Stages of Cruelty*, 1856–90. 24½ × 23. City Art Galleries, Manchester.
112–13 *Work*, 1852–65. 53 × 77½. City Art Galleries, Manchester.
156 *Crabtree watching the Transit of Venus (AD 1639)*, 1883. Oil on plaster, 126 × 58. Courtesy of the Town Clerk, Town Hall, Manchester.

BURNE-JONES, SIR EDWARD COLEY, BT. (1833–98)

119 *The Beguiling of Merlin*, 1874. 73 × 43½. Courtesy of the Trustees of the Lady Lever Art Gallery, Port Sunlight.
133 *The Prioress's Tale*, 1865–98. Watercolour, 41 × 25. Samuel and Mary R. Bancroft Collection, Delaware Art Centre, Wilmington, Del.
134 *Going to the Battle*, 1858. Indian ink on vellum, 8¾ × 7¾. Reproduced by permission of the Syndics of the Fitzwilliam Museum, Cambridge.
135 *Clara von Bork (1560)*, 1860. Watercolour, 13¼ × 7. Tate Gallery, London.
136 *King Cophetua and the Beggar Maid*, 1884. 115½ × 53½. Tate Gallery, London.
137 *The Golden Stairs*, 1880. 109 × 46. Tate Gallery, London.

138 *The Mill*, 1870. 35¾ × 77¾. Victoria and Albert Museum, London.
139 *The Mirror of Venus*, 1898. 47¼ × 78¾. Collection the Calouste Gulbenkian Foundation, Lisbon.
140 *Pan and Psyche*, 1872–74(?). 25¾ × 21⅜. Courtesy of the Fogg Art Museum, Harvard University, Cambridge, Mass. Bequest of Grenville L. Winthrop.
141 *Panel from Briar Rose Series: The Sleeping Beauty*, 1871–90. 28½ × 50½. Courtesy of the Trustees, Buscot Park, Faringdon. *Photo Copyright Courtauld Institute of Art.*
142 *Sponsa de Libano*, 1891. Watercolour, 127 × 61¼. Walker Art Gallery, Liverpool.
143 *The Depths of the Sea*, 1887. Watercolour on panel, 77 × 30. Courtesy of the Fogg Art Museum, Harvard University. Bequest of Grenville L. Winthrop.
144 *Panel from Briar Rose Series: The Briar Wood*, 1871–90. Courtesy of the Faringdon Trustees, Buscot Park, Faringdon. *Photo Copyright Courtauld Institute of Art.*
145 *Perseus Slaying the Sea Serpent*, c. 1875–77. Body colour, 60½ × 54¼. City Art Gallery, Southampton.
146 *Pluto and Proserpine* (also known as *The Rape of Proserpine*). Pencil, 8½ × 12⅞. City Museum and Art Gallery, Birmingham.
157 *Illustration to Morris's 'A Dream of John Ball and a King's Lesson'*, 1892. Wood engraving.

BURTON, WILLIAM SHAKESPEARE (1824–1916)
92 *The Wounded Cavalier*, exh. R.A. 1856. 35 × 41. Guildhall Art Gallery, London.
93 *The World's Gratitude*, exh. Rome 1911.

CAMPBELL, JAMES (1828(?)–1903)
103 *The Poacher's Wife* (also known as *The Wife's Remonstrance*), exh. Suffolk Street 1858. City Museum and Art Gallery, Birmingham.

COLLINS, CHARLES ALLSTON (1828–73)
33 *The Pedlar*, 1850. 38 × 49½. Ashmolean Museum, Oxford.
35 *Convent Thoughts*, 1850. 33¼ × 23¼. Ashmolean Museum, Oxford.

COLLINSON, JAMES (1825(?)–81)
32 *St Elizabeth of Hungary* (also known as *The Renunciation of Elizabeth of Hungary*), c. 1848–50. 48 × 72½. Art Gallery of Johannesburg.

DEVERELL, WALTER HOWELL (1827–54)
31 *Twelfth Night*, 1850. 40¼ × 52½. Collection the Edmondson family.

DYCE, WILLIAM (1806–64)
9 *Virgin and Child*, c. 1838. Oil on plaster, 29¾ × 20½. Nottingham Castle Museum.
12 *Titian's First Essay in Colour*, 1856–57. 36 × 26½. Art Gallery and Museum, Aberdeen.
90 *Welsh Landscape with Two Women Knitting*, c. 1858. 13½ × 19½. Collection Sir David Scott.
91 *Pegwell Bay, Kent, a Recollection of October 5th, 1858*, 1859–60. 24¾ × 35. Tate Gallery, London.

94 *George Herbert at Bemerton*, exh. R.A. 1861. 34 × 44. Guildhall Art Gallery, London.

HERBERT, JOHN ROGERS (1810–90)
10 *Our Saviour Subject to his Parents at Nazareth* (also known as *The Youth of Our Lord*), 1847–56. 32 × 51. Guildhall Art Gallery, London.

HUGHES, ARTHUR (1830–1915)
69 *April Love*, 1855–56. Arched top, 35 × 19½. Tate Gallery, London.
74 *The Nativity*, exh. R.A. 1858. 22⅜ × 13¼. City Museum and Art Gallery, Birmingham.
75 *The Annunciation*, 1858. 22⅜ × 13¼. City Museum and Art Gallery, Birmingham.
77 *The Eve of St Agnes*, 1856. Triptych, oil on paper. Centre, 25¾ × 22½; sides, each 23¼ × 11¾. Tate Gallery, London.
78 *The Brave Geraint*, c. 1859. 9 × 14. Collection Lady Anne Tennant. *Photo Messrs Rodney Todd-White.*
79 *Home from Work*, exh. R.A. 1861. Arched top, 40½ × 31. Collection the late Sir George Huggins, K.B.E.
80 *The Woodman's Child*, 1860. 24 × 25¼. Tate Gallery, London.
81 *Home from Sea*, 1863. Oil on panel, 20 × 25¾. Ashmolean Museum, Oxford.

HUNT, WILLIAM HENRY (1790–1864)
46 *Primroses and Bird's Nest*, Watercolour, 7¼ × 10¾. Tate Gallery, London.

HUNT, WILLIAM HOLMAN (1827–1910)
17 *Rienzi vowing to obtain justice for the death of his young brother, slain in a skirmish between the Colonna and the Orsini factions*, 1849. 34 × 48. Collection Mrs E. M. Clarke. *Photo Walker Art Gallery, Liverpool.*
18 *Love at First Sight*, 1848. 9 × 11¼. Collection Mrs Elizabeth Burt. *Photo Paul Mellon Foundation.*
24 Study for *'Valentine Rescuing Sylvia from Proteus'*, 1850. Pen and ink, arched top, 9¼ × 12. Courtesy of the Trustees of the British Museum.
25 *Valentine Rescuing Sylvia from Proteus*, 1851. Arched top, 38⅞ × 52½. City Museum and Art Gallery, Birmingham.
26 *A Converted British Family Sheltering a Christian Priest from the Persecution of the Druids*, 1850. 43¾ × 52½. Ashmolean Museum, Oxford.
27 Study for *'A Converted British Family Sheltering a Christian Priest from the Persecution of the Druids'*, 1849. Pen and ink, 9 × 11¾. Art Gallery of Johannesburg.
30 Frontispiece to *'The Germ'* (illustrations to Thomas Woolner's poems 'My Beautiful Lady' and 'My Lady in Death'), published January 1850. Two etchings on one plate, 7¾ × 4¾. Tate Gallery, London.
52 *The Hireling Shepherd*, 1851. 30 × 42½. City Art Galleries, Manchester.
53 *Claudio and Isabella*, 1850. Oil on panel, 30½ × 18. Tate Gallery, London.
54 *Our English Coasts* (also known as *Strayed Sheep*), 1852. 16¾ × 22¾. Tate Gallery, London.
55 *The Light of the World*, 1853–56. Original sketch for the painting at Keble College, Oxford.

Arched top, 19¾ × 10⅞. City Art Galleries, Manchester.
56 *The Awakening Conscience*, 1852. Arched top, 29¼ × 21¾. Property of the Trustees of Sir Colin and Lady Anderson. *Photo Walker Art Gallery, Liverpool.*
57 *The Scapegoat*, 1854. 33¾ × 54½. Courtesy of the Trustees of the Lady Lever Art Gallery, Port Sunlight.
71 *The Afterglow in Egypt*, 1854–63. 73 × 34. City Art Gallery, Southampton.
72 *A Street Scene in Cairo; the Lantern-maker's Courtship*, 1854. 21½ × 13¾. City Museum and Art Gallery, Birmingham.
73 *The Finding of the Saviour in the Temple*, 1854–60. 33¾ × 55½. City Museum and Art Gallery, Birmingham.
76 *The Eve of St Agnes*, c. 1848. 30½ × 44½. Guildhall Art Gallery, London.
150 *The Lady of Shalott*, c. 1889–92. Oil on panel, 17½ × 13⅞. City Art Galleries, Manchester.
155 *The Triumph of the Innocents*, 1883–84. 61½ × 100. Tate Gallery, London.

INCHBOLD, JOHN WILLIAM (1830–88)

82 *Early Spring* (also known as *In Early Spring*), exh. R.A. 1870. 20 × 13¾. Ashmolean Museum, Oxford.

LASINIO, GIOVANNI PAOLO (1789–1855)

11 *The Drunkenness of Noah*, c. 1832. Engraving, after Benozzo Gozzoli's fresco in the Campo Santo, Pisa, 6⅞ × 13½. Courtesy of the Trustees of the British Museum.

MARTINEAU, ROBERT BRAITHWAITE (1826–69)

101 *The Last Day in the Old Home*, 1862. 41¼ × 56½. Tate Gallery, London.

MILLAIS, SIR JOHN EVERETT, BT. (1829–96)

14 *Cymon and Iphigenia*, 1848–51. 45 × 58. From the Collection of the Third Viscount Leverhulme. *Photo Royal Academy of Arts.*
15 *Study for 'Isabella'*, 1849. Oil on panel, 8¾ × 11¾. From Lord Sherfield's Collection. *Photo Royal Academy of Arts.*
16 *Isabella* (also known as *Lorenzo and Isabella*), 1849. 40½ × 56¼. Walker Art Gallery, Liverpool.
19 *Christ in the House of his Parents* (also known as *The Carpenter's Shop*), 1849. 34 × 55. Tate Gallery, London.
21 *Two Lovers by a Rose Bush*, 1848. Pen and ink, 12¼ × 8¾. City Museum and Art Gallery, Birmingham.
22 *Study for 'Christ in the House of his Parents'*, c. 1849. Pen and ink, pencil and wash, 7½ × 13¼. Tate Gallery, London.
23 *The Disentombment of Queen Matilda*, 1849. Pen and ink, 9 × 16¾. Tate Gallery, London.
28 *Caricature of Post-Raphaelite Composition*. Pen and ink, 7⅞ × 7¼. City Museum and Art Gallery, Birmingham.
36 *Mariana*, 1851. Oil on panel, 23½ × 19½. From Lord Sherfield's Collection. *Photo Messrs Rodney Todd-White.*
37 *The Return of the Dove to the Ark*, 1851. 34½ × 21½. Ashmolean Museum, Oxford.

38 *The Woodman's Daughter*, 1851. 35 × 25½. Guildhall Art Gallery, London.
40 *John Ruskin*, 1854. 31 × 26¾. Private Collection.
41 *Ferdinand Lured by Ariel*, 1849. Oil on panel, 25½ × 20. From Lord Sherfield's Collection. *Photo Eileen Tweedy.*
42 *Effie in Natural Ornament*, 1853. Pen and ink, 7¼ × 9¼. City Museum and Art Gallery, Birmingham.
43 *Effie in a Ball-dress*. Pen and ink, 8¾ × 5¾. City Museum and Art Gallery, Birmingham.
44 *Design for a Gothic Window*, 1853. Charcoal and sepia wash heightened with white and green, on grocery paper mounted on canvas, arched top, 84 × 109. Courtesy of Mrs Mary Lutyens. *Photo A. C. Cooper, Ltd.*
45, 47 *Ophelia*, 1851–52. 30 × 40. Tate Gallery, London.
48 *The Vale of Rest*, 1858–59. 40½ × 68. Tate Gallery, London.
49 *Autumn Leaves*, 1856. 41 × 29⅛. City Art Galleries, Manchester.
50 *Sir Isumbras at the Ford*, 1857. 49 × 67. Courtesy of the Trustees of the Lady Lever Art Gallery, Port Sunlight.
51 *The Blind Girl*, 1856. 32½ × 24½. City Museum and Art Gallery, Birmingham.
70 *The Huguenot*, 1852. 36½ × 24½. Collection Mr Huntington Hartford, New York.
95 *The Rescue*, 1855. Arched top, 46 × 32½. National Gallery of Victoria, Melbourne.
98 *The Black Brunswicker*, 1860. 39 × 26. Courtesy of the Trustees of the Lady Lever Art Gallery, Port Sunlight.
99 *The Race Meeting*, 1853. Pen and sepia ink, 10 × 7. Ashmolean Museum, Oxford.
100 *Retribution*, 1854. Pen and sepia ink, 8 × 10⅞. Collection Miss Veronica MacEwan. *Photo Royal Academy of Arts.*

MORRIS, WILLIAM (1834–96)

118 *Queen Guinevere* (also known as *La Belle Iseult*), 1858. 28½ × 20. Tate Gallery, London.
120 *'Daisy' Wallpaper*, c. 1866. *Photo British Council.*
121 *'Woodpecker' Tapestry*, 1885. High warp woollen tapestry, 115 × 60. William Morris Gallery, Walthamstow. *Photo Victoria and Albert Museum.*

PRINSEP, VALENTINE CAMERON (1838–1904)

153 *'Whispering Tongues can poison truth, | And to be wrath with one we've loved, | Doth work like poison on the brain'*, exh. R.A. 1862. Courtesy of the Arts Club, London. *Photo Eileen Tweedy.*

ROSSETTI, DANTE GABRIEL (1828–82)

13 *The Girlhood of Mary Virgin*, 1848–49. 32¾ × 25¾. Tate Gallery, London.
20 *Dante drawing an Angel on the First Anniversary of the Death of Beatrice*, 1849. Pen and ink, 15¾ × 12¾. City Museum and Art Gallery, Birmingham.
29 *Ecce Ancilla Domini* (also known as *The Annunciation*), 1849. 28½ × 16½. Tate Gallery, London.

58 *Hist! said Kate the Queen*, 1851. 12¾ × 23½. Courtesy of The Provost and Fellows of Eton College. *Photo Thomas Agnew and Sons Ltd.*
59 *Hamlet and Ophelia*, 1858. Pencil, 14¾ × 11. Courtesy of the Trustees of the British Museum.
60 *The Tune of the Seven Towers*, 1857. Watercolour, 12¾ × 14¾. Tate Gallery, London.
61 *Dantis Amor*, 1859. Oil on panel, 29½ × 32. Tate Gallery, London.
62 *Mary Magdalene at the Door of Simon the Pharisee*, 1858. Pen and indian ink on paper, mounted on canvas, 21¼ × 18¾. Reproduced by permission of the Syndics of the Fitzwilliam Museum, Cambridge.
63 *Portrait of Miss Siddal*, 1855. Pen and brown and black ink, 4¾ × 4¼. Ashmolean Museum, Oxford.
64 *Miss Siddal standing next to an easel*. Drawing. Formerly at Bath, destroyed during the Second World War.
65 *Rossetti sitting to Miss Siddal*, 1853. Pen and brown ink, 4¾ × 7. City Museum and Art Gallery, Birmingham.
66 *Study for 'Giotto Painting Dante's Portrait'*, 1852. Pen and brown ink, 7½ × 6¾. Tate Gallery, London.
67 *Dante Drawing an Angel on the Anniversary of the Death of Beatrice*, 1853. Watercolour, 16½ × 23¾. Ashmolean Museum, Oxford.
68 *How They Met Themselves*, 1851–60. Pen and ink, 10¾ × 8¾. Reproduced by permission of the Syndics of the Fitzwilliam Museum, Cambridge. *Photo City Museum and Art Gallery, Birmingham.*
97 *Found*, 1853–82. 36 × 31½. Samuel and Mary R. Bancroft Collection, Delaware Art Centre, Wilmington, Del.
114 *Beata Beatrix*, c. 1863. Oil on canvas, 34 × 26. Tate Gallery, London.
115 *Astarte Syriaca*, 1877. 72 × 42. City Art Galleries, Manchester.
116 Jane Morris, posed by Rossetti, Kelmscott Manor, 1865. *Photo St Bride Printing Library, London.*
117 *Jane Burden as Queen Guinevere*, 1858. Pen and ink, 19 × 15. National Gallery of Ireland, Dublin.
122 *The Blessed Damozel*, 1871–79. 43 × 22, plus predella. Courtesy of the Trustees of the Lady Lever Art Gallery, Port Sunlight.
123 *Paolo e Francesca*, 1855. Watercolour, 9¾ × 17½. Tate Gallery, London.
124 *The Maids of Elfin-Mere*, 1855. Pencil on paper. Now lost.
125 *The Maids of Elfin-Mere*, 1855. Wood engraving by Dalziel Brothers, 5 × 3. Tate Gallery, London.
126 *The Palace of Art* (also known as *St Cecilia*), 1857. Wood engraving by Dalziel Brothers, for Moxon's Tennyson, 3⅞ × 3⅛. Tate Gallery, London.
127 *King Arthur's Tomb*, 1855–60. Watercolour, 9¼ × 14½. Tate Gallery, London.
128 *Launcelot's Vision of the Sangreal*, c. 1857. Watercolour. Ashmolean Museum, Oxford.
129 *The Wedding of St George and Princess Sabra*, 1857. Watercolour, 13½ × 13½. Tate Gallery, London.

130 *Dante's Dream*, 1871. 85 × 123. Walker Art Gallery, Liverpool.
131 *Monna Vanna*, 1866. 35 × 34. Tate Gallery, London.
132 *The Bower Meadow*, 1872. 33½ × 26½. City Art Galleries, Manchester.

RUSKIN, JOHN (1819–1900)

1 *Mer de Glace, Chamonix*, 1860. Watercolour heightened with white, 15¾ × 12. Whitworth Art Gallery, University of Manchester.
2 *St Mary's and All Souls, Oxford*, 1835 (signed 1880). Pencil, 14¾ × 10¾. Courtauld Institute Galleries, London, Witt Collection.
3 *Amalfi*, 1840–41. Pen and watercolour on buff paper, 13⅞ × 19¾. Courtesy of the Fogg Art Museum, Harvard University, Cambridge, Mass. Gift of Mr and Mrs Philip Hofer.
4 *Fribourg*, 1856. Pen drawing. Ashmolean Museum, Oxford.
39 *Study of Gneiss Rock at Glenfinlas*, 1853. Pen and brown wash heightened with white body colour, 17¾ × 12¾. Ashmolean Museum, Oxford.

SANDYS, ANTHONY FREDERICK AUGUSTUS (c. 1829–1904)

104 *The Old Chartist*, 1862. Wood engraving by Dalziel Brothers, for *Once a Week*, 3½ × 4½?. (The engraving has been reversed in reproduction.)
149 *Morgan le Fay*, 1864. Oil on panel, 24¾ × 17½. City Museum and Art Gallery, Birmingham.

SCOTT, WILLIAM BELL (1811–90)

147 *A. C. Swinburne*, 1860. 18¼ × 12½. Courtesy of the Master and Fellows of Balliol College, Oxford. *Photo Oxford University Press.*
148 *Iron and Coal*, c. 1855–60. 74 × 74. The National Trust (Trevelyan Collection), Wallington, Morpeth.

SHAW, BYAM (1872–1919)

154 *The Boer War 1900*, 1901. 39¾ × 29½. City Museum and Art Gallery, Birmingham.

SOLOMON, SIMEON (1840–1905)

151 *The Meeting of Dante and Beatrice*, 1859–63. Pen and ink, 7¾ × 9. Tate Gallery, London.

WALLIS, HENRY (1830–1916)

85 *The Stonebreaker*, 1857. Oil on panel, 25¾ × 31. City Museum and Art Gallery, Birmingham.
86 *A Sculptor's Workshop, Stratford-upon-Avon, 1617*, 1857. 15½ × 21. Courtesy of the Governors of the Royal Shakespeare Theatre, Stratford-upon-Avon.
87 *The Death of Chatterton*, 1856. 23¾ × 35¾. Tate Gallery, London.

WINDUS, WILLIAM LINDSAY (1822–1901)

88 *The Outlaw*, 1861. 13 × 12½. City Art Galleries, Manchester.
89 *Too Late*, 1858. 38 × 30. Tate Gallery, London.

215

Index

ALLINGHAM, William 54, 175–76
Arnold, Matthew 161

BEARDSLEY, Aubrey 204, 209
Blake, William 27, 97, 115
Brett, John 88, 119–22, 147, 158
Brown, Ford Madox 18–20, 27, 28, 32, 33, 50, 59, 125, 136, 138, 139, 147–59, 172, 183, 206, 209
Buchanan, Robert 183
Bulwer Lytton 38, 49
Burden, Jane *see* Morris
Burne-Jones, Sir Edward Coley 139, 140, 161–63, 172, 189–202, 207, 209, 210
Burton, William Shakespeare 130

CAMPBELL, James 125
Carlyle, Thomas 122, 159, 161
Collins, Charles Allston 55, 59, 67, 105, 135
Collins, Wilkie 55
Collinson, James 10, 32, 54, 59, 105, 205
Combe, Thomas 66, 68, 110, 162, 189
Cornforth, Fanny 182
Courbet, Gustave 122

DALE, Thomas 11
Davis, William 125
De Morgan, Evelyn 204
Deverell, Walter Howell 50, 59, 62, 105
Dickens, Charles 52, 59, 92, 144
Dowson, Ernest 207
Dyce, William 22, 54, 126–29, 192

FRITH, W. P. 143
Furnivall, James 133

HAYDON, Benjamin Robert 59, 158
Herbert, John Rogers 22
Hughes, Arthur 112–118, 144, 164, 209
Hughes, Thomas 133
Hunt, William Henry 16, 54
Hunt, William Holman 10, 28–29, 31–35, 38–39, 46, 49, 50, 57, 59, 66, 84–94, 97, 99, 107–11, 113, 136, 139, 140, 150, 202, 205, 209

INCHBOLD, John William 119, 147

JAMES, Edward Rees 211

LASINIO, Giovanni Carlo 24, 31
Lee, John 125
Leigh Hunt 24, 27, 31
Leslie, G. D. 202
Lewis, J. F. 159
Linnell, John 58, 88

MACKAIL, J. W. 167
Martineau, Robert Braithwaite 144, 146
Maurice, F. D. 133, 158

Millais, Sir John Everett 10, 22, 27, 29, 31, 41, 46, 49, 52, 54, 57, 59, 61, 65, 68–83, 84, 88, 89, 99, 105, 107, (108), 116, 125, 134, 139, 140–41, 144, 154, 163, 189, 205, 209
Miller, Annie 183, 186
Morris, Jane (*née* Burden) 59, 166–69, 182, 183–87
Morris, William 158, 159, 161–73, 195–96, 201, 209, 210
Mulready, William 57, 143
Murray, Charles Fairfax 208

NAZARENES 19, 22, 25, 126
Newman, John Henry, Cardinal 24, 163

PALMER, Samuel 58, 60, 88, 201
Pollen, John Hungerford 163
Prinsep, Val 164, 204
Prout, Samuel 15, 16

RAPHAEL 14, 22, 29, 157
Reynolds, Sir Joshua 26, 27, 46, 58, 83
Rossetti, Christina 26, 50, 94
Rossetti, Dante Gabriel 10, 26–29, 31–35, 40–41, 47, 49, 50, 65, 88, 94–101, 105, 115, 137, 139, 140, 164, 166, 172, 175–87, 189, 190, 194, 202, 209
Rossetti, William Michael 10, 26, 32, 46, 47, 72, 105, 106, 137, 162, 205
Ruskin, Euphemia (Effie), later Lady Millais 59, 75, 107
Ruskin, John 10, 11–17, 23, 26, 31, 46, 54, 57, 66–77, 92, 112, 118–22, 126, 133–38, 148, 159, 162, 195, 207, 208–09, 210

SANDYS, Frederick 147, 203
Scott, William Bell 27, 50, 146, 202
Shaw, Byam 204
Shields, Frederick 211
Siddal (later Rossetti), Elizabeth 59, 60, 99, 101, 107, 175, 178–79
Solomon, Simeon 9, 202
Stanhope, Spencer 164, 204
Stephens, Frederick G. 10, 31, 32, 49, 59, 205
Stillman, Marie 204
Swinburne, Algernon Charles 179, 182, 202

TAYLOR, Tom 82
Tenniel, Sir John 82
Tennyson, Alfred Lord 54, 60, 65, 161, 176
Thomas, William Cave 50
Turner, Joseph Mallord William 11, 15, 17, 56, 58

WALLIS, Henry 122–24, 146, 158
Whistler, James McNeill 206
Wilson, George 202
Windus, William Lindsay 125–26, 146
Woodward, Benjamin 163
Woolner, Thomas 10, 32, 41, 49, 106, 151, 205